My very best wishes

Stuart Purser

12/22/'80

THE
DRAWING HANDBOOK
APPROACHES TO DRAWING

PURSER PUBLICATIONS
2210 N. W. 2nd AVENUE
GAINESVILLE, FLORIDA 32603

THE
DRAWING HANDBOOK
STUART PURSER
UNIVERSITY OF FLORIDA

Dedicated to Mary

PURSER PUBLICATIONS
2210 N. W. 2ND AVENUE
GAINESVILLE, FLORIDA 32603

Printed by
STORTER PRINTING CO.
Gainesville, Florida

PREFACE

There are two important considerations which the author has kept in mind while writing *The Drawing Handbook*:

First, the book must emphasize the importance of both the concrete academic fundamentals and the less tangible creative aspects of drawing;

Second, the book's contents must reflect the broad interpretation and extensive range of drawing today, the unique position it holds as a service to other disciplines of the visual arts. One of its greatest contributions to art has been in the conception of ideas which have produced masterpieces in other media. Drawing does not have to depend on an identity within its own area for existence: there is no boundary within which it is confined; it penetrates and moves at will among all areas of the visual arts.

This service to other disciplines should not minimize or obscure the fact that drawing can also express, through its own inherent vitality, a complete statement and in itself become an art product.

For many years I planned to write a book on drawing. I saved for that purpose student drawings, class notes, assignments, and lectures, assuming that a book would be only a matter of arranging this material in its proper order and selecting appropriate reproductions. This assumption did not prove to be true. I found that teaching a class in drawing and writing a book on drawing are two different things. I worked many months trying to organize and present the accumulated materials as I had used them in the classroom; finally I confronted the fact that this arrangement was impossible.

The major problem, I concluded, was how to instruct and direct students whose drawings I could not see. There are certain basic problems and directions which are the same whether one is teaching students in a classroom or writing instructions in a book; however, the problem of checking the progress and evaluating the work must be solved if the book is to be effective.

It was clear that any student using the book who did not have an instructor available would have to evaluate his own drawings periodically. He must, therefore, have some rules and guidelines set up for this *self-evaluation*. My first draft had been no more than an instructor's manual: I had discussed problems which I knew the student needed, and I felt that the instructors would readily recognize that need. I had not, however, clearly explained the purpose of the problems or their relation to preceding and following problems, nor had I made clear to the student his necessary role in the plan of study.

Keeping these important considerations in mind, I revised the introduction so that it might serve as a key to the use of the book; I then felt that the

v

problem of writing about ways of improving student drawings which I could not see had been solved to some degree.

It became obvious that even with class instruction a specific plan for a student's evaluation of his own drawings would develop an awareness and encourage more independent thinking.

The selection of reproductions for my book presented a problem that seldom confronts the drawing instructor today. He often clips and posts examples from magazines, shows available slides and reproductions, or refers the students to books of reproductions in a nearby library. This affords the student an opportunity to see numerous examples of artists' works which illustrate a variety of solutions to the same problem. However, there is a limit to the number of illustrations which can be included in one book, and I found that often only one reproduction had to serve as an example of a technique, medium, or idea.

The problem of selecting reproductions of works by the masters was especially difficult: I had visualized a book that would include only the outstanding drawings by each artist represented; it was startling to discover that some of my favorite drawings had little to do with the problems discussed in the outline. Consequently, reproductions which obviously illustrated specific points were substituted. The necessity of limiting the number of reproductions had some advantages; I found that a careful study of a few well-selected examples proved more helpful to my students than a quick survey of an unlimited number of reproductions.

Along with the masters' drawings, the work of students at the undergraduate level has been extensively used. This can be a questionable procedure since the vast difference between master and student in experience and quality is immediately obvious. However, I am assuming that students will find it refreshing to see other students' solutions to some of the academic and creative problems, along with the often-reproduced master drawings. The vigor, sensitivity, and variety expressed in student drawings can be both stimulating and challenging.

I wish to express my appreciation to all those who assisted me with *The Drawing Handbook*.

First of all I am grateful to the many talented and devoted students whom I have taught throughout the years.

Also I must thank the individuals and museums who gave helpful information or granted permission to reproduce works from their collections: Agnes Mongan (Fogg Art Museum), Richard Tooke (Museum of Modern Art), June Wayne (Tamarind), Louis Hafermehl (University of Washington), and many others who graciously lent their assistance.

I am indebted to Paul Chalker, Roy C. Craven, Jr., Marian Fox, William McGraw, and the staff at Storter Printing Company for their help with the

layout, photography, and final production. From the very outset my wife, Mary, has assisted me with the manuscript and given me encouragement.

Finally, let me express my appreciation to my colleagues at the University of Florida for their interest and expertise: Eugene Grissom, Hollis Holbrook, Marcia Isaacson, Leonard Kesl, Kenneth Kerslake, Ronald Kraver, David Kremgold, Geoffry Naylor, Marshall New, Jack Nichelson, John O'Connor, Mallory O'Connor, John Petruchyk, Douglas Prince, Nathan Shiner, Robert Skelley, Jerry Uelsmann, Todd Walker, Shigeko Walton, John Ward, Phillip Ward, Hiram Williams and Kathleen Yuriglas.

S.R.P.

Gainesville
Jan. 1976

CONTENTS

PREFACE V

PART ONE: **THE BEGINNING STUDENT—
 FUNDAMENTALS**

 Chapter I **INTRODUCTION** 3
 Chapter II **STUDENT CONCERNS** 7
 Chapter III **ART ELEMENTS** 15
 Chapter IV **COMPOSITION—
 PRINCIPLES** 56
 Chapter V **MATERIALS AND
 TECHNIQUES** 71
 Chapter VI **FIGURE DRAWING** 125

PART TWO: **A PLAN FOR STUDY**

 Chapter VII **SCHEDULE AND
 ASSIGNMENTS** 133
 **INSTRUCTIONS FOR
 WORK SCHEDULE
 AND ASSIGNMENTS** 134
 **WEEKLY
 SCHEDULES (30)** 134-228

PART THREE: **THE ADVANCED STUDENT—
 PROJECTS**

 Chapter VIII **THE ADVANCED
 STUDENT** 233
 STUDENT PROJECTS 243
 **CONTEMPORARY
 APPROACHES TO
 DRAWING** 318

 BIBLIOGRAPHY 321

 INDEX 327

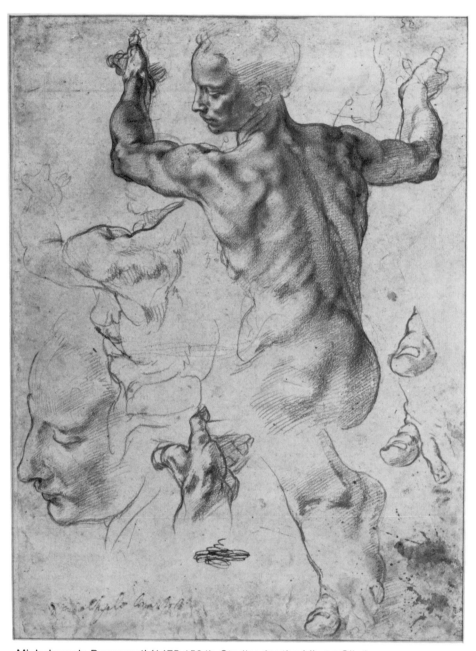

Michelangelo Buonarroti (1475-1564). *Studies for the Libyan Sibyl.*
Red chalk. The Metropolitan Museum of Art, New York.
Purchase, 1924, Joseph Pulitzer Bequest.

PART ONE
THE BEGINNING STUDENT: FUNDAMENTALS

CHAPTER I
INTRODUCTION

This chapter introduces the student to *The Drawing Handbook.* It states the purpose, suggests its most effective use, and outlines the desired results.

Our purpose is to present to serious art students with varying degrees of talent, and beginning at different levels of instruction, a course of study that will help each of them develop his own unique way of drawing. Most of these students will plan to major or minor in art. Some will be interested in learning to draw for pure enjoyment; others will want to strengthen their skills in an area related to art. Regardless of whether the student is a major or non-major, he should become seriously involved in the act of drawing in order to derive the greatest benefit from this book.

The natural ability of a student is of course important, but it is not a factor with which the student or teacher should be too concerned at the outset. Some students will draw with facility the first week, others will show promise only after being introduced to the basic fundamentals of drawing and after putting in many hours of hard work.

Class problems and assignments must have enough flexibility to meet the individual needs of all students. Uniformity is not the aim. Some students will achieve more than others because of their ability, previous experience, work habits, and enthusiasm.

Since the main purpose of this book is to help each student develop an effective individual approach to drawing, it is necessary to call attention to two important factors: *experimentation* and *self-evaluation.* These factors will be emphasized throughout the book. Continuous experimentation with a variety of techniques and materials permits the student to have some choice in his mode of expression. Naturally, through this diversity, his breadth and depth of expression increases. *Experimentation with ideas* is encouraged from the beginning, and when the student is involved with the more technical and less imaginative aspects of drawing, he is advised to provide a balance by working more creatively in his sketchbook and on outside problems.

There will be times when a student's experimentation will explore different ways of expressing the same idea. At other times it will lead him to the development of an idea that is entirely new. It is mainly while he is working

that a student conceives new ideas, and it is therefore best for him to continue drawing even though he may not have a clear-cut idea in mind. The important thing is to draw frequently and to be ever alert to ways of expressing and improving the esthetic quality of his drawings.

The idea of experimentation has been abused in recent years, and unfortunately too much emphasis has been placed upon variety and novelty. Experimentation with materials and techniques is not stressed for the purpose of keeping the student interested, of giving variety to the course, or of producing the novel result; it is intended simply to develop in the student an ability to select the appropriate materials and techniques for his drawings.

Materials and techniques cannot always be presented separately; many times they overlap and must be considered simultaneously. For example, it is impossible to tell a student how to do a transparent wash without also discussing the appropriate paints, inks, papers, and brushes.

More difficult to teach in this plan of study is the student's effective self-evaluation. This ability to evaluate his drawings is absolutely necessary if he is to derive the most benefit from his work. By effective self-evaluation I mean the student's ability to look objectively at his own work and to see his deficiencies and his strengths. When the student can do this, the problems of the instructor will be simplified.

Some students assume that they know what constitutes good drawing but feel unable to do it, when actually they have been ignoring weaknesses and trying to become proficient in areas where they already excel. Some students think their drawings are better than they are, and they become content with their efforts; others think their drawings are worse than they are and become discouraged. It is essential for the student to know his position in the scale of progress and recognize the important things he must work for during each phase of his development.

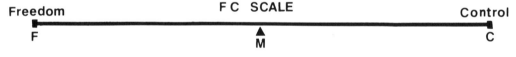

1. FC Scale.

The secret of successful drawing is to know and maintain a proper balance between freedom and control. To remind my beginning students of this highly important concept I present to them the simple "FC Scale" shown in Figure 1. This scale represents the range between freedom (Point *F*) and control (Point *C*) and shows the middle point of balance (Point *M*). It has proved helpful in reminding students to increase their range and to maintain a balance between the two extremes; it suggests that drawing is not just *creative expression,* but is *creative expression controlled.* The degree and kind of control suited to the needs of individual students will vary widely.

There are other terms which are sometimes substituted for freedom and control: informal and formal, subjective and objective, emotional and intellectual, feeling and facility, sketch and study, and others like them. Most of these combinations, however, have a slightly different connotation from what I mean by freedom and control. The words *sketch* and *study*, for example. As a rule the quick sketch does encourage freedom, while the longer study often demands control. But this is not always the case: A longer study can be done with a good deal of freedom and a sketch can be done with control.

The letter M midway between F and C represents the perfect balance between freedom and control. *This is not to suggest that all students are to strive for a perfect balance.* For the past decade and longer there has been *the tendency to overemphasize the importance of freedom* in art instruction from kindergarten through university. Assuming that freedom is all important, many instructors have insisted that every student work large and fast to attain freedom of expression. This insistence that everyone should work large, with bold media and large shapes and at the same rate of speed, assumes that every person feels and experiences freedom to the same degree. Actually, such a demand removes freedom and pushes the student toward conformity. An overemphasis on freedom makes it difficult for the student to draw with control at a later date. Rembrandt, Goya, Van Gogh, and many other artists drew carefully and thoughtfully during their earlier years. They produced free and highly expressive drawings only after they had gained confidence, knowledge, and skill.

If the FC Scale is to be helpful, the student must begin drawing according to his natural position on the scale, and then try to achieve an appropriate balance. Many students naturally draw in a free and spontaneous way, and their first efforts will be a great source of satisfaction to their instructor. These students should be made aware of their asset, but they should also be encouraged to work for control—the control which permits them to use their natural freedom in such a way that their expressions become meaningful to themselves and to others.

On the other hand, many students are formal and precise in their early approach to drawing, and naturally strive for control and technical facility; they, too, should be made to realize that this attitude is an important asset, essential to drawing. However, considering their position on the scale toward the C end, they should be encouraged to work with more freedom and come to understand that freedom can actually be a component of control.

The student in the first group who leans toward the emotional side of the scale (F) should be advised to work neither at the extreme C end nor at the midpoint M, but somewhere in between F and M with the idea of developing his control; this will strengthen his emotional expressions but not destroy them. Likewise, the student in the latter group who ranges near the C end of the scale should be encouraged to work neither at the extreme F end nor at the

midway point M; he should be encouraged to develop more feeling and emotional quality in his drawings so that his highly controlled statements may become artistic expressions.

A few students will from the very beginning express a good balance between freedom and control. These students should be informed of their potential and be encouraged to work diligently. Extremely talented students, or those who have had training and experience, frequently tend to rest on their laurels. They should instead become the pacesetters of the class. A talented and conscientious student with good work habits will serve as an inspiration to the rest of the class.

In summary, the student who has developed both the free and controlled hand early in his career will have more choice of expression than the one who has placed all emphasis on one or the other. As the student advances, he gives less conscious thought to these equally important approaches to drawing.

Definite benefits should result if the study of this book has been thorough: A student should expect to draw naturally and easily, because he has given his primary attention and efforts to having his drawings fit his emotions, experiences, desires, and abilities.

Along with a natural and spontaneous way of expression, the student should have developed a sound knowledge of drawing materials and techniques. At the beginning the selection of the appropriate media and techniques might necessarily require deliberation, but as the work progresses, the student will select them freely and naturally.

The student should expect to be able to use his drawings in a practical way. At times he may consider his work as a complete means of expression and draw only for the sheer enjoyment of drawing. However, he should also be able to relate his acquired skill to other disciplines and to use it in other areas. I refer to such areas as sculpture, crafts, advertising design, fashion design, interior design, illustration, painting, printmaking, and others. This wider application requires an awareness of the various forms of art from the earliest times to the present and a special knowledge of the area or areas in which the student wants to use his drawing skills.

To some students the emphasis will always be on drawing *as a product*, even though they may be making a working drawing for a piece of sculpture or a painting. These students naturally consider the esthetic quality of their drawings regardless of purpose. Others will use their drawings only for planning and testing ideas and art forms which are to be used in other areas of art and give little thought to drawing's esthetic quality.

Finally, the author feels that this book will have been successful if the student considers it a step in his creative development, a step leading to his future progress and achievement. It should help the student to continue his creative work with a higher degree of understanding and accomplishment.

CHAPTER II

STUDENT CONCERNS

In this chapter I will describe important responsibilities which the drawing student must assume. They pertain both to a professional attitude toward his work and to the necessary amount of work the student must do in addition to class assignments. In specific terms, I refer to keeping a sketchbook; working in the library; attending exhibitions and lectures; reading books and periodicals; and to the organization of the student's materials and time. To do these things properly he must become thoroughly *involved* with his drawing. It is not the easiest approach, but it is the only one that challenges the potential of a really talented student. Limiting responsibilities and activities to class assignments has led many students to a dead end.

The student must take every opportunity to visit museums and art galleries. He must have an interest in other areas besides drawing; he must investigate painting, sculpture, design, crafts, printmaking, and other related areas. Students will impede their development if they express interest only in the art of the past and neglect contemporary works. And students without a knowledge of the art of past civilizations may also limit themselves if they show an interest only in contemporary trends. They jump into a world created by their favorite artist, without having his background and broader understanding of art. By combining the study of *past* civilizations with an awareness of *contemporary* developments, the student is more capable of charting his own creative course in regard to his *future* development.

It is false economy when a student feels that he cannot spare the time to see an important exhibition or hear a fine lecture, for through these experiences he will return to his own drawing with more knowledge, vigor, and enthusiasm.

The attitude of the student must be professional in regard to his equipment and materials. He should obtain all the materials necessary for drawing and he should contain them in an orderly and convenient manner. He must not bring to class only the materials necessary for the first assignment, planning

to add the others to his kit as needed during the year, for an assortment of materials, at hand, inspires creative and imaginative work at the outset.

The student needs a suitable container for his drawing materials. One of the best containers is a fishing-tackle box or a similar metal box sometimes used by workmen. The former has a large area at the bottom useful for pencils, brushes, and other long objects; the top section has compartments which can hold thumbtacks, pens, clips, and smaller items.

Each student will have his favorite drawing materials and will want to add to any standard list; however, here is a list of materials likely to be found useful for most drawing courses:

Pencils (H, HB, B, 2B, 4B, 5B); assorted pens, pen staff, large clips to hold paper to board, thumbtacks, masking tape, vine and compressed charcoal; black conté crayon (soft and medium), newsprint pad, assorted papers, scissors, rubber cement, plastic glue, kneaded eraser, art-gum and other erasers, sponge, chamois skin, clean rags, water container, small mixing tray, mat knife, ruler, celluloid right angle, india ink, lithograph crayon, red and brown conté crayon, colored chalks, number 7 watercolor brush, other assorted brushes, chinese white and fixative.

More detailed information on these materials can be found in the chapter on materials and techniques.

A good portfolio for papers and drawings is as necessary as the metal box for materials. A student who comes to class without his portfolio, holding a pencil or piece of charcoal in one hand and a couple of pieces of paper in the other, has made a bad start. Even during the first week when drawings are done mostly in soft pencil or conté crayon on newsprint, the student should have his other materials in readiness.

The beginner should possess a sketchbook of convenient size and should carry it with him at all times. The sketchbook is his personal property, and its contents should be based upon the student's individual needs and interests. It tells more about him, his individuality, originality, interests, dedication, and general approach to drawing, than does all his work in class—provided of course that he gives enough time to this very important outside activity. The *sketchbook should be a catch-all.* It will contain some of the subjects that have been introduced in class assignments and need further study but it will also contain many things that are not covered in class. The student himself makes the selection. Away from the class and the instructor, he will not only decide what he is to draw but also how he will approach it: whether he will draw from objects or from imagination; whether he will make a descriptive or an interpretive drawing; whether he will do a sketch or a careful study. At first the student will need consciously to give the selection some thought in order to get a good balance in covering his overall needs. Later he will pick up his book and draw without consciously thinking about the subject or the approach. There will then be so many obvious needs and interests that it will be only a

matter of his choosing which to do first. He will find himself making anatomical drawings of bone and muscle, details of parts of the body not understood in class. He will make drawings from reproductions of old and contemporary masters, studies from nature, studies for composition; he will draw plans and ideas to be used in such other areas as sculpture, printmaking, crafts, and painting. He may also use his sketchbook as a testing ground for drawing media; here, there are limitations, however, because of the lack of sufficient

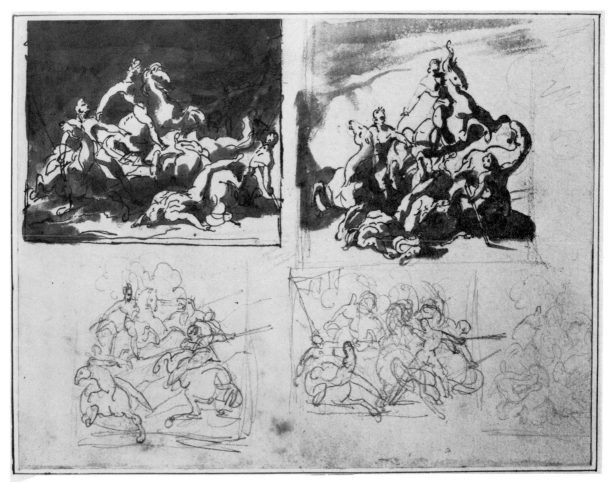

2. Théodore Géricault (1791-1824). *Leaf 50 from Sketchbook.*
Pen and ink, pencil with wash.
Courtesy of the Art Institute of Chicago.

3. Henri de Toulouse-Lautrec (1864-1901).
Study for the Black Countess, from the Sketchbook.
Courtesy of the Art Institute of Chicago.

4. Kenneth Kerslake (1930-). *Sketch for print*. Graphite.

variety of papers and grounds. Figures 2, 3, and 4 are from artists' sketch-books. Figures 5, 6, 7, and 8 are from student's sketchbooks.

It is suggested that in the sketchbook the student at first give more time to descriptive drawing than to interpretive and relational drawing. (Here I refer to "relational drawing" as that giving consideration to the art forms, the relationships among the objects and spaces in a picture plane.) In addition to the human figure, the student should draw an assortment of things: furniture, dishes, containers, books, lamps, plants, and any other objects that are accessible. Doing descriptive drawing helps him learn to observe and perceive and —eventually—to express this awareness and perception in all his drawings. Along with these descriptive studies, he should draw objects in their relation-ships to other objects, to space, to environment, and to the total picture plane. The FC Scale mentioned in the introductory chapter also applies to the work in the sketchbook. The student must seek a good balance between freedom and control. A neater and more impressive sketchbook may be turned out by repe-titiously doing only those things in which the student excels; but again I re-mind him that *a sketchbook serves only to fulfill his needs*. It will be the test-ament to his sincere desire to learn to draw.

5. William Shirley. *Purple Mouth-scape*,
from Sketchbook. Pen and ink, pencil.
Student drawing, University of Florida.

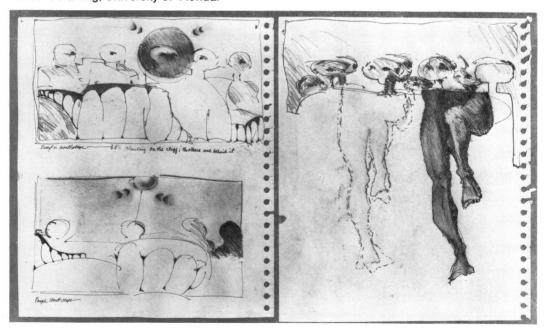

above: 6. Guy Benson. *Line Statements*,
from Sketchbook. Conté crayon.
Student drawing, University of Florida.

below: 7. Dave Ross. *Wiring Diagram for Kinetic Relief*,
from Sketchbook. Pencil and ink.
Student drawing, University of Florida.

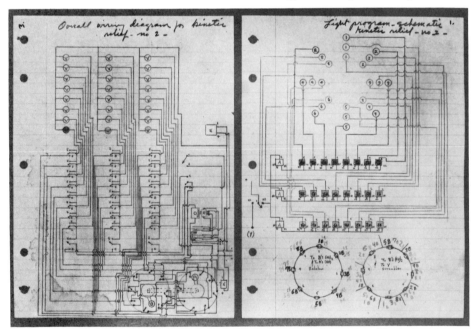

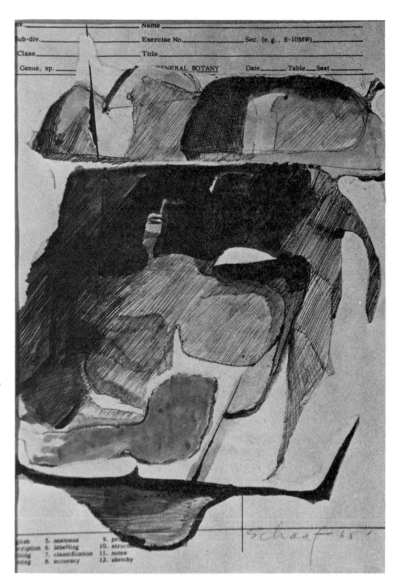

8. William Schaaf.
Drawing from Sketchbook.
Pen and ink, and wash.
Student drawing,
University of Florida.

Here is a final reference to the sketchbook and its importance to the student and artist. It is through the sketchbook that the student recognizes drawing as the area in art best fitted to the complicated schedules confronting him today. With only pencil and paper a student can start drawing in any block of available time, without previous planning or scheduling. He can sketch while he is waiting for a bus, sipping his morning coffee, waiting for an appointment, watching a one-sided ball game; he can draw on vacation and on various other occasions when time becomes available. There are few other activities that take less planning and equipment than drawing. After he has completed the scheduled courses and has mastered the basic fundamentals of drawing, the artist can fit the act of drawing into his daily schedule and make it a part of his way of life.

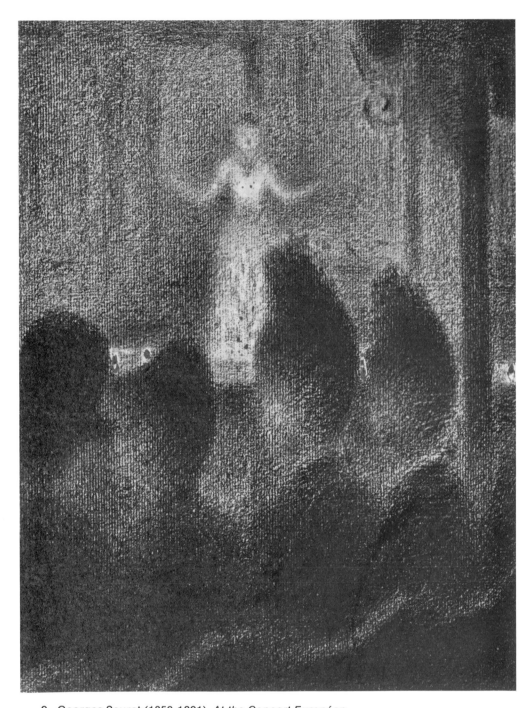

9. Georges Seurat (1859-1891). *At the Concert Européen.*
Conté crayon heightened with white crayon.
Collection, The Museum of Modern Art, New York. The Lillie P. Bliss Collection.

CHAPTER III
ART ELEMENTS

In drawing, as in architecture, painting, sculpture, and other forms of the visual arts, the artist works with such elements as *line, value, texture, color, form* and *space*. One of the definitions of the word *draw* as given in *Webster's New Collegiate Dictionary* is "to produce a likeness of by making lines on a surface." Many artists would reject this definition because they more readily associate value with their drawings than they do line. Others would be unwilling to accept a definition that limits drawing to line and value or that definitely confines it to the process of producing a likeness. Nonetheless, in drawing, line is an important element; it is associated with drawing in the way that color is associated with painting and form with sculpture. Some of our first expressions as children have been linear marks in the wet sand or on a rock wall, wood fence, or some other inviting surface, just as the primitive cave dwellers drew or incised their earliest expressions on the walls of caves.

Line can never be entirely divorced from the other art elements. A student has only to make several linear expressions on a page to realize that value is being introduced as an element of drawing, since consideration is given to the light or dark quality of the lines. Space, too, is involved when the student decides how long the lines are to be projected and what is to be their position relative to the space on the page. In Figure 9, Seurat has by using value introduced the elements of line, form, texture, and space. In Figure 10, Dürer has through the use of line suggested value, form, texture, and space. Here it would be simpler to consider drawing as only line and value, since all the other elements, except color, can be expressed by the use of the two. However, I find that at the beginning it is helpful to the student and instructor to take up each of these elements separately and to investigate its place and value in drawing. The student can do this by experimenting with the elements in his own drawings and also by studying how other artists have employed them.

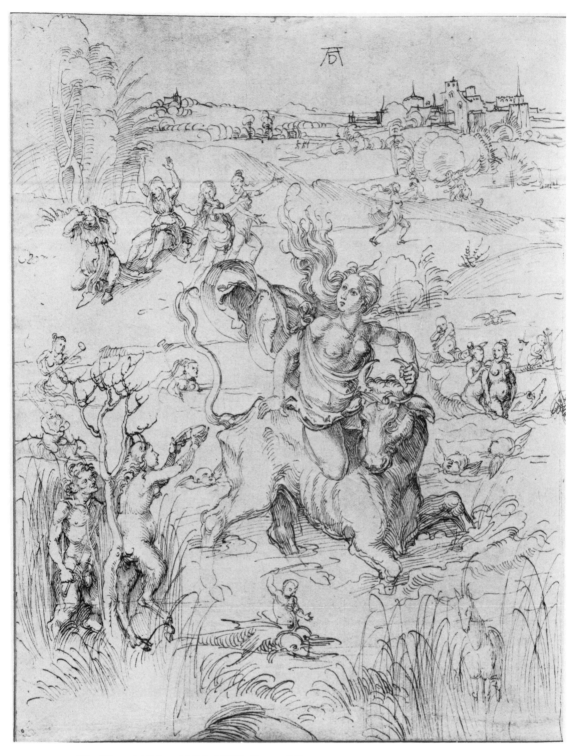

10. Albrecht Dürer (1471-1528). *Rape of Europa*.
Pen and ink. Albertina, Vienna.

16 THE DRAWING HANDBOOK

LINE

There are many definitions of line. To the artist it has a different meaning than to a fisherman, poet, actor, football coach, telephone operator, soldier, or seamstress. With the drawn line the artist expresses his emotions and records boundaries, divisions, or contours. Although he may at times draw a line in a cold and unemotional manner to record a fact or test an idea, his most important use of line is to create an emotional expression that will appeal to man's esthetic sensitivities.

In this chapter, though the importance of line as a boundary is acknowledged, I put the emphasis upon the *use of line as a graphic statement* to express the *student's feelings and emotions.* The word *use* is most important because we are primarily concerned here with the student's actual involvement in drawing. A person may read books on how to play tennis or how to swim, and understand the process, correct form, and strokes, yet still be unable either to play tennis or to swim; likewise, in drawing, a person may recognize a sensitive and effective line and still not be able to project that sensitivity into his own drawing. There is a danger in overemphasizing the intellectual approach and giving too little time to the act of drawing.

At the beginning the student must set a portion of his time aside for drawing with the idea of making the drawings *expressive of his inner feelings.* Regardless of how successful or unsuccessful the student thinks the drawing is, he should try others to determine whether different kinds of lines can be more expressive. At first this subjective approach may be at the expense of proportion, technique, and overall accuracy; after a period of time, however, feeling becomes an innate part of a student's drawing, as natural as walking. This early emphasis on feeling does not imply that the use of line as a descriptive element is not important, but the emphasis on sensitivity must be given priority if the student's drawing is to be anything more than an ordinary illustration.

Students often assume that feeling or sensitivity is something that one either has or does not have. As a result, they work entirely toward improving their proportions, accuracy, and techniques. It is suggested here that the student in his conscious early efforts to get feeling into his drawing select subjects that can more readily be expressed through feelings than through accuracy. At first feeling can be more easily expressed when the student is drawing a haystack, a wheat field, a tangle of steel wire, or a waterfall than when he is drawing an ink bottle, a fountain pen, or a book. And the beginner will be more likely to emphasize sensitivity in a quick sketch of the entire figure than he will in a long, detailed study of a hand, foot, or head. This may not be true after the student has drawn a long time and has reached the point where all of his drawings effectively project feeling, regardless of the subject or time element.

The use of varied drawing materials (as pointed out in the chapter on materials and techniques) will also enable the student to experience more variety in his ways of "feeling" a line.

It is important that lines be thought of as expressions, not as a set of symbols to represent different objects (Figure 6). The character of the line will depend not only upon the object that is being presented but also upon its environment and upon other lines and elements in the drawing. The Japanese often draw straight parallel lines in a somewhat formal manner to represent rain. The practice is most effective and convincing with their style of drawing. However, this method of depicting rain may not be appropriate for the drawing a student may be doing; he may wish to say more than the fact that it is raining. How hard is it raining? Is the wind blowing? Is the sky ominous? Is the rain the same when it passes the darker sky and when it is against lighter shapes? Does it form the same pattern when it falls upon a rocky surface and when it falls on the surface of a pool of water? These and similar questions may be helpful to the student in stating things that are important in his particular drawing. There are times when the straight parallel lines would represent rain as he might wish to express it, but they do not therefore have to become his symbol of rain. An attempt by a *beginner* to reduce his drawing to a set of stereotyped symbols can be detrimental to his real creative expression.

An elementary art supervisor suggested to classroom teachers on one occasion that they give their students "trees" as a subject for drawing and painting. When a certain teacher assigned the problem she proceeded to give a talk about trees that might have been very helpful if she had presented it differently. She told her class that there were several ways of drawing trees and she illustrated some of them on the blackboard. Some trees, she said, could be drawn as triangles, some as ovals, and some as rectangles; she also declared that trees were brown and green in color. Some of her students then hurriedly outlined the tree shapes the teacher had suggested, and spent the remainder of the period filling in the boundaries with green or brown crayons or paint. Another teacher presented the same problem to her class. This one explained to her students that there were really many varieties of trees, that even the same tree did not look the same at different times of the day and in different seasons of the year. She asked her students if a tree would look the same from an upstairs window looking down as it would from under the tree looking up, or from a position across the street. Additional questions provoked thought in her students and produced drawings that were creative expressions based upon the students' individual experiences and observations. As a result, some of the trees in the students' drawings had heavy foliage, some were void of leaves, some were burnt and blackened, and some had massive trunks and limbs. The class had also drawn trees that were thin and graceful or small and scrubby with textured limbs. In the discussion the group had associated other objects with trees; ladders, birds' nests, swings, climbing children, tree houses, kites, cats, colorful blossoms and varied fruits. And by encouraging imaginative thinking this teacher had also brought about a more creative use of color by her students.

As stated in the previous chapter, much can be learned from observing the effect of line in the drawings of other artists, but much more can be gained by actually drawing from the works of these same artists. The student can best experience the quality of a line as Holbein expressed it by making studies from Holbein's drawings. He thus learns to feel the variety of lines and the character of the materials in ways similar to Holbein's experiences (Figure 11).

11. Hans Holbein, the Younger (1497-1543). *A Lady Unknown*.
Chalk (black, red, yellow on pale pink priming).
The Royal Library, Windsor Castle, England.

12. Pierre Bonnard (1867-1947). *La Promenade*. Pen and ink, wash and pencil.
Photograph, courtesy Frank Perls, Art Dealer, Beverly Hills, California.

13. Rico Lebrun (1900-1964). *Veterans*. Brush and ink. Courtesy of the
Fogg Art Museum, Harvard University, Cambridge, Massachusetts. Gift of Arthur Sachs.

Observe the use of line in the following reproductions: Figures 12, 13, 14, 15, 16, 17, 18, 19, 20, 21, 22, 23.

Finally, after emphasizing the importance of line, it is necessary to point out the dangers of its overuse and isolation. For a student to practice the use of line until he has complete mastery and then consider value would be most illogical. For practical purposes, line is presented as the first element; it is necessary however that the student be concerned with the use of all the elements vital to his drawing rather than with the limiting use of only one. He must, for example, remember that any time he is drawing a line, it can become value. See Figures 12, 13 and 14. A value area, a smudge, a series of dots, a textured area may be as important to a drawing as line.

14. Aristide Maillol (1861-1944).
Deux Femmes Nues. Pen and ink.
Musée du Louvre, Paris.

15. School of Ingres (copy)
Study of Female Head and Arms.
Pencil on buff paper.
Courtesy of the Fogg Art Museum,
Harvard University,
Cambridge, Massachusetts.

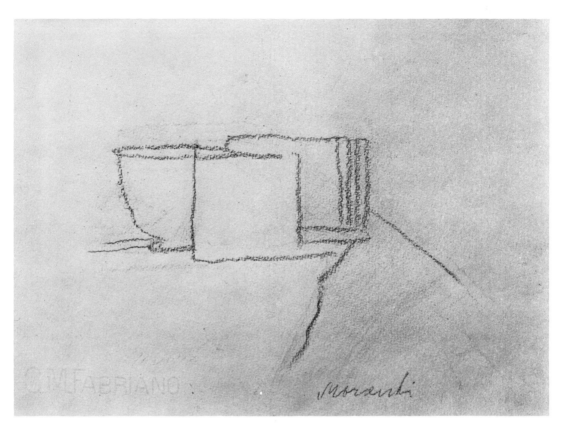

16. Giorgio Morandi (1890-1964).
Natura Morta. Charcoal.
From the collection of
Odyssia Gallery.

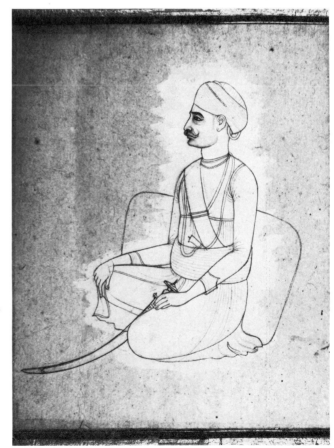

17. Indian, 18th Century. Jaipur.
Seated Courtier with Sword.
University of Florida Gallery
Collection. Gift of Mr. George P.
Bickford.

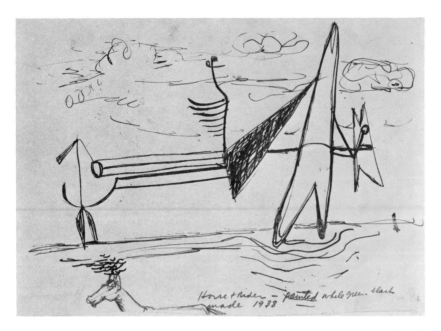

18. David Smith (1906-1965).
Horse and Rider.
Brush, india ink and pencil.
Courtesy of the Fogg Art Museum,
Harvard University.
Gift of David Smith.

19. Eusebio Sempere (1924-).
Untitled. Colored inks, gouache,
graphite on black paper.
Courtesy of the Fogg Art Museum,
Harvard University.
Gift of Fernando Zobel de Ayala.

20. Mauricio Lasansky (1914-). *Drawing from the Nazi Series.*
Courtesy of Mauricio Lasansky.

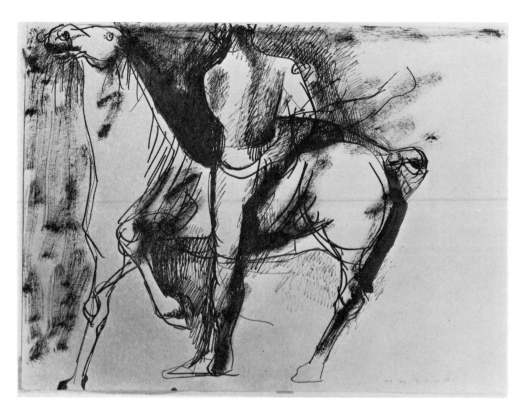

21. Marino Marini (1901-).
Man Mounting Horse.
Pen and brush.
The St. Louis Art Museum.

22. Al Stormes. *Standing Figure.*
Brush and ink. Student drawing,
University of California
at Northridge.

23. Lance Richburg. *Horse in Action*.
Pen and ink. Student drawing,
University of Florida.

VALUE

Value in drawing simply refers to the lightness or darkness of an area. Value serves many purposes: it expresses form and volume; it describes surface quality and texture; it depicts a mood; and it designates or qualifies space. An artist also uses value as an element of composition to direct the eye across or into the picture plane.

The student is first introduced to value for a technical purpose. He is concerned at that time with the problem of giving form and volume to his drawings of three-dimensional objects, and the use of value is his main tool for doing this. This problem alone can present a formidable challenge to the beginning student.

24. Beatrice Nettles. *Stars Over Ionia.* Drawing and photography. Student drawing, University of Florida.

Drawing and observing value from nature offers several important benefits to the discerning student. Naturally a careful study and rendering of various surfaces and textures will help him to increase his knowledge of materials and techniques and at the same time it will strengthen his ability in the actual drawing process.

Another important benefit will be increased perception. Through visual experiences he will be stimulated by pattern and value relationships, thus enabling him to develop new and more interesting art forms. This perceptual awareness will also benefit his work in such other areas as photography, design, sculpture, and painting. Conversely, the emphasis on perception in such classes as photography and design will serve to strengthen his drawing. Some of the most interesting drawings are done by photography majors who combine photographic materials and techniques with their drawing. See Figures 24, 25, 331, 332 and 333.

25. Leonard Weinbaum. *Sandwich.*
Drawing and photography. Student drawing,
University of Florida.

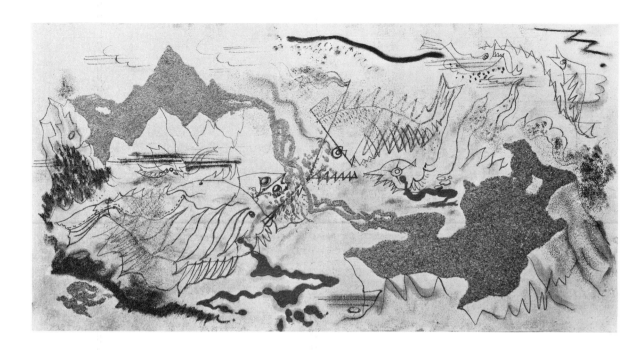

above:
26. Andre Masson (1896-).
Battle of the Fishes.
Oil, sand, pencil on canvas.
Collection, The Museum of
Modern Art, New York.

left:
27. Charles Sheeler (1883-1965).
Of Domestic Utility.
Black conté crayon.
Collection, The Museum of
Modern Art, New York.
Gift of Abby Aldrich Rockefeller.

opposite:
28. Fernand Leger (1881-1955).
Study for *The Divers*.
Pencil, pen and ink, ink wash.
Courtesy of the
Art Institute of Chicago.
Gift of Tiffany and Margaret Blake.

Another benefit to be derived from the study of values in nature is more subtle and emphasizes the creative aspects of drawing. I refer to factual discoveries modified so as to be more expressive than the original subject. For example, a student may observe that one of two shapes of equal size and value becomes smaller and lighter in value as it recedes in the distance. The student discovers that he can create greater distance within the picture plane by drawing the shape even smaller and lighter than it appears in nature. (If a shallow space concept is necessary because of other space statements in the composition, it may be advisable to keep the shapes equal in size and value and show that one of them is in the distance by such other means as overlapping, placement, converging lines, or blurred edges. See Figure 26.)

Some of the most interesting drawings reproduced in this book are actually contradictions of existing situations. In Figure 27, Charles Sheeler has felt it necessary to change his source of light for compositional purposes rather than to comply with that which obviously exists in nature. He has created a more interesting pattern of lights and darks by introducing a new source of light from left to right in the lower part of the drawing, contrary to the source from right to left in the upper part. In summary, if the study of nature is limited to finding iron-clad truths which will always be adhered to, it will restrict the creative approach. These visual facts are to be thought of by the student only as possibilities which can be imaginatively applied to the appropriate situations.

As the student progresses, he should guard against forming a tight and restricted formula for expressing value, even when he is giving form to a space or object with definite boundaries and geometrical regularities. When used subjectively value, like line, can become an emotional expression. A smudge or any arbitrary value area is as valid as the shadow area of a tree trunk or other three-dimensional object.

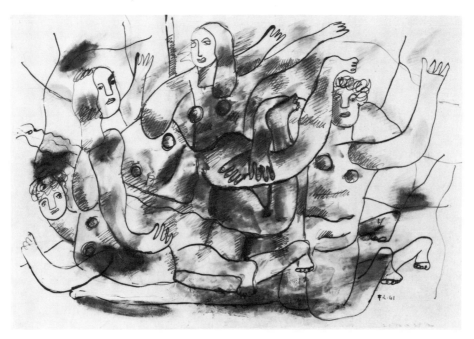

In Figure 28, *The Divers*, Leger has created smudges or value shapes around the edges to carry the eye to various sections of the composition (upper left and other areas), while nearer the center he has applied the smudges to areas to give them more form and interest; still the values all interrelate and give unity and completeness in the drawing.

Any one of the illustrations in Figure 29 can suggest the form of a tree trunk if placed in a proper environment. All of them to some degree form a change of value whether by a subtle gradation of tone or by an abrupt sharp-edged value plane. In Figure 29a only a scribble represents a value area; in Figure 29b it is a smudge. In Figure 29c a series of parallel lines suggest a value plane; in Figure 29d a carefully modulated area becomes a value statement. Figure 29f is the most abstract and formal of all, and Figure 29a is the most emotional and informal. Figure 29e probably expresses texture more than do the others.

In regard to mood, value is usually thought of as dark areas expressing a gloomy or depressed feeling. This simplification can be true. If Figure 29d were placed in an appropriate environment, it would more readily express a deep and low-keyed mood than could Figure 29a. Here, though, I refer to mood in a broader context. Figure 29a would probably express a gayer or lighter mood than the other drawings if it were placed in a proper environment. Any one of the drawings may be expressive of a particular mood if it is used appropriately. The beginner is inclined to draw the object that seems

29. *Trees*. Value studies.

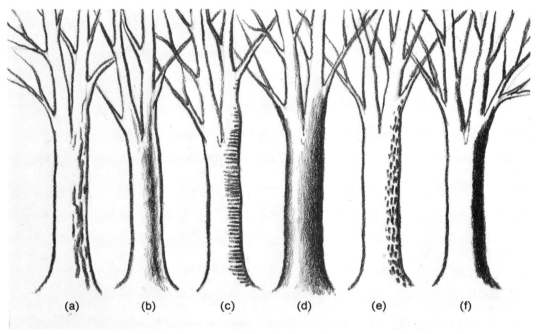

(a) (b) (c) (d) (e) (f)

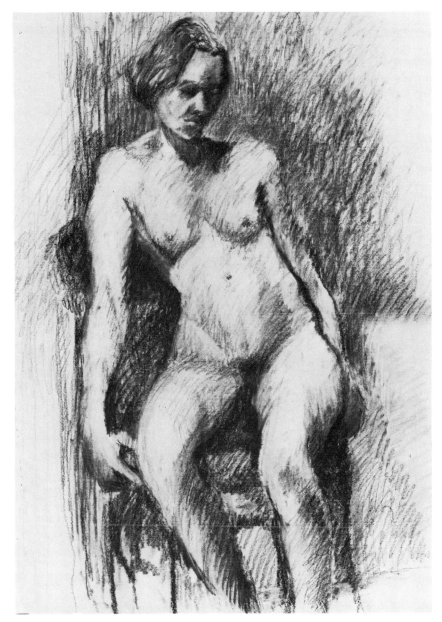

30. *Figure Study*. Charcoal.
Student drawing, University of Washington.
Courtesy of Louis Hafermehl.

most important to him and then draw the mood around it. He is apt to find that after he has finished that all the drawing has a consistent mood except the object itself. The best approach is to think about the mood from the time the pencil first touches the paper until the drawing is completed. This procedure will permit an interplay of value areas of both objects and spaces and assure a unity of expression. In Figure 30 the student would have experienced real trouble with the overall value and tonal quality if he had first drawn the figure

and then tried to place it in its environment. This is also true of Seurat's drawing, *Seated Boy with Straw Hat* (Figure 31).

31. Georges Seurat (1859-1891).
Seated Boy with a Straw Hat. Conté crayon.
Yale University Art Gallery, New Haven, Conn.

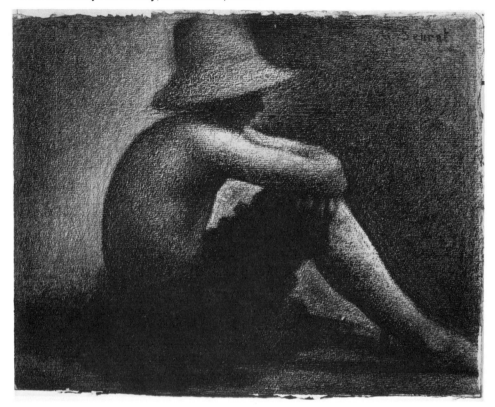

An interesting use of value is often limited by following the convention that objects and forms are always dark and spaces are always light. Any such fixed idea concerning the use of value reduces the number of creative possibilities. Figure 2 presents two value sketches from a page of Gericault's sketchbook. They show the importance of experimenting with various value combinations. In Figure 32 a student by reversing through a photographic process the values of space and content has given her pencil drawings an appropriate mood and environment.

The use of value to direct the eye through or across a drawing is taken up in the next chapter on composition. However, the use of value in composition cannot be separated from the use of value to express form and mood. The art student more readily sees the possibilities of these varied functions of

32. Beatrice Nettles. Negative photograph of pencil drawing sequence. Student drawing, University of Florida.

value by studying the works of other artists. It should be remembered that in the study of the drawings of some artists it is impossible to separate the element of value from the element of texture and the method of technique; this unity is true of most of Seurat's drawings (Figure 31). In this drawing the technique itself expresses the line, value, texture, form, and space. The close interrelationship of value and the other elements will be noted again when thought is given to form and space.

TEXTURE

One can make an object or surface recognizable without expressing its texture. By the use of line, the student can best suggest a tangle of thin wire, and by the use of value he can best suggest a cast shadow. However, to describe the smooth surface of a table or the rougher surface of grass upon which the shadow is cast is another matter. One student, when given an assignment to make drawings of a variety of textures, brought in a drawing of a brick wall as in Figure 33. He remarked when he handed in his drawings that the brick

33. Drawing suggesting brick.

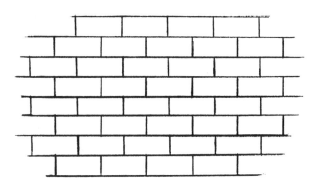

texture was easier to express than that of bark or eggshell or wood grain. Actually he had used lines to suggest each individual brick. To express the real textural quality of a brick wall is most difficult. The use of *line* to suggest brick is frequent and has become a recognizable symbol, but the method does not in any way describe the textural surface of the brick wall. In Figure 228 value has been added, and even though there is more accurate recording of the appearance of the brick and the mortar, the textural surface of the two materials has still not been expressed. More space than the area that the student gave to his drawing would be necessary, and probably fewer bricks drawn nearer to actual size would be advisable. This larger scale would permit space for modulating the surface of the brick and expressing the rougher quality of the mortar (if such is the case). To describe the texture of the brick wall it may be necessary to use a variety of pencils and a more careful approach.

In the same class another student resorted to a method of placing pieces of drawing paper over sandpaper and other textural surfaces and getting the effect of their textures by rubbing pencil or crayon over the paper. This is an interesting assignment for a beginning design or art appreciation class because it records and calls attention to a variety of surfaces; but it has little to do with the development of the student's ability to describe a texture in drawing.

It is advisable at the very outset to make in a sketchbook drawings of textures that are most easily expressed: pieces of crinkled butcher paper, sponges, tree bark, and the like. For these texture drawings, the student must think about the use of drawing media. He should select six or seven textures and draw all of them with the same pencil, trying to record their individual surface qualities by the skillful manipulation of one medium. He can then take the same subjects and select the medium that best states the texture of each object. After he has made numerous textural drawings, he will notice that they tend to fall into two categories; those which require careful study and a highly developed skill in modulating or building up the surfaces, and those which require skill but can be expressed more effectively in a free and less definite manner. In this latter group I refer to such drawings as those of a grain field, flower beds and ocean waves (Figures 34 and 35). In the first category the approach is actually one of rendering, and such is the case in Schedule number XXVII. The problem pertains to the description of the textural and structural quality of each individual object (Figure 187, 188, 189 and 190).

In assigning problems which will make the students more aware of and capable of expressing the differences in textural surfaces in a drawing, there is a danger of encouraging overemphasis. Some students have unusual technical skill and through the encouragement of teachers and other students they camouflage weak drawings or neglect the overall structure and composition within the picture plane.

Consideration must always be given to a drawing as an esthetic product and at times textures will be introduced into a drawing only to give *interest*

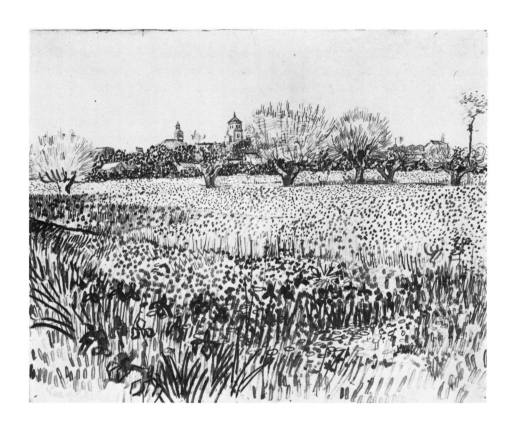

above: 34. Vincent Van Gogh
(1853-1890). *View of Arles*.
China ink with reed pen and wash.
Museum of Art,
Rhode Island School of Design,
Providence, R. I.

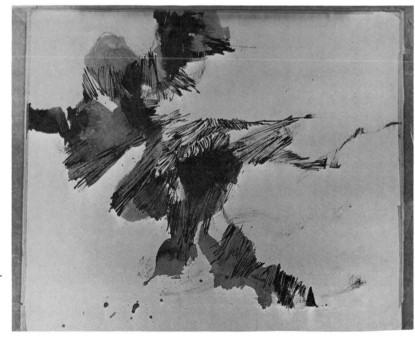

right: 35. William Bristow.
Landscape. Pen and ink,
brush and wash.
Student drawing,
University of Florida.

or *emphasis* to an area. The ultimate aim is not necessarily to describe subject matter more realistically but to give the desired textural quality to any art form, whether realistic or abstract. In dealing with abstract forms, there will be times when the student may feel the need for a smooth or rough surface, a hard or soft one; the skill with which he is able to express the character of an abstract form or space is as meaningful as his skill in expressing the difference between the texture of hair and skin in a descriptive figure drawing.

Later assignments and discussions will pertain to ways of expressing texture through collage and other three-dimensional methods. Texture will also be discussed under materials and techniques.

COLOR

The beginning drawing student is not encouraged here to become too much involved with the use of color. The problems and assignments in Part II of this book, unless otherwise specified, can be best done by limiting the media to black and white. Color used attractively by the beginner may make his mistakes and poor drawing less obvious, and its stimulating effect may cause him to give too much time to this element. Black and white are best for fundamental drawing and the student should give them first priority. Later he may practice the use of one color, such as sepia or brown crayon, and he will find that a near-neutral wash is not likely to be too different from lamp black, black watercolor, or india ink washes.

The use of color should always be carefully considered by the student, and he should employ it only to strengthen or enhance his drawing. A drawing meant to express a certain mood may do it more effectively on dusty blue paper than on light yellow or buff (and vice versa).

In Part III of this book problems employing the use of color are more numerous. Even then, the student is warned against laying on a spot of well-placed color to pep up a drawing or to cover up poor organization and draftsmanship. I find that color is used more effectively when it is incorporated into the drawing and made an integral part of it. The color must work with the other graphic elements of line, value, texture, and form, so that the drawing will not become a color project that could have been done equally well or better as a design or painting.

Color that is effectively used in a drawing, besides creating a mood, may serve to form structures and tensions which direct the eye through or across the drawing. It can also point up, or hold the eye to, a certain area important to the drawing.

There are three reasons why the subject of color is not dealt with extensively in this book: first, this is a course in drawing, not in painting; second, many expensive color reproductions would be necessary to illustrate the points of discussion; and, third, the subject of color cannot be covered in one short

chapter, or for that matter even in one book. Many art departments offer a special course in color theory, dealing with both physiological and psychological approaches to the use of color. Other departments cover the subject in design and painting courses.

FORM

In drawing form is so closely related to value that the two are sometimes presented as one element; the use of value is an important device for expressing form. In sculpture value is most important in visually expressing form; however, a person can close his eyes and by feeling a three-dimensional object respond to its form and volume.

Students can learn as much about form through the study of sculpture and other three-dimensional art forms as they can from the study of drawings. In studying the drawn and incised line of the cave paintings, we observe an early attempt to introduce value and to give form to the incised lines by rounding off the inside edges of their contours. This method of creating form is also noted in low-relief examples of Egyptian art and that of other early civilizations (Figure 36). On two-dimensional surfaces, the same effect can be achieved in contour drawing by manipulating the pencil point in a way that expresses the feeling of the form that is inside the boundaries. Many artists have demonstrated skill in giving form to objects by the use of line only; by varying the line's width, by reinforcing it, overlapping it, fracturing it, feather-

36. Sculpture, Egyptian,
Old Kingdom, Early 6th Dynasty.
Relief from Mestaba Tombs—
Ox and Attendant.
Courtesy of the Fogg Art Museum,
Harvard University,
Cambridge, Massachusetts.
Gift of Grenville L. Winthrop.

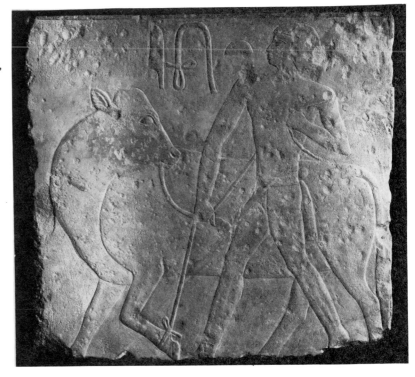

ing it, and other means, artists have expressed extreme volume with little or no use of value (Figures 37, 38, 39, 40 and 41).

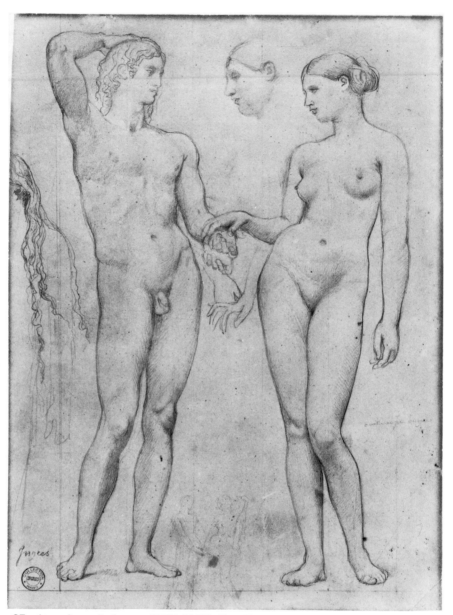

37. Jean-Auguste Ingres (1780-1867). *Two Nudes—Studies for the Golden Age*. Graphite.
Courtesy of the Fogg Art Museum,
Harvard University, Cambridge, Massachusetts.
Grenville L. Winthrop Bequest.

38. Pablo Picasso (1881-1973). *Bathers*. Graphite.
Courtesy of the Fogg Art Museum, Harvard University, Cambridge, Massachusetts.
Bequest of Paul J. Sachs, "A Testimonial to my friend W. J. Russell Allen."

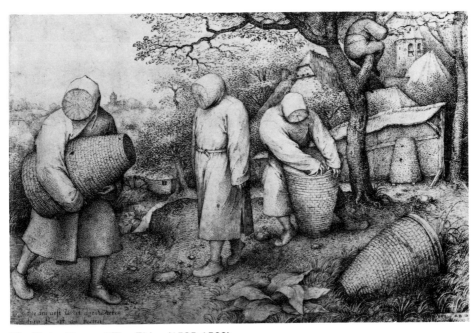

39. Pieter Bruegel The Elder (1525-1569).
The Bee-keeper. Pen and ink.
Kupferstick Kabinett Museum, Berlin.

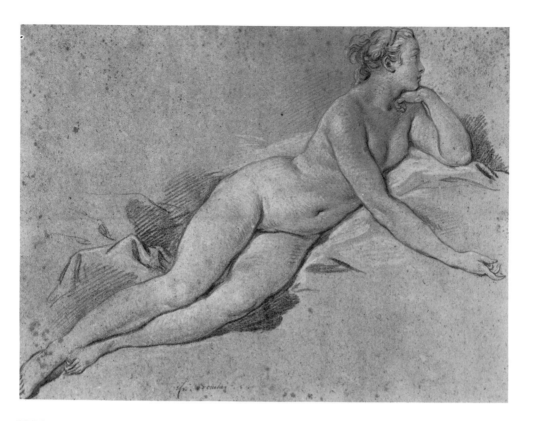

40. Francois Boucher (1703-1770). *Reclining Nude.* Natural red chalk with white heightening. Courtesy of the Fogg Art Museum, Harvard University, Cambridge, Massachusetts. Meta and Paul J. Sachs Collection.

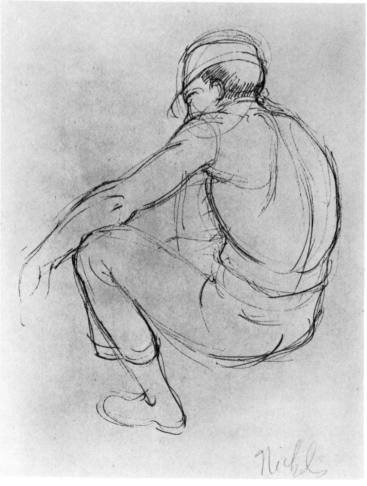

41. Bradley Nickels. *Seated Figure.* Pen and ink. Student drawing, University of Florida.

There is a limit, however, to what can be done with line alone to express form and volume of an object. In Figure 42a the line states that the shape is a cylinder and gives us its height in relation to its width, but it tells us no more about the cylinder's form and volume. Value must be introduced to indicate whether it is a cylinder of thin material or a solid form. The first shaded drawing in Figure 42b tells us that this particular cylinder is made of a thin material with space inside; Figure 42c indicates that its cylinder is closed at the ends and is perhaps a solid form. A heavy value of shading would more readily suggest weight or solidity; a lighter shading would suggest less weight. Still, several drawings from different viewpoints would be necessary to fully describe the cylinder, including real exploratory drawings which describe the inside of the cylinder as well as its surface form. See Figure 42d. In the assignments in Part II the reason for the many required GS (Gesture-Structure) drawings (Figure 133) is to make the student study and explore the form (structure) along with its movement (gesture).

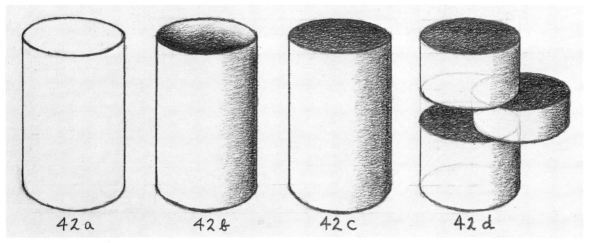

42. Cylinders.

The student's ability to express the extreme or actual form of each object doesn't guarantee his success as a draftsman. His ability to sense the amount of form and volume needed and then to proceed through technical proficiency to give meaning to the drawing is the real test. Here again it is impossible to separate form from the space concept; some artists purposely depend upon an ability to minimize their expression of form to have it relate to a desired space concept. *Like all of the elements, form and space exist to serve the artist*; by complete mastery the artist can reduce or extend form to produce the most expressive drawing.

In Figures 43 and 44 the artists have considered the appropriateness of form to space to give their drawings meaning. Also see student drawings (Figures 45 and 46).

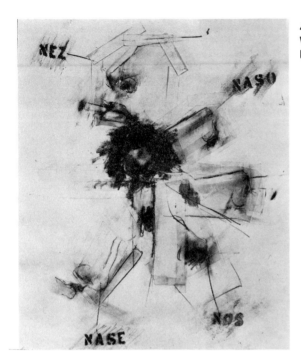

43. Larry Rivers (1923-). *Noses.* Watercolor, collage and crayon. Marlborough-Gerson Gallery, New York.

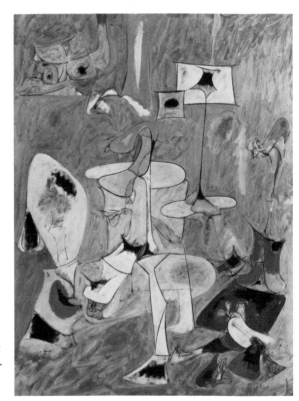

44. Arshile Gorky (1904-1948). *The Betrothal II.* Oil on canvas. 50-3/4'' × 38''. Collection, Whitney Museum of American Art, New York. Photograph courtesy of Geoffrey Clements.

45. C. Lazzo. *Figure Interpretation*.
Spraypaint, collage and crayon.
Student drawing, University of Florida.

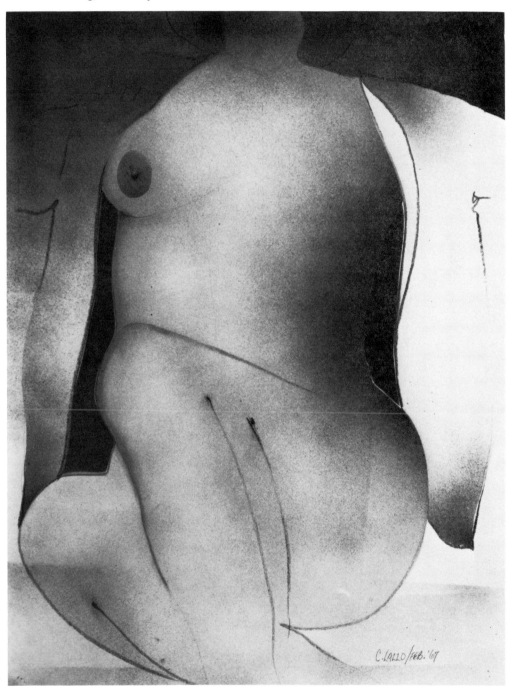

46. Stan Brumley. *Study in Form*. Pencil and ink. Student drawing, University of Florida.

SPACE

A definition of space that is somewhat nebulous serves the beginning student better than one which is too specific. Space discoveries are more meaningful to him when they result from his own informal explorations. As the student progresses, he creatively applies drawing skills and fundamentals to problems pertaining to space.

When the student places the figure on the page and gives thought to the proportion, balance, form, structure, and attitude of the pose, the space concept is minimized for him and he gives little conscious thought to it as an element in his drawing. It is when he attempts a drawing within a picture plane or a specific area that he clearly recognizes the problem of space involvement. Then the need to employ method, medium, technique, or device to express an appropriate space concept becomes apparent to him. One student may need to give conscious thought to whether the space will be shallow and show little form or depth, or whether depth will be expressed by means of perspective, form, or another method. Another student will be able, through feeling, to let the drawing itself, as it develops, dictate the solution of these spatial concerns.

The student should diligently use his sketchbook for space experiments outside of class. It is better for him to draw within marked off rectangular areas than to draw figures or other objects on the page and then mark off the space. He should try to give objects and space varying degrees of depth in regard to the surface of the picture plane. After making many of these space explorations, he will inevitably realize that *all art forms are dependent upon space for their existence and esthetic value.*

This dependence is more easily recognized in architecture, sculpture, and other three-dimensional areas in which the physical dimensions of distance, area, and volume actually exist. In drawing, painting, graphic design, and other two-dimensional areas the arbitrary use of space seems to obscure its important relationship to the other elements. Often space is thought of simply as areas left over after the drawn objects have been created and arranged. The definition in *Webster's New Collegiate Dictionary* of the verb *space* "to place at intervals or arrange with space in between" is suggestive of its use as a creative element.

In any work of art there can be no doubt that the positive and negative relationships between space and form have been an important concern of the artist; however, in drawing it is possible to give so much attention to this process that the results become academic expressions. The practice of drawing only the negative area is occasionally helpful, provided the students are frequently reminded that the interchange and shift between the negative and positive give real interest to their space concept. In Figure 48 the space between the legs of the figure has to a degree become positive, but this is not true of all the negative areas in the composition. Any form, whether positive or negative, that is structurally or esthetically important to a drawing can be de-

veloped or emphasized. Some of the most interesting drawings and paintings being done today are dependent upon space phenomena for their effectiveness. By a close treatment of values a figure can be almost lost in space, or with sharp contrasting edges the figure can separate and disassociate from the space (Figures 47, 48 and 49). This interplay between objects and space not only creates definite space qualifications, it also creates interesting phenomena in which the viewer has a choice of interpretation. The relationships may be so subtle that one person sees a space or shape as part of the distance, and another experiences it as an area in the front part of the picture plane. Here the nebulous space statement permits the spectator to participate in structuring the drawing, but a more controlled statement may function only to inform the viewer of his position in relation to the objects and spaces in the picture plane. Both space statements are important.

47. Nancy Reese. *Two-figure Study*. Graphite. Student drawing, University of Florida.

48. Clara Kern. *Figure Movement.*
Graphite. Student drawing,
University of Florida.

The key to understanding space as related to the drawing surface is a *complete unity of thought in regard to the pattern which actually exists between shapes and spaces (positive and negative) on the two-dimensional surface and the movement that apparently exists between shapes and spaces on an illusionary three-dimensional surface.* The completeness of a drawing depends upon the artist's ability to feel and express relationships pleasing and stimulating to the idea or concept being expressed; the spontaneity and authority which must also accompany these space concepts require the execution by the student of a vast number of drawings and perceptual experiences.

Regardless of the interrelations of the two space considerations termed *pattern* and *perspective,* it is necessary to present perspective separately. A survey of the ways artists have introduced perspective into their works from the earliest times to the present is an introduction to contemporary drawing and painting. All of these systems of perspective are employed by the present-day artist.

49. Ron Chesser.
Running Figure Series. Graphite.
Student drawing,
University of Florida.

1. *Tiered space.* The Egyptian, Oriental and other cultures suggested space by placing sections of the drawing at different levels. The bottom level represented the section closest to the spectator and the top level the one most distant (Figures 50, 51 and 53). A variation of this system is seen in Figure 52. Also see Figures 254, 255 and 256.

50. *Hunting Scene*—Rhodesia. Replica.
The Denver Art Museum.

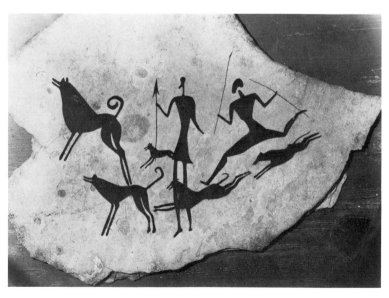

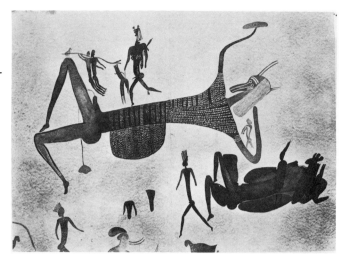

51. *Burial Scene of a King—*
South Rhodesia.
Elgentum des Frobenius.
Institutes Frankfurt/M.

52. Larry Rivers (1923-).
Stravinsky Collage.
Collage with pencil, pastel and crayon.
Marlborough-Gerson Gallery, New York.

2. *Isometric Perspective.* Oriental artists before the tenth century used this method to express distance. In isometric drawings each dimension of an object is represented in its actual measurements and proportions in scale; it is further characterized by equal axes at right angles and lines parallel to the edges drawn in true length (Figure 53). The impressionists often used variations of isometric drawing, and many contemporary artists use modified versions to control the depth of their drawings. In Figure 54, Paul Klee adheres to the system enough to give the spectator the feeling of a tilted plane and a very high eye level. Today isometric perspective is used frequently by architectural draftsmen, interior designers, and industrial designers.

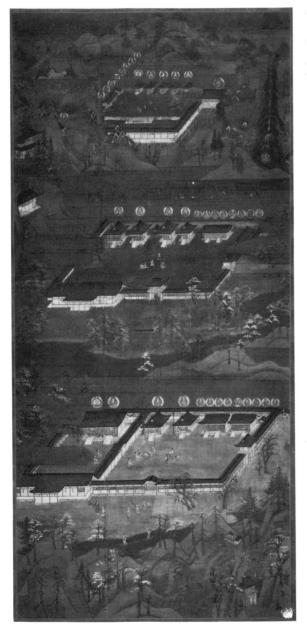

53. Hanging Scroll—Kamakura Period, c. 1300. Japanese. *Kumano Mandala: The Three Sacred Shrines.* Color on silk, 52-3/4" × 24-3/8". The Cleveland Museum of Art. Purchase, John L. Severance Fund.

54. Paul Klee (1879-1940). *Santa A in B*. Pen and Ink.
Stedelijk Museum, Amsterdam.

3. *Linear Perspective.* A method of expressing distance developed by Renaissance artists. Through linear perspective the artist is able to express distance as it appears to him in nature. As objects recede in the distance, parallel lines do appear to converge and horizontal lines do assume various angles. See Figures 55, 56 and 166. The principle is simple, but linear perspective can be complicated when representing a number of objects interestingly spaced within a picture plane. The difficulty is especially present if the drawing is to appear correct according to our impressions.

Most contemporary artists understand and use linear perspective when it can serve their needs, but they reserve themselves the privilege of distorting it and deviating from its mathematical accuracy as they choose. When entirely accurate, the method has its creative limitations, for the subject is viewed from a single point and the line of vision is trained on only one point of the scene.

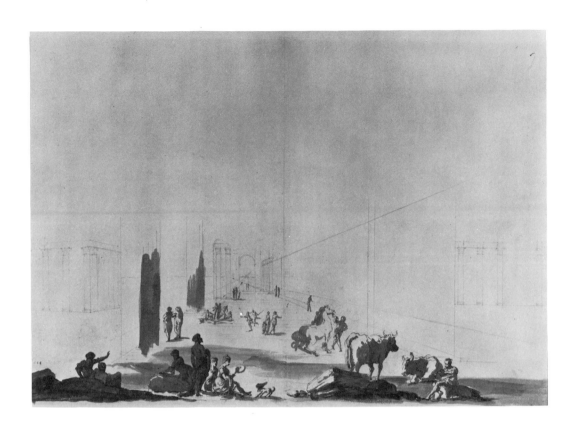

4. *Aerial Perspective.* This method is based on the principle that because of atmospheric conditions the color and value of objects appear to lose intensity and depth of tone as they recede (Figures 57 and 109). It is of little value to the artist when the principle is accepted factually. Whether he complies with it or deviates from it is his own concern. See the discussion of a similar principle in the section on value.

57. Richard Frank.
Architectural Environment Series.
Acrylic, pencil, and collage.
Student drawing,
University of Florida.

CHAPTER IV
COMPOSITION: PRINCIPLES

Composition is the process of organizing the parts of a work of art into a unified, and interesting whole. By the artist's handling of the graphic elements of line, value, texture, color, form, and space, the picture plane is transformed from a simple unit into a more complex one consisting of smaller units and shapes. Regardless of their individual simplicity or complexity, these parts must be organized in relation to one another if the result is to be a work of art. But a work of art must also be interesting, and there are fundamental principles which the artist employs to give his statements interest as well as harmony and unity. These principles of composition are movement, repetition, proportion, balance, rhythm, contrast, and emphasis.

Early in this century many artists and teachers, endeavoring to strengthen the organization of their compositions, began to emphasize harmony and unity at the expense of imagination and invention. As a result the word composition became identified with an academic and methodical use of these principles of organization. Likewise, the word had become largely associated with easel painting and with those methods employed by the Renaissance masters. This development defeated the real purpose which the principles of composition should fulfill, that of serving as a creative device to give interest and clarity to the artist's expressions.

Many departments of art then substituted other titles for the courses dealing with the organizational process: Design, Structures, Theory, Fundamentals, and many others. They chose to eliminate entirely the use of the word *composition* and the phrase *principles of composition*. Especially was this trend apparent in schools that were technically oriented. Students were instructed to create interesting designs by considering the positive and negative relationships inside the picture plane. These exercises are important; however, it becomes obvious that this procedure when overemphasized can also be detrimental to real invention and discovery, and can be no more than a mechanical process of changing values and sizes of positive and negative shapes until the art forms become academic and stilted.

The creative act must precede, and command emphasis over, any process of organization.

The more perceptive departments of art later began to adjust the principles of composition to contemporary trends and needs. Thus revised, the art courses not only permitted but encouraged discovery and invention by the student. It was obvious to some teachers that there was indeed a need for rules and guidelines which could serve artists of all periods, but serve them in individual ways.

The proper approach to composition in relation to the student's drawing can be likened to the balance of freedom and control (FC Scale, Figure 1). There is the *felt* composition and the *reasoned* composition. Let us first consider the former. The felt composition is intuitive and is based upon the artist's feelings about an expression. It may have strong emotional qualities and still lack organization. If such is the case, the valid approach is for the student to attempt through reasoned organization to give his drawing unity without destroying its originality and esthetic quality. The reasoned composition is done more deliberately and the student gives thoughtful consideration to both space and shape relationships within the drawing. During a class critique when the compositions of the members are presented for criticism, each drawing can be classified. A large majority of them will fall into two groups: (1) those which are over-organized, having order but little feeling, and (2) those which lack organization, having feeling but little order. A third group, usually small, will be the more successful compositions. They will express feeling *and* order, and they are the ones I refer to as the *felt* and *reasoned* compositions.

Most students instinctively start with the felt composition which is free, sketchy, and loosely put together, and then endeavor to give it more organization. They may do so by working over the original drawing or by keeping it in its free and spontaneous state and making other drawings from it which express the necessary order. Few artists find it possible to successfully transform a highly ordered composition into a more emotional one.

Again the student is reminded that periodic self-evaluation is essential if he is to retain his individuality and still conform to the necessary academic procedures, which are basic and fundamental. Usually it is easy to distinguish between a composition that is overworked and one that is underdeveloped. In a classroom situation the instructor helps the student maintain an appropriate balance; but even so, the student should be aware of his position because awareness will accelerate his progress in class and assure him of that independence and self-reliance so necessary to his work after he completes the course.

In the following brief discussion of the principles of composition it is well to remember that there is usually some overlap of principles, though they are presented separately. A composition can be complete without the application of all the principles, just as a drawing can be complete without the involvement of all the graphic elements.

MOVEMENT

Movement is important to works of art and is usually created in conjunction with other principles of composition such as rhythm, repetition, and contrast. Although movement can be produced by subject matter itself, such as a running figure or a falling tree, *movement in composition* usually refers to the structuring of the art elements to lead the eye across and into the picture plane. Line, value, texture, form, color and space are employed by the artist to produce the kind of movement he feels is most suitable for his drawing. The movement can be violent, fast, slow, obvious, subtle, regular, or irregular; it may in the same composition be pleasing to the eye or irritating to it, or both. By carefully modulating forms or closely relating values, the eye can be directed to travel slowly across the surface or can be brought to a stop; this can be done by inserting a contrasting shape, value, or color for emphasis. Through repetition of the elements a rhythmical movement may be created, and it will carry the eye rapidly across an area. The student's aim is not necessarily to create the most harmonious movement possible, nor the most violent and conflicting one. The individual expression determines the kind and amount of movement; whether it is a slight ripple or a violent wave, it must be introduced in support of the sensation the artist desires to create. A typical Charles Sheeler drawing, Figure 27 permits the eye to scan the surface with restful pauses at appropriate intervals, while a Rico Lebrun drawing (see Figure 13) introducing conflicting and uncomfortable passages, forces the eye to rush across the surface. The viewer who understands and appreciates art can enjoy both drawings.

More recent methods of producing movement are those which employ tension and suggestion, though both methods have also been used by artists of earlier periods. Sassetta, Uccello, and other early Renaissance painters used color tensions in the same manner that painters employ them today. The use of tension and suggestion is discussed in Part III.

Whether the eye is led across the picture plane by a modulation of surfaces, a sequence of rhythmic forms, a creation of tensions, or simply by suggestion, the student's purpose is to create a movement appropriate to the drawing.

REPETITION

Repetition is one of the simpler ways of producing unity in the organization of a composition. So close is its relationship to movement and rhythm that in many instances the three are inseparable. To repeat a shape, color, value, line or texture is one of the most comfortable ways of producing unity, but also one of the most overused. A student's drawings naturally express a certain degree of rhythm and repetition, and especially so as the student becomes more facile and confident. He may unconsciously yield to the temptation to repeat the same interesting art forms, and before he is aware of it, the composition has become monotonous.

When repetition is used more subtly, it often detaches itself from the related principles and takes on an identity of its own. In Figure 58 the repetition of the two heart shapes has a tendency to break the rhythm of the horizontal line and value flow across the composition. Thus, adding the heart shape on the extreme right gives a necessary degree of balance to the drawing. It also slows down and stops the movement of the eye off the page. This pause permits the more dominant heart shape on the left side of the composition to create a tension and to pull the eye back into the picture plane. It is true that balance, movement, and a certain amount of rhythm are found here, but the repetition of shape gives unity to the drawing even though its parts actually are quite varied. In Figure 59 the repetition is obvious and, like the beat of a congo drum or the drip of water from a faucet, the repetition and rhythm are here inseparable.

Repetition in a composition, it must be remembered, does not necessarily make the drawing better; just to repeat shapes like pickets on a fence or ties on a railroad can be very monotonous. Effective repetition must give interest to the drawing and relate to the other units in the picture plane. Although all great works of art must be based upon a consideration of design principles, their success is the result of the artist's highly individual and creative mastery of these principles.

58. William Schaaf. *Project I.*
Pencil and collage.
Student drawing, University of Florida.

59. *Repetitive Pattern*. Litho crayon.
Student drawing, University of Washington.
Courtesy of Louis Hafermehl.

In Figure 60, *Persimmons,* the artist has employed repetition, but there is also variety, however subtle. A slight degree of perspective is introduced by moving the third persimmon lower in the picture plane. The outline of the first and last persimmons expresses the same symbol or shape as the others, but it is a line statement; this gives variety to the other value statements without minimizing the repetition of the unit shape. The beauty here is in the simplicity of expression and in the quiet mood; the painting indicates understanding and sensitivity on the part of the artist.

To some degree the same sort of relationships appear in the David Smith sculpture in Figure 61; the curves and angles are both repeated throughout. However, all the angular shapes have been compromised by curves and so related to the circles. An interesting balance has been produced by introducing the smaller and more intricate pattern of angles and curves on the left in contrast to the large and simple circle and rectangle on the right. The negative area in the center of these two units becomes the most interesting art form of the composition. Again, repetition, movement, rhythm, balance, and emphasis are here so closely related that any attempt to separate them or even to analyze their organizational structure verges on the academic. After developing an awareness of the structure of the art elements, the student is able to enjoy these esthetic forms and procedures without making a conscious analysis of their organization.

60. Mu Ch'i. *Six Persimmons.*
Chinese, Sung Dynasty, 13th Century.
Ink on silk.
Daitokoji, Kyoto, Japan.

61. David Smith (1906-1965).
Voltron XVIII. Steel Sculpture.
Owned by State of New York.
Collection of the Empire State Plaza.
Albany, New York.

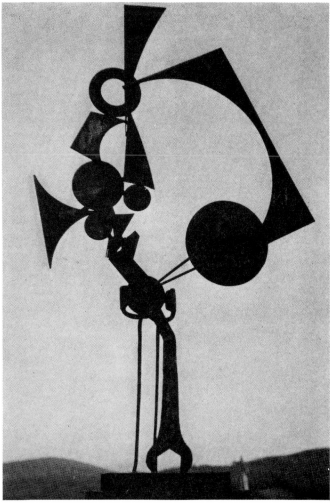

PROPORTION

Proportion as an art term usually refers to the relation of one part of a work of art to another or to the whole, with respect to magnitude, quantity, or degree.

A beginning student in a figure-drawing class is introduced to proportion when he is asked to determine the correct sizes of the parts of the body in relation to the entire figure. (Here the correct sizes are those of the average person, with slight variances for the individual characteristics of different models). As the student begins to draw more creatively, however, distortion of the figure becomes a possibility. For example, by making the head smaller and taking other liberties to give the figure or its parts abnormal relationships, the student may make his drawing more interesting. He will then begin to think more of the esthetic proportion of the figure, and less of the correct proportion. The esthetic proportion is that one emphasized within a particular drawing in order to give it interest and meaning. It may, of course, be that the correct proportion is the better choice. Distortion cannot be justified merely because it is intentional or interesting in itself, it must be right for the drawing.

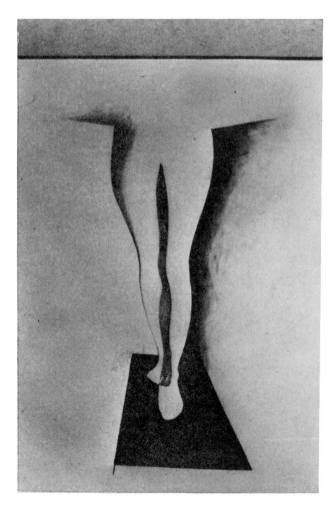

62. Ron Chesser.
Running Figure Series. Graphite.
Student drawing, University of Florida.

Proportion in regard to composition is always arbitrary and can be regulated only by the needs of the individual work of art. Within the picture plane the student must give consideration to the proportion of light area to dark area, warm color to cool color, intense color to grayed color, textured to nontextured areas, and to other choices which will arise as the composition develops. In Figure 58 the light and dark areas are almost proportionately equal; in Figure 62 the light areas are much larger than the darker areas. Unless they are called to his attention, the viewer will give little conscious thought to these proportions of light and dark; yet they are extremely important to the moods of both drawings. By placing a piece of tracing paper over Figure 62, the student can reverse its light and dark areas or substitute different value proportions, and he will see how readily the mood changes.

It is well to remember that a set procedure for establishing correct proportions in a picture plane can be detrimental to a student's creativity, for the needs of each composition will be different.

BALANCE

The word balance generally means to equal or equalize in weight, number, or proportion—adjustment between opposing elements. In the visual arts balance also suggests an esthetically pleasing integration of the disparate elements of a composition. Again, as in the case of proportion, the beginning student becomes involved with a simple form of balance when he first draws the human figure. He is then concerned with equilibrium, a static or a dynamic state of balance between opposing parts, forces, or actions. In drawing a simple standing pose, the student must properly distribute the weight of the body between the ankles in order to give the pose the necessary feeling of stability.

In two-dimensional composition there are times when a simple and formal distribution of shapes will give the necessary stability to the composition. However, neither the complexity nor the simplicity of its balance determines the success of a work of art. It can be either; the appropriateness of the balance is the determining factor in creating interest and meaning in a drawing on a two-dimensional surface.

There are many possibilities and combinations a student may employ to achieve balance on a two-dimensional surface (picture plane), and this richness of choice can make the problem of balance more involved than it is in ceramics, sculpture, architecture, and other three-dimensional areas. The picture plane invites endless experimentation when the student works with the space concept. The balance need not be achieved by stabilizing parallel shapes and forms at relative depths in the picture plane, but at any depth forms can be introduced to give a proper balance to the composition (Figures 63 and 64). Thus the student may create an interesting movement in and out of the picture as well as across the surface.

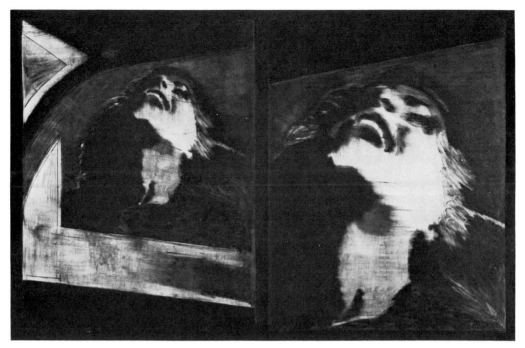

above: 63. James Gill. *Laughing Woman and Close-up*.
Crayon. Collection, The Museum of Modern Art, New York.

opposite: 65. Leonard Weinbaum.
Running Dog Series. Tempera and crayon.
Student drawing, University of Florida.

below: 64. Maxine Eisen. *Construction and Cloud Series*.
Airbrush, acrylic and pencil.
Student drawing, University of Florida.

There are other reasons why a two-dimensional surface permits and invites experimentation. With little effort forms, textures, shapes, values or spaces can be changed in a drawing. In sculpture and other three-dimensional areas a physical change in the material is necessary. To make a sculptured metal shape larger, the sculptor must insert a new and larger piece of metal or add another section to the original piece; if he needs more or less form, he must rework the shape of the metal; if texture is desired, he must change the surface, or perhaps add new material. In drawing the solution is simpler; the shift of a line can make an area larger or smaller; a smudge of charcoal can give a shape more volume; a smooth surface can be changed by skillful manipulation of line and value. This facility not only allows the artist to experiment with the use of balance in his composition, but it also demands that he always be aware of the many choices and degrees of stability if his two-dimensional surfaces are to hold the interest of the viewer.

It is easy to balance one shape with another when they are of equal size and value, and to do so often fulfills the needs of the composition. However, there are numerous means of achieving balance which are more subtle and difficult; a sharp black line if properly used may balance a large but inactive value; an added texture can give weight to a light area which needs more volume to improve its relationship with other parts of the composition; a small spot of red may add the necessary weight to balance a larger area of cool color; an empty space in proper proportion and placement may balance a complicated area. The important thing for the student is to explore balance creatively and to discover interesting ways of introducing it into his drawing (Figure 65).

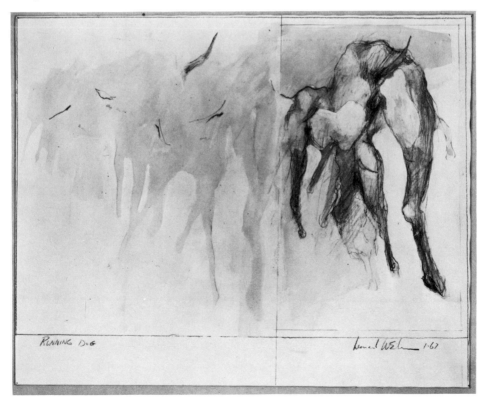

RUNNING DOG Leonard Wel___ 1-67

RHYTHM

Rhythm is defined in the dictionary as "a movement or fluctuation marked by the regular recurrence or natural flow of related elements." In reference to the rhythm expressed in drawing, painting, and the other visual arts, the definition describes only a limited use of this important principle. The rhythm of a composition can be as simple as walking or the repetitive utterance of a chant. In art this regular recurrence of related elements is usually more evident in pattern and design. In Figure 59 the simple repetition of the design element at regular intervals gives an overall rhythmical quality which does not disturb the limited interpretation of space at any particular point.

It is true that some artists depend entirely on the use of regular and measured repetition of elements in drawing and painting, but other artists are continually finding new and unusual means of producing rhythm, ranging from its most formal use to one that is entirely informal. In this last category the rhythm sometimes becomes so subtle that it hardly seems to exist. After a careful study of the drawings of well-known artists, the student will find that the rhythm employed is often the keynote to the style of a particular artist. (Examples: Jackson Pollock, Piet Mondrian, Eugene Delacroix and others. Figures 66, 67 and 68).

66. Jackson Pollock (1912-1956).
One (Number 31, 1950). Oil and enamel on canvas.
Collection, The Museum of Modern Art, New York.
Gift of Sidney Janis.

67. Piet Mondrian (1872-1944). *Tree II 1912*. Charcoal on paper.
Collection, Haags Gemeentemuseum, The Hague.

68. Eugene Delacroix (1798-1863). *The Giaour on Horseback*.
Brush and wash. The Arts Council of Great Britain.

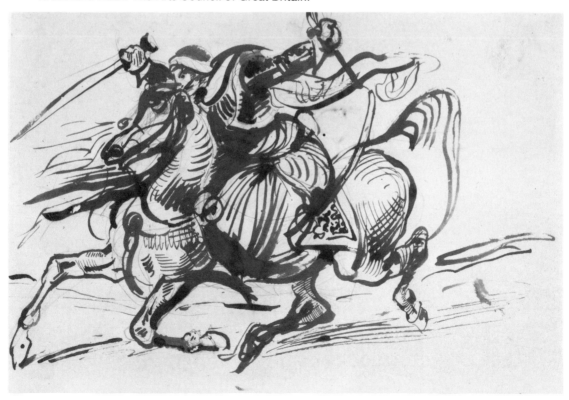

CONTRAST

Contrast is one of the main principles of composition. It has just been pointed out that repetition is one of the easiest ways of giving unity to a drawing; it can also be said that contrast is a most effective way of adding interest. Since composition really means a sort of balance, the student frequently needs to add contrast to keep a drawing from having entirely too much unity and harmony. Contrariwise, a drawing can overemphasize contrast and so need more unity. Often when contrast is serving as a device to stabilize movement, rhythm, balance, and repetition, it also serves the equally important purpose of giving emphasis to a form or area. The importance of contrast to emphasis is discussed in the next section.

A successful use of contrast to give interest to a drawing is seen in Figure 69. Raphael was a master of Contrapposto, a method of arranging the human figure so that its large masses moved in different planes.

69. Raphael (1483-1520).
Fighting Men. Red chalk.
Ashmolean Museum, Oxford.

EMPHASIS

Emphasis is the principle of composition which gives significance and importance to selected areas or elements in a work of art. There are many ways of placing stress on certain aspects in a drawing, and the beginning student is advised to explore several of these ways before he develops a set pattern of procedure. After a while he may find that emphasis on particular elements and ideas best expresses his individual feelings and gives clarity to his statements. Continued emphasis places stress on these aspects; they become characteristics of his work and a style emerges. It is through such emphasis that the masters have developed their individual styles; Rembrandt emphasized light and it became the chief organizing element in his paintings. By repeatedly placing dots of paint to create line, value, texture, color, form, and space, Seurat emphasized a process which causes the viewer to instantly relate his works to a highly individual style (Pointilism). El Greco, Klee, Matisse, Pollock, Rothko, Wyeth, and others are each important through the emphasis of some one significant aspect of an individual approach to creativity.

Each of the great periods of art reflects a specific style which results from the repeated emphasis by its leading artists of certain structural elements. In Gothic architecture the pointed arch and the slender vertical piers and counterbalancing buttresses were dominant. The Impressionist school of painters stressed color and light, and a definite style developed from the theory and practice of using broken color to simulate reflected light; its effective achievement was the production of subjective and sensory impressions in place of the reproduction of objective reality. The great periods of art of past civilization all call attention to trends which came about through the emphasis of one or more aspects of organization.

The points of emphasis in contemporary art are more varied and less easily defined. Attention is now focused on invention and rapid change. Therefore, it is less likely that one simple and easily-defined period style will emerge. However, art today derives from the discoveries of all the earlier civilizations and from a vast reservoir of new ideas. If the young artist is unable to draw upon the art of other civilizations, his expression will have little breadth and depth. Without an academic background, he will more than likely depend upon borrowed ideas from more knowledgeable contemporary artists, or else he will substitute novelty for the real creativity which is the outgrowth of understanding and invention. The basic and fundamental approach to which I refer has been mentioned earlier in the discussion of the student's responsibilities. The successful student will gain an understanding of the art of the past, an awareness of the art of the present, and he will gain a sense of direction in which the art of the future will develop in terms of his individual needs.

Among the specific ways of giving emphasis to an area in a composition is the effective use of contrast and repetition. We are familiar with the simple use of contrasting lines, values, colors, textures, forms, and spaces as ways of

calling attention to given areas or of giving importance to a particular form. Usually the beginning student tries to give emphasis to a particular form by some change that is related to the form itself, such as changing its shape or value. This procedure is effective in many instances; however, the student should consider the possibility of changing other areas of the drawing to give emphasis through contrast to the selected form. A form can be made to appear light by the darkening of other shapes or spaces; a color can be made to appear intense by the juxtaposition of another color; an area can be made to appear large by inserting smaller contrasting shapes; and the picture plane can be subdued around the area that has been selected for emphasis. The possibilities and combinations are endless.

To give emphasis through repetition is an entirely different process. Here, too, the need for individual expression is paramount. Too much repetition can lessen the desired emphasis but repetition properly applied can create several points of interest within the picture plane.

Figures 70 and 240 illustrate some of the ways in which artists have given emphasis in their drawings to selected points of significance.

70. Osservanza Master Painting, Italian, 15th Century. *Christ in Limbo.* Egg tempera. Courtesy of the Fogg Art Museum, Harvard University, Cambridge, Massachusetts.

CHAPTER V
MATERIALS AND TECHNIQUES

Because of their close interrelationship it is necessary to discuss drawing materials and techniques in the same chapter.

Many drawing instructors have in recent years given less class time to the study of materials and media. There are a number of reasons: A more complete and better supply of materials is available to students now than ever before; being sure of the materials now being manufactured by reputable companies, instructors have used for creative projects the time that was formerly spent in making and testing materials; however some departments of art have added courses that deal exclusively with the materials of the artist. In these courses the student learns of the techniques and materials used by the old masters and becomes familiar with the new materials that are constantly appearing on the market. Not only does the student learn the physical properties of egg tempera, oils, water color, silverpoint, synthetics, and other media, but he also learns the best techniques for applying the materials to appropriate grounds. Also there is a possibility that some of the students have been introduced to drawing materials in basic design, rendering, water color, art history, and other classes.

Regardless of how much the student knows about materials, I still consider it important to assign problems pertaining to the specific use of each drawing medium because there is always the danger that students will limit their use of materials to those which they find most interesting or with which they are comfortable. Students who know a great deal about synthetics and other new media may have learned very little about bistre, silverpoint, or the preparation of a gesso panel; students with a knowledge of the techniques and materials of the old masters may not have bothered to investigate any of the useful new products.

I have seen students who have had several previous courses in drawing enter an intermediate drawing class and confess that they had until then drawn only with conté crayon on newsprint. Their drawings were usually stylized and monotonous expressions of a single medium. The trick of bearing down on the sides of the square sticks and achieving a dark and vibrant line as

they turned the crayon on its sharp edges had become a mechanical and contrived device. At first they were frustrated when they found that pencil, charcoal, and brush did not conform to this method, but after using other materials they were able to handle conté crayon with much greater versatility and strength.

The appropriateness of the material to the drawing can be seen in the master drawings reproduced in this book. Two drawings by students (Figures 71 and 72) illustrate this point. In Figure 71 a student has drawn quill-type pen lines on a smooth paper which permitted a free and easy flow of line. The materials here are appropriate to the expression. In Figure 72 the student has used a wood wedge (key for tightening stretcher pieces) as a drawing tool. Dipping the point of the wedge in ink and drawing on a rough piece of paper, he has made an interesting ink line ranging from dark and heavy to light and scratchy as the ink on the wedge diminishes. Each drawing has its own individual character; the right medium and ground are as important as the selection of art forms to express the idea.

It is impossible to give one formula which may be taken as an accurate guide for matching specific materials to various grounds, or for the designation of a particular medium that will fulfill an individual's needs. The student must assume this responsibility. Through experience he will become sensitive to the materials and learn to make certain that they are appropriate to the idea he is trying to express.

71. Kathe Totten. Quill pen and ink. Student drawing, University of Florida.

72. Wood wedge and ink and wash.
Student drawing, University of Florida.

The selection of materials is approached subjectively and objectively. First, the student should try to relate a material to an idea and then give consideration to the physical properties of the material. Is the medium compatible and permanent? After a period of conscious awareness, the student will instinctively select the appropriate material for each drawing. He will gradually realize the possibilities and limitations of the various drawing materials and will combine this technical knowledge with esthetic sensitivity. Directives to a sensitive approach are unreliable in a sense—no one rule fits every individual—but several books give definite information on materials and they should be investigated by beginning and advanced students. Among those books listed in the bibliography, *The Artists Handbook* by Ralph Mayer and *The History of Drawing* by Daniel Mendelowitz will be most helpful as general guides.

In conclusion, a knowledge of materials is indeed important, but experimentation with them cannot be overemphasized. Drawing is one area in which the excitement of new materials can impede progress. The newness of a product must not take precedence over its appropriateness. As an example, many students have ceased to use vine charcoal and have substituted compressed charcoal. Both have advantages if used appropriately. The intense black pigment of the compressed charcoal and the added binder in it may be desirable for quick sketches, large cartoons, and the like, but the soft vine charcoal, having neither grease nor binder, is easier to erase than compressed and therefore is more suitable for long, careful studies. It may be erased or changed for better placement and to improve a contour, lighten a value, or correct a proportion. In both cases a fixative can be put on to make the drawing permanent. Another misuse of materials occurs when students prepare their own

73. Judy Haber.
Rock Shapes and Landscape.
Wash, watercolor and ink on gesso.
Student drawing,
University of Florida.

gesso panels for drawing. Because they have found polymer gesso an easily available and suitable ground for painting, they assume that it will work equally well for drawing. If the student desires an extremely hard ground and feels no need to work the drawing into the gesso or to correct it by using abrasives, the polymer ground will indeed work well with most drawing media, with the exception of silverpoint. However, there is no substitute for gesso made with gelatin or rabbit skin glue if the student wishes to change a drawing or work his material into the surface of the ground. He can often enhance the beauty of his drawing by painting a wash into the gesso surface, or by scraping or sanding an area to correct it (Figure 73).

In Part III few problems are assigned which designate materials. Advanced students, having worked with a variety of materials and media, must be given assignments which permit a choice. At this stage the subject or idea of their drawing may engage them more than problems related to materials and techniques.

The following notes on drawing materials are necessarily brief, but should be adequate. I have included the materials which pertain to particular exercises and assignments and also those most commonly used in drawing.

PENCILS

What are commonly referred to as "lead" pencils are made of graphite, a form of carbon mixed with clay. The hardest pencils contain a considerable amount of clay and the softest little or none. The drawing pencils range in number from 9H, the hardest, to 6B, the softest (hard: - 2H, 3H, 4H, 5H, 6H, 7H, 8H, 9H; medium: HB, F, H; soft: 6B, 5B, 4B, 3B, 2B, B). A student does not need to purchase all of these for the assignments. Numbers 4H, 2H, H, HB, 2B, 4B, and 6B are suggested as useful, but 2H, HB, 2B, and 4B are necessary.

For the sketchbook and general use, HB and 2B pencils are the best. Drawing pencils purchased at art supply stores are of a better quality than the varieties used for writing and for general school work. There are other drawing pencils which can be added to this list: ebony, charcoal, conté, lithograph, glass marking, carbon, flat lead sketching, layout, colored pencils, and others.

Since the mark of the graphite pencil is produced by a stroke across the surface of the paper or other ground, the student must learn the characteristics of the ground as well as those of the graphite. The fibers of the drawing paper wear away particles of carbon from the pencil, and the particles are left on the paper's surface or are pushed into the interstices of the paper. Thus the coarseness or smoothness of the paper becomes as important as the hardness or softness of the graphite. After reading the material on paper in this chapter, the student should select as many kinds of papers as are available and experiment on them with a variety of pencils. He should not limit the use of pencils to paper only, but also draw with them on a gesso surface which has

been sanded or honed with a smooth stone. He will find that the pencil works very much the same on the gesso as it does on a smooth, hard paper surface and in addition permits a special variety of techniques and modulations.

Some surfaces, such as blotter paper, filter paper, and others, which have not been sized or do not have sufficient rag content are not suitable for pencil. When real vitality is desired in a pencil drawing, such papers as charcoal and extra-rough water color papers should be avoided. Newsprint may be useful for practice, but the student should weigh its impermanent properties against its compatibility with drawing materials. Using a wide range of pencils, the student can make tests with half-inch squares on a variety of papers. He should make at least ten of these value squares with each pencil. Starting with a light square, that is, with very little pressure on the pencil, he will increase the pressure and strokes on each following square until he has produced a very dark value. Here the graphite is pushed and stroked into every pore of the paper's surface. On slick surfaces he should try using his thumb, erasers, or stumps to smear or modulate the carbon. Some of the most effective pencil drawings are made by unorthodox uses of the medium as well as by standard and controlled techniques (Figure 74).

74. Robert Smith. Graphite.
Student drawing, University of Florida.

75. Paul Fullerton. *Diagonal Technique*. Pencil.
Student drawing, University of Florida.

The two most common techniques in pencil drawing are the *linear* and *tonal*. There are many variations and combinations of the two methods.

In the linear technique pencil lines or sequences of lines are drawn to express the character of the art forms and spaces. There are three ways of applying the lines to the surface of the paper: The first is the most formal and limits the stroke of the pencil to one direction, usually a diagonal of varying lengths with the lines parallel to one another. Sometimes the strokes are vertical and may be so short that they more nearly produce dots than lines. This method sometimes indicates boundaries, omitting the usual linear contours. Figure 75 is an example of a controlled diagonal technique. This technique is suggested in the outside assignment (Schedule XVII) as a problem which is especially effective with vine charcoal.

A second linear technique is less formal and demands a more varied use of parallel lines. The lines may be curvilinear or straight, short or long, and of any type which best expresses the form or surface of the shapes and spaces in the picture plane. In Figure 76 many variations of this technique express form, texture, and space.

The third linear technique is called crosshatching (related to hatching, a form of the first technique mentioned). It is used most frequently with pen and ink, but it can be very effective with pencil, charcoal, and crayon. In the method parallel lines cross one another obliquely; a continued repetition of the process will produce any degree of value. If the drawing is skillfully executed, cross hatching can develop deeply modulated tones as well as lighter areas (Figures 77, 80, and 88).

76. William Massey. *Reflections*. Graphite. Student drawing, University of Florida.

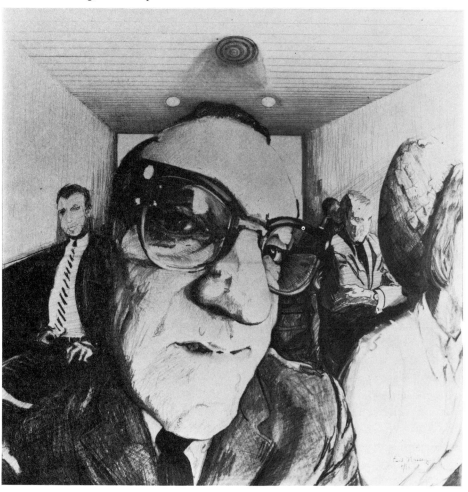

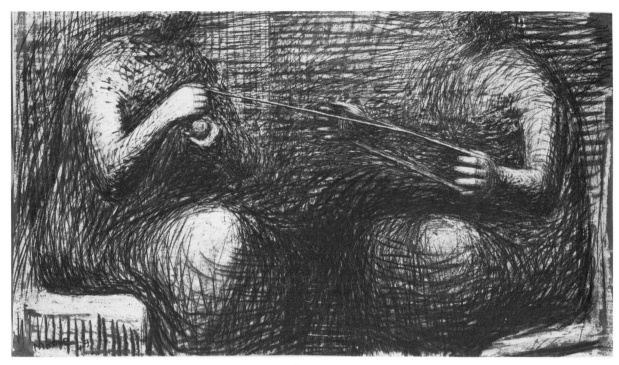

77. Henry Moore (1898-). *Women Winding Wool*. Watercolor and crayon.
Collection, The Museum of Modern Art, New York.
Gift of Mr. and Mrs. John A. Pope in honor of Paul J. Sachs.

In all these linear techniques pencil works best on drawing paper which has a medium-rough surface. If the paper is too rough, the grain will give the drawing a sameness that emphasizes the texture of the paper more than the quality of the line; if the paper is too smooth, the graphite reflects less light, and the lines lose their vitality and interest. An appropriate grade of white drawing paper comes in most drawing pads and sketchbooks, and these are available in all art stores. The paper has enough tooth to act as a file and will retain particles of graphite as the pencil passes across the surface; these areas catch the light and produce a rich, vibrant effect.

In the tonal technique the lines or strokes are placed close together to form a value area. Usually short strokes put on evenly are necessary to produce subtle gradations of tone, and extreme darks can be created by pushing the soft graphite into the grain of a good, smooth-surfaced paper. (Pencil drawings do not always need spraying with a fixative. However, if the softer graphite is used for extremely dark areas the completed drawing should have a light coat of fixative to keep it from smearing.) This method, as seen in Figure 78 and Figure 79, obviously places more emphasis on form and surface modulations than on line and texture.

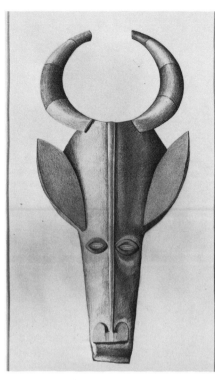

78. Jean Purser. *Drawing from Museum Collection*. Graphite. Student drawing, University of Florida.

79. Ron Chesser. *Running Figure Series*. Graphite. Student drawing, University of Florida.

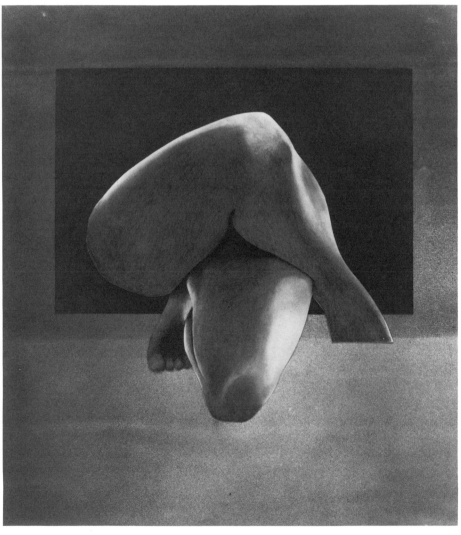

Some artists use both techniques according to the need, but others have definite styles that favor either the linear or tonal technique. Figures 80 and 81 are examples of drawings in which both techniques have been employed.

80. Ray Stefanelli. Graphite.
Student drawing, University of Florida.

81. Henry Aguet.
The Circle-Landscape. Graphite.
Student drawing, University of Florida.

A beginning student should be conscious of these various techniques, but after he becomes more involved in drawing, his statements will determine his method—that is, his feelings about the drawing will be more directive than a carefully reasoned consideration of techniques. Unless he has an assigned problem dealing with technical processes, he will not set out to draw a technique but rather to do a drawing by means of the appropriate techniques.

Collage can be combined with pencil drawing by pasting papers on the picture plane to give more variety to the pencil techniques (Figure 82). However, this method requires more sensitivity, skill, and knowledge of materials than is usually supposed, and it is not recommended for beginning students unless assigned in the form of a basic problem (see assignment in schedule IV). More information can be found on this approach in the discussion of collage.

82. Abby Drew. *Talking Men Series.*
Graphite and collage.
Student drawing, University of Florida.

CHARCOAL

Charcoal is one of the oldest and most popular of all the drawing materials. It is made by burning wood in closed containers so that little air will reach the flames and the wood will not burn completely. The result is a brittle and porous carbon. Charcoal for drawing comes in various degrees of hardness: very soft, soft, medium, and hard.

Two varieties are used in drawing, *stick charcoal* and *compressed charcoal*. The compressed is made by pressing powdered charcoal into sticks. It is excellent for making large cartoons and quick sketches. Because of its binder, it adheres to newsprint and to smoother- and harder-surfaced papers better than does stick charcoal; it can be rubbed and worked into smooth grounds to produce deep, rich tones of black.

Stick charcoal comes in either round or square pieces approximately six inches in length and a quarter inch in diameter. Vine charcoal is the best grade; it is made by burning small limbs of willow, beech, and other close-grained woods which are straight and free from knots. Usually vine charcoal is soft and of even texture and can be easily erased. For that reason it is excellent for long and careful studies where much revision is necessary. It works best on regular charcoal paper or papers of similar texture, but most of the medium rough papers are suitable for it. Unlike the compressed, stick charcoal will not adhere to extremely shiny and slick papers and boards. Even when it is used on the appropriate charcoal papers, the drawings so made must be properly sprayed with fixative.

Some artists handle charcoal as a single medium, while others combine it with such media as ink, pencil, crayon, wash, and tempera. As with pencil, it is difficult to discuss charcoal without mentioning some of the drawing techniques most commonly used. Actually charcoal techniques are similar to pencil techniques. The two chief methods of drawing with charcoal are the linear and the tonal. The tonal technique differs from pencil in that charcoal is more easily rubbed into the paper's surface with the finger tips, stumps, or tortillons. It is also easily removed from the surface with the aid of a soft rag, chamois, or kneaded eraser (Figure 83).

Charcoal lines can be applied over the rubbed-in tonal areas to give the value more depth and variety; these two techniques of rubbing in the tones and applying them directly may be combined in the same drawing (Figure 84).

The linear techniques are also much like the pencil, with one exception. The soft charcoal is not suitable for cross hatching and although the harder variety can be used, it is not nearly as applicable to this technique as are pencil, and pen and ink.

83. *Long Study*. Charcoal.
Student drawing, Art Institute of Chicago.

84. John Singer Sargent (1856-1925). *Study of a Nude Youth with Arms Raised*. Charcoal.
Courtesy of the Fogg Art Museum, Harvard University, Cambridge, Massachusetts.
Gift of Miss Emily Sargent and Mrs. Francis Ormond in memory of their brother, John Singer Sargent.

Both compressed and stick charcoal work well with other art media and are used effectively with oil or acrylics on canvas to express sensitive linear statements or to add value areas to paintings. But when charcoal is combined with other media, consideration must be given to the ground. Like chalk and other materials subject to smudging, charcoal must be properly fixed. (See fixatives under chalks and crayons.) Figure 85 (charcoal and watercolor) and Figure 86 (charcoal and collage) are examples of the use of charcoal with other media.

landing B. Nettles 68

85. Beatrice Nettles. *Landing*. Compressed charcoal and watercolor.
Student drawing, University of Florida.

86. Aaron Law. *Seated Figure*. Charcoal and collage.
Student drawing, University of Florida.

PEN AND INK

The following notes on pen and ink materials and techniques are general and brief, but they should be adequate for the beginning student. Through experimentation he will arrive at varied and specific conclusions which will serve his particular needs.

It is known that pen and ink was used for writing and drawing as early as 2500 B.C. but from the Renaissance through the nineteenth century artists and draftsmen developed the pen and ink media and techniques to the important position they now hold. This increase in the popularity of pen and ink and its consequent technical development have been the result of several factors: First, pen and ink is probably the most durable of all drawing media when the best quality materials are selected. Second, a pen and ink drawing can be effectively and economically reproduced; a simple line cut will record with complete accuracy detailed areas of a black india ink drawing on light paper. Third, pen and ink drawing was a natural outgrowth of those techniques which were used in silverpoint and engraving. Aside from these practical aspects, characteristics of pen and ink offer many benefits related to the artist's desire for individual expression. By the grouping of dots, the repetition of short strokes, the shaping of long and short parallel lines or free expressive lines, and the combining of lines and areas of ink to create shapes and patterns, pen and ink can be used to express the most casual or the most precise and formal statements.

Two types of pens have served in drawing from the earliest times to the present: the quill and the reed. Quill pens were made from the pinion feathers of large birds. They were light and responsive to the slightest variations of touch; their soft points wore away rapidly and it was necessary to recut them continually. The artist, cutting the points according to his needs, applied varying pressures on the pen and produced a broad line or a thin, flexible line. Early in the nineteenth century the quill pens were almost entirely replaced by steel pens which served the same purpose and permitted the artist to achieve a higher degree of technical proficiency than before. There are so many varieties and sizes of steel quill-type pens on the market today that the student is able to find one for every purpose, eventually narrowing his choice to those best suited to his style.

The reed pens used by the early Oriental and the later Renaissance artists were made from sections of tall grasses and reeds which had slender, often jointed stems, such as cane and bamboo. These pens were sturdier than the quills, and like the quills could be cut with points of different lengths and widths; they varied from very fine to very broad tips, sometimes more than a quarter inch in width. Although steel lettering pens are designed to serve the same purpose, they have not completely replaced the reeds. Many students prefer to make their own pens from small sprigs of cane or other reeds. The width of the cane should not be less than three-eighths of an inch nor wider than

five-eighths; the space between the joints determines the length of the pen. Longer pens are preferred because they allow room for the hand to fit comfortably around the staff, permitting a free wrist and arm movement. If they are cut while green, the tips are more easily split and may be shaped to very delicate points. There is no set procedure for cutting the nibs. Some artists like long points which gradually taper down to very thin nibs; these have considerable spring when completely dry. Others prefer a short stocky point strong enough to carry the weight of the hand and to assure a forceful line. Most art stores carry a supply of bamboo pens which are imported from the Orient. Steel lettering pens can be purchased in various shapes and sizes and are usually listed as round, oblong, square, and flat, producing lines or areas from one thirty-second to one-quarter of an inch or larger. Some of the newest lettering pens have a spring on the ink holders which presses against the nib and can be opened for cleaning.

A large assortment of fountain pens with both felt tips and steel points is now available. India ink can be used in both types but care must be taken to keep the pen capped when not in use. Otherwise the ink dries quickly and clogs the tip.

Of all the inks on the market today, india ink is the most commonly used for drawing. It is made from lamp black and glue binders. Used by the Chinese at least since 2600 B.C., it can be purchased today in both stick and liquid forms. The liquid india ink is obtainable in either soluble or waterproof solutions. The stick form used by Oriental writers and artists is referred to as *sumi*. When dipped in water and ground on a stone, the solid ink dissolves into a non-waterproof liquid which can be used for pen or brush. Ink sticks and ink stones may both be bought in art supply stores today and are becoming increasingly popular. Chinese ink can also be purchased as a paste in tubes.

During the Renaissance and through the eighteenth century bistre and sepia were used as inks and washes. Bistre was yellowish brown and made from charred beechwood. Sepia was reddish brown and prepared from the ink sacs of the cuttlefish. Neither is entirely permanent, and in the nineteenth century they were largely replaced by the durable india ink. Today a large variety of colors in drawing inks is available, but most of these inks are not permanent. Black india ink, purchased in bottles, is permanent and can be diluted to obtain different values of gray. The solutions are described more fully in the discussion of washes.

Selecting the correct papers for each type of pen is not difficult if a few simple rules are kept in mind: Quill pens and quill-type steel pens work best on a smooth, hard-surfaced paper. If the paper is soft and rough, the finer pens will catch on its surface and break the rhythm of the stroke. They will also collect paper particles on the points and make it difficult to produce a clean and flexible line. The student should try a variety of papers and determine which ones work best for him. Most sketchbooks contain paper suited to fine pen

drawings; those with papers specified for general use can be used for all pens except the finest and most sensitive steel quills. Fine grades of smooth illustration board are especially good for detailed and sensitive line drawings.

Reed pens and similar types of steel pens work well on rough and smooth papers. These pens can also be used on heavy illustration board, chip board, and other types of cardboard; the rougher grounds seem to give strength and authority to reed pen drawings. The gesso panel affords a good ground for both quill and reed pens. (Gesso surfaces are described in the section on grounds.)

Pen and ink techniques are usually limited to clear, clean statements of dots and lines and to well defined shapes. The three linear methods described as pencil techniques can be even more effective with pen and ink. Crosshatching is especially suitable, but the student must remember to let the initial strokes dry before crossing over them with the oblique lines, otherwise the ink will smear and clog up the negative areas between the lines (Figure 87). He

87. William Gonda.
Sculpture Forms.
Silverpoint and ink.
Student drawing,
University of Florida.

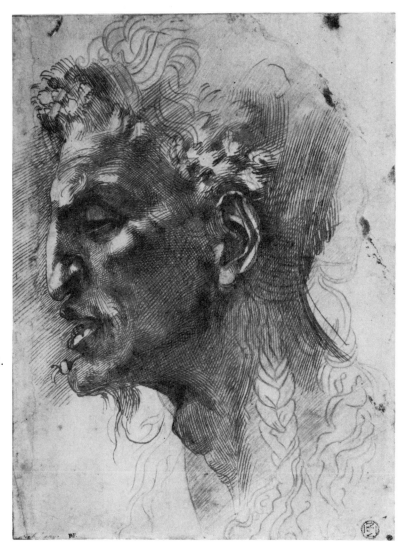

88. Michelangelo Buonarroti
(1475-1564). *Head of a Satyr.*
Pen and ink over chalk.
Musee du Louvre, Paris.
Alinari—Art Reference Bureau.

must also be careful to keep the pen point clean and free from lint particles which collect on the point and produce fuzzy lines.

Pen and ink is compatible with wash and water color. However, the student should take care not to use it on grounds which are water resistant or will not afford a permanent base. Such materials as wax crayons, grease pencils, soft chalks, and the like can be applied successfully over the ink areas; they may also be used initially and intentionally in a "resist" or "batik" fashion. Ink applied with pen and brush in the same drawing can be most effective. The following drawings illustrate pen and ink techniques and the results of combining pen and ink with other media: Figures 34, 88, 89, 90, 91, 92 and 93.

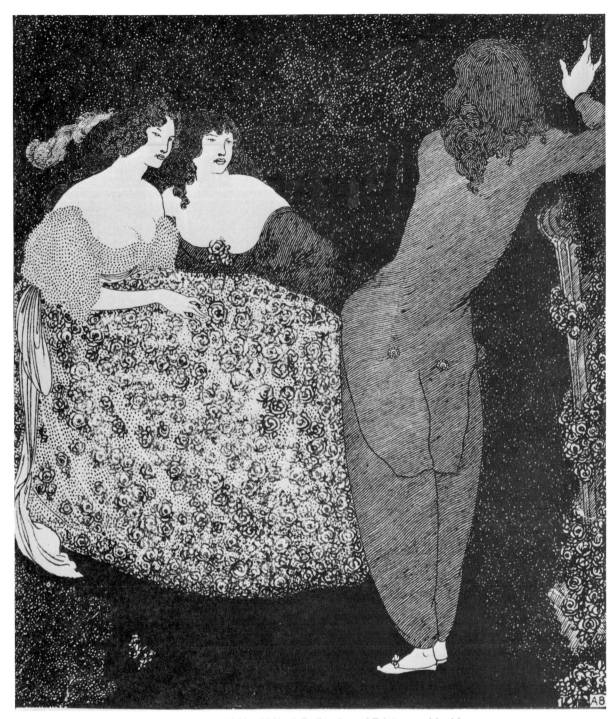

89. Aubrey Beardsley (1872-1898). *A Reflection of Tristan and Isolde*.
Pen and ink. Victoria and Albert Museum. Courtesy of R. A. Harari.

90. Leonardo Cremonini (1925-). *Maternity 1951*. Pen and ink.
Courtesy of the Fogg Art Museum, Harvard University, Cambridge, Massachusetts.
Bequest of Meta and Paul J. Sachs.

91. Rodolfe Abularach. *Stele*.
Pen and ink. Collection,
The Museum of Modern Art, New York.
Inter-American Fund.

92. Raphael Fiol. Pen and ink, and pencil.
Student drawing, University of Florida.

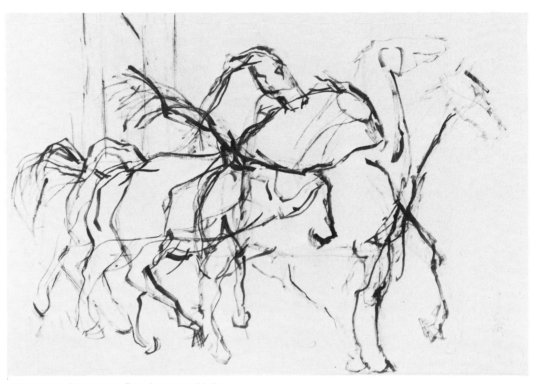

93. Lance Richburg. Reed pen and ink.
Student drawing, University of Florida.

WASH

Some choose to classify as a *wash drawing* any drawing that contains a transparent water soluble medium that is applied with a brush, although other media and combinations of media may actually dominate the composition. Others refer to wash drawing as a brush drawing or a painting, in neutral values, that is limited to a transparent water soluble medium. The wash drawings suggested for student assignments in this text are limited to water solutions of india ink, lampblack, black watercolor and black acrylic. They can be reinforced by other graphic media.

The student should limit his early experiments with wash to the basic materials: a number 7 red sable watercolor brush, black waterproof india ink, a container of water, and the appropriate papers. For him to know the possibilities and limitations of the pure wash media is highly important, and he can later explore different combinations. Students often begin a drawing with crayon, pencil, or pen and ink, and then add wash to give form to the drawing (Figure 94). This method is easy and quite effective, but the student is advised to try it only after he has given sufficient effort and time to a free and spontaneous use of wash and brush (Figures 95 and 96).

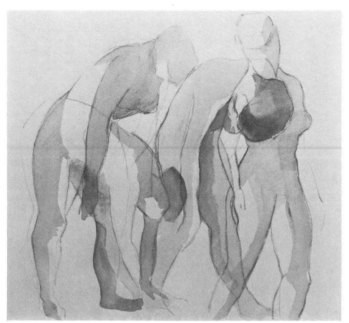

94. Wash and crayon. Student drawing,
University of California at Northridge.

95. Experiments with ink.
Student drawing, University of Florida.

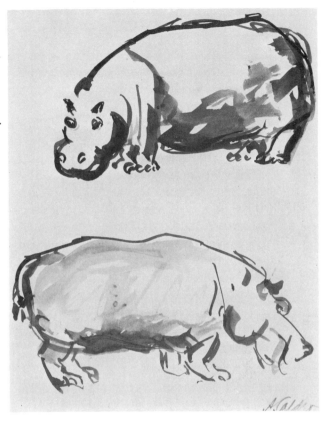

96. Alexander Calder (1898-).
Hippopotamus. Wash.
Courtesy of the Fogg Art Museum,
Harvard University,
Cambridge, Massachusetts.
Meta and Paul J. Sachs Collection.

Wash drawing reached a high peak in China several centuries before the Renaissance masters were using it so effectively in the West. Drawing and painting, both done with the brush in the East, were not really separate techniques. The calligraphic style was well developed in China before the first century B.C. During the thirteenth and fourteenth centuries the Chinese were able to express in paintings the same simplification and abstraction they had so beautifully achieved in their calligraphy.

One of the important characteristics of Chinese brush drawing is its directness, which demands perfect control in the handling of the brush. The artist gives much thought to the graphic idea before the brush touches the ground, and he makes no subsequent changes.

Artists in the West, unlike those of the East, early made a definite distinction between the areas of drawing and painting. Some of the Renaissance artists considered their drawings important as products, but more often the drawings served the artist only as preliminary plans and ideas for his painting or sculpture. Generally speaking, Renaissance artists handled wash informally as a technique. Many of the master drawings of the fifteenth, sixteenth and seventeenth centuries owe their interest and charm to the artist's informal approach; he restated lines and values to correct a drawing or to give it addi-

tional vitality and movement. The artists did not always restrict their wash drawings to brush and ink; many times they laid in the values with brush and then made the linear statements with a pen or a combination of pen and brush (Figures 97 and 98). They also combined washes with crayon, chalk, charcoal, and various other media. During the following centuries artists continued this free use of wash with other media (Figures 99 and 100).

As stated in the preceding section, bistre and sepia washes were extremely popular with artists during the eighteenth century. They often used these two materials with other inks and in combination with a variety of graphic media. Artists today continue to use wash with all the media used in earlier centuries, and more recently they have been combining it with synthetics and a variety of new media. Most of these are permanent and work well when combined or used in juxtaposition with each other. However, many of the colored inks produce beautiful effects as washes when mixed with soluble and waterproof black india ink, but they fade noticeably when exposed to light.

The wash most commonly used by students today is made by diluting waterproof india ink with water; with it a student gets a range of values from the darkest (pure black) to the lightest. In addition to being permanent, waterproof ink dries quickly, and when allowed to dry successive washes can be

97. Attributed to Caravaggio (1573-1610). *Study.* Pen and brown ink.
Achenbach Foundation for the Graphic Arts,
California Palace of the Legion of Honor, San Francisco.

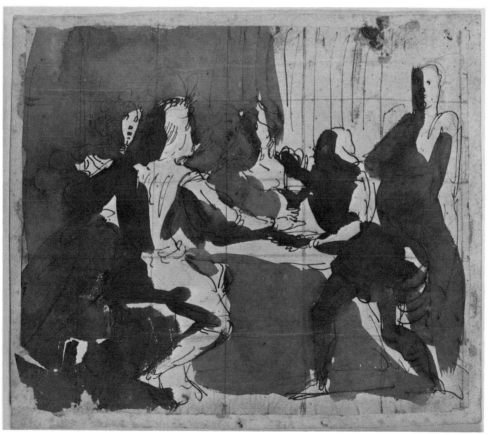

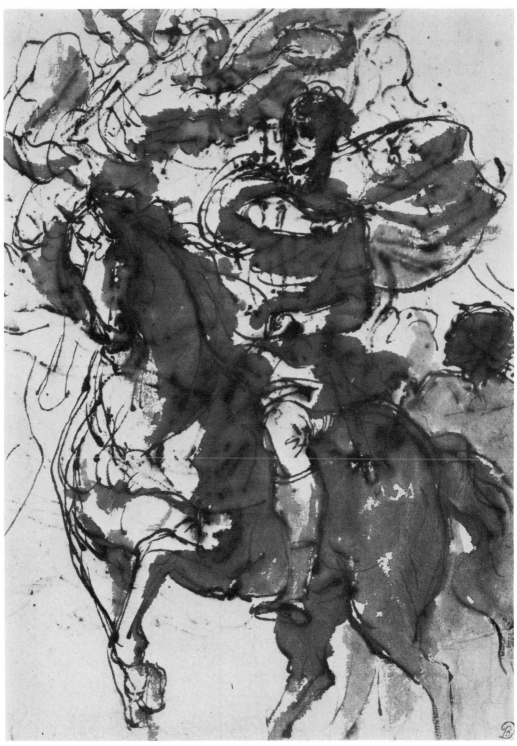

98. Venetian, 17th Century. *A Triumphant General Crowned by a Flying Figure.*
Wash, pen and ink. Courtesy of the Fogg Art Museum,
Harvard University, Cambridge, Massachusetts.
Bequest of Meta and Paul J. Sachs.

99. Francois Boucher (1703-1770). *Eros and Psyche*.
Pen and ink over black chalk with brown and rose wash.
Courtesy of the Art Institute of Chicago. The Joseph and Helen Regenstein Collection.

100. Auguste Rodin (1840-1917). *Study for a Bas Relief*. Graphite, wash, and white gouache.
Courtesy of the Fogg Art Museum, Harvard University, Cambridge, Massachusetts.
Grenville L. Winthrop Bequest.

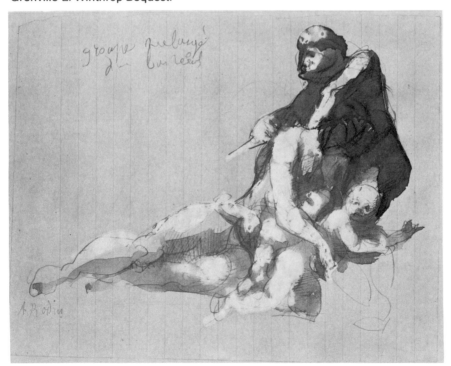

brushed on without disturbing the surfaces of those underneath. Some artists prefer soluble india ink to waterproof because it permits them to work in the tones and also to make corrections. The student can achieve beautiful gradations of tones by permitting the value areas to fuse with one another and with areas of clear water (Figure 101). Waterproof india ink is more controllable, but as a student becomes familiar with ink washes, he should also try tube lamp black and black watercolor. These, mixed with water, will produce similar gradations of gray tones; but drawings made with them are quite different in character from those made with waterproof india ink. Deep smoky tones can be obtained with lamp black when the medium and technique have been mastered. All these washes have consistent general characteristics, but they will produce different results when used on a variety of papers.

101. Georg Kolbe (1877-1947). *Nude Study*. Wash drawing. The Cleveland Museum of Art.

Synthetic washes include three general types of polymer: polymers with an acrylic base, those with a polyvinyl base, and those known as copolymers. Each of these produce a durable and insoluble wash when the drawing has dried. The water evaporates and leaves a film of synthetic resin which can be gone over immediately. Although I prefer to limit the discussion of washes to water-soluble media, I have found that one of the most exciting and successful problems for advanced students is a drawing-painting on a large canvas using a turpentine wash made from ivory black oil paint. Additional washes made by working the turpentine into black chalk, crayon, or charcoal, will, like oil, result in varied textures, modulated forms, and many other effects.

Some general reference must be made here, as we did with pen and ink, to help the student select the best papers for wash drawings. Testing is always advisable when a paper is doubtful. The more absorbent papers will permit the wash to spread and so prevent sharp and definite boundaries. Wrinkles will appear in thin papers after the wash has been applied. Those papers which

102. John Singer Sargent (1856-1925). *Spaniard Dancing Before Nine Seated Figures.*
Pen and brush with purple ink and wash on white paper.
Courtesy of the Fogg Art Museum, Harvard University, Cambridge, Massachusetts.
Gift of Mrs. Francis Ormond.

are slick and heavily sized will tend to resist wash and produce uneven or splotched areas. A heavy grade of white drawing paper with a medium-smooth surface, a good grade of illustration board, or smooth grade of watercolor paper is always dependable. Charcoal paper tends to wrinkle and cause the wash to appear flat and dull, but superior grades of white, gray, and colored charcoal papers, when mounted on cardboard and sized with a solution of gum arabic afford excellent surfaces for detailed wash drawings. Newsprint is not suitable for wash. Heavy manila paper is effective but soon discolors and becomes brittle. Sketchbooks which contain the heavier grades of drawing paper are well suited for student wash drawing. The better grades of extremely rough textured water color papers are too expensive for student experimentation, and their exaggerated surface is not compatible with certain types of brush work.

A gesso panel is one of the best and most permanent grounds for wash drawing; its texture, either smooth or rough, affords a choice of surfaces for technical experimentation (Figure 73). Gesso is discussed in a later section.

There are two definite approaches to wash drawing: In the first the linear statements are made before wash is applied (Figures 99 and 102). In the second

103. Ella Gelvan. Wash and ink.
Student drawing, University of Florida.

the value areas are painted in first and the linear statements are made over the wash (Figures 103 and 104). These approaches introduce the beginner to wash-drawing techniques. More experienced students who prefer a freer use of wash will give no conscious thought to whether the value or line is applied first. With wash drawing a student can be highly inventive, especially when he has learned to embody elements of surprise and to seize upon successful "accidents". In Figure 105 the student has combined line and value into one single statement, and though they both exist, there is no separating them as can be done in the drawing in Figure 94. One feels the same complete conjunction of the elements in Figure 106 as in Figure 105.

104. Wash. Student drawing, University of California at Northridge.

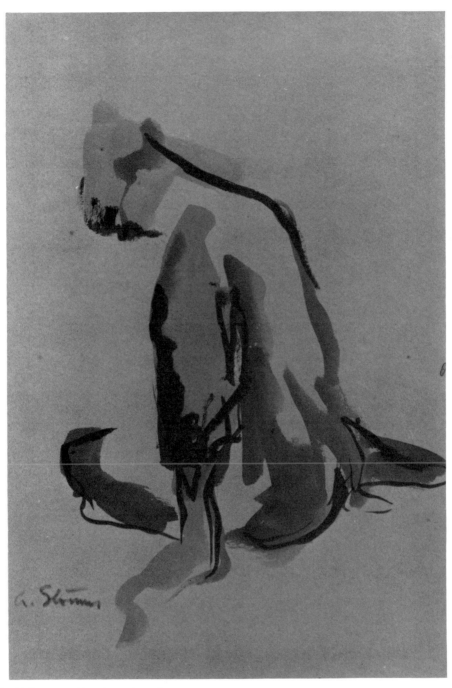

105. Al Stormes. Brush and wash.
Student drawing, University of California at Northridge.

106. William Schaaf. *Project I*. Wash, pen and ink.
Student drawing, University of Florida.

Another prime concern in applying the wash is whether the value areas are to be flat with definite edges or are to have blended tones from light to dark to suggest form. In Figure 107 a wash very close in value has been used to indicate all the value areas without any intentional gradations of tones within

107. Nicolas Poussin (1594-1665). *Bearing the Cross*.
Wash drawing. Museum of Dijon.

these areas. In Figure 103 the tonal areas are expressed by successive transparent washes with definite edges, ranging from the lightest value to the darkest. In Figures 101 and 108 the dark and light areas of wash have been applied before their edges were permitted to dry. This "wet wash" technique permits subtle value gradations which can give maximum form to the figure, and can also produce beautiful modulations of the surface areas.

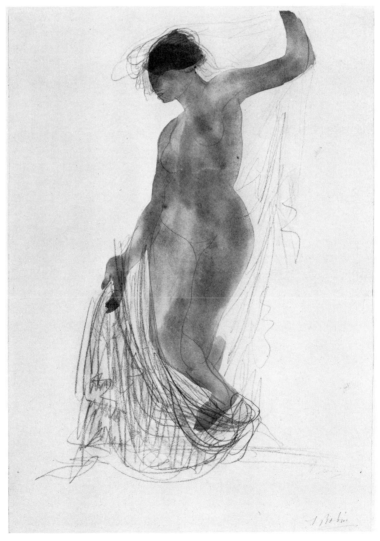

108. Auguste Rodin (1840-1917). *Standing Nude*.
Pencil and watercolor. Courtesy of the Art Institute of Chicago.

Definite processes for using wash are not easily outlined when the medium is combined with such others as crayon, chalk, and tempera, but as a general rule the artist will employ the technique most adaptable to the medium and to the problem. Occasionally he will apply the chalk to wet wash areas, and at other times he will let the wash areas dry before adding the chalk or pastel. Unless there is such an excessive variety in media and techniques that the drawing loses its continuity and meaning, there is no reason for the student to confine his expression to a limited number. In Figure 109 chalk, collage, charcoal and wash have been used—the wash in flat abstract areas with sharp edges and as a wet wash with values graduating from light to dark. The drawing is interesting and meaningful, and the viewer enjoys it without being conscious of the numerous media and techniques.

109. Bea Nettles. *Expecting Rain*.
Pencil, rubbings and watercolor.
Student drawing,
University of Florida.

CHALKS AND CRAYONS

All drawing media have certain deficiencies, but chalk is the most vulnerable of them all. Concern must be given to the quality of chalks, papers, fixatives and even to the method of applying the fixative. The cheap grades of colored blackboard chalks often used by students have little strength of pigment and lose their color and value effects when they are fixed. The student must be careful to select quality chalks and pastels of appropriate composition. If the pastels are too hard, they will cut the paper and prevent an easy, fluent stroke; if they are too soft, they will crumble, smear easily, and hang loosely on the paper. Figures 110, 111 and 112 will illustrate effective use of pastels.

110. Pierre-Paul Prud'hon
(1758-1823). *La Source*.
Black and white chalk.
Collection of the Sterling and
Francine Clark Art Institute,
Williamstown, Massachusetts.

111. Pierre Auguste Renoir (1841-1919).
The Bathers.
Red chalk on yellowish paper.
Courtesy of the Fogg Art Museum,
Harvard University, Cambridge,
Massachusetts.
The Maurice Wertheim Bequest.

112. Lorna Andrae Craven.
Gray Pastel. Student drawing,
University of Tennessee at Chattanooga.

The student must choose those papers that have enough barb or "tooth" to hold the chalk to its surface, but not those so rough as to exclude details. Chalk will not adhere well to a smooth, slick-surfaced paper, and it requires so much fixative that the medium loses its original color and tone. For long, careful studies paper made especially for pastels should be selected. The best grades are expensive and students may find that for quick sketches manila, construction, charcoal, and other papers of medium texture and weight are practical.

A correct choice of fixative and recommended methods of its application are important. An economical fixative can be purchased in bottles and sprayed on with an atomizer; another kind comes in a pressure can with a push-button so that the fixative may be quickly applied to the surface of the drawing. Regardless of whether he applies it with a spray can or atomizer, the student must put the fixative on in thin layers, allowing each layer to dry before the next is put on. The applicator is held at a proper distance from the drawing, about twelve to twenty inches; but here much depends upon the pressure and density of the mist. If it is sprayed excessively and held too close to the surface, the color and tones of the chalk will change noticeably. For best results the fixative should be applied according to the directions on the container. Some artists put on less than the minimum amount recommended, preferring to place their drawings under acetate or glass rather than taking the chance of losing the quality of the chalk by an excess of fixative. Because so many brands and mixtures are available today, it is impossible to discuss them all. One group includes diluted alcohol solutions of mastic, shellac, copal, and casein. Another group is made up of those non-yellowing synthetic resins dissolved in various solvents. Both of these types are at present sold in the spray containers and are convenient and efficient. They are highly recommended for the average charcoal, chalk, and pencil drawing. For the long and careful study in pastel, those fixatives specially designed for pastel are recommended.

The high-gloss plastic fixative often changes the character of a drawing or painting, but it is useful for displays and printed copy, and it furnishes a protective coating for three-dimensional objects. It adds richness to a water medium, often giving it the appearance of oil. However, more than any other fixative, the high-gloss plastic darkens the values and colors of chalks, transparent water colors, wash, opaque drawings, and most other graphic media which contain any amount of color, and it should not be applied to a drawing in which the least change of color and value is not desired.

Here is a test that will help to distinguish among the various fixatives: On a horizontal panel about twenty-four inches long and 16 inches in height, the student will tape or glue a variety of papers. It is not necessary for him to test all the colors and values of each medium, but the tested colors should include some of the warm and cool hues and several dark and light values. The space for each medium (chalk, wash, tempera, and so on) should be limited to a strip

about one-half inch in width and from eight to twelve inches in height. The student places a large mask over the panel covering the entire area except for an opening one inch high by twenty inches wide. He evenly sprays the exposed area. He then moves the mask vertically down the panel before he applies, in succession, the other fixatives. It is best to leave a narrow strip of the original media between each section for comparison of value and color. The completed panel can be placed in the studio or work room for future reference and additional tests.

A study of the works of Odilon Redon and Edgar Degas will show the use of pastels in their purest state. These artists handled chalk effectively as a major medium for their most celebrated works.

113. Wash, ink and wax. Student drawing, Syracuse University.

Today it is difficult to distinguish some chalks and pastels from crayons. There are many brands of each that have both the chalk and crayon binders, and some have trade names that indicate that they are combinations of the two. Many of these materials produce rich, interesting effects, and the better grades are quite permanent. They are used extensively in school art programs, and many professional artists have used them successfully. Conté crayon is probably the most popular and most widely used of these combined products. Conté comes in black, white, sepia, and sanguine, and its degree of hardness is designated as medium, soft, and very soft. Actually conté is a chalk of fine texture, but it has enough oil in the binder to keep it from dusting off of the paper's surface.

Lithographic crayon contains a large amount of grease binder and is one of the most durable of the media in the crayon classification.

Wax crayons were previously used mainly in the elementary schools, but they have been improved in quality in recent years. Not only are they now more lasting, but they can be purchased in a large variety of hues, values, and intensities. They are less messy than charcoal and chalks, and their hardness permits a close control of boundaries and lines. Their most effective and general use by art students and professional artists is in combination with other media (Figures 113 and 114).

There are other crayons and chalks on the market today too numerous to mention; when they are made by reliable companies, they can all be depended upon for a reasonable degree of durability and quality.

114. Henry Moore (1898-).
Madonna and Child.
Pen, black ink and black wash, black and orange crayon on white paper.
Courtesy of the Fogg Art Museum, Harvard University, Cambridge, Massachusetts. Gift of Meta and Paul J. Sachs.

GROUNDS

Contemporary artists use a larger variety of grounds for their drawings than ever before. Various metals, plastics, glazes, clays, stones, fabrics, woods, painted materials and other grounds furnish inviting surfaces for the large variety of graphic media now available. Since the earliest times man's linear statements have been incised, marked, and painted on various surfaces. The grounds have had much to do with the permanency of the drawings which have remained intact from past civilizations.

With a wider choice afforded today, the student must give more thought to the appropriateness and permanency of grounds. A beginning student is apt to think of a ground that is compatible with a media as the right one for a drawing; often this is the case but there are times when a ground which resists a media will best express a particular idea.

Generally speaking, from a practical standpoint of economy and storage, paper is still the best and most commonly used ground for drawing.

Papers

The importance of paper to drawing is seldom fully realized; too little thought is given to appropriateness and permanence. As a result many outstanding works by twentieth century artists have already shown evidence of deteriorating or fading.

Students often assume that they need not be concerned with the permanency of papers until their drawings become more proficient. However, there is the danger of using the cheaper and less permanent papers for so long a period of time, that they become responsive to one's expressions and the better papers will seem less appropriate and effective. However, at the start of a figure drawing class for beginners the best results are realized when papers are specified and limited to a very few, namely, newsprint, manila and white drawing paper. Newsprint is more than adequate for quick sketches and gesture drawings, not only because it is inexpensive, but because its surface is right for the movement and action that can be expressed with the soft conté crayon and graphite. The student will readily discover that it is not appropriate for washes and many other drawing media. He should also be mindful of its impermanence. The tendency to turn yellow and become brittle with age restricts its use to explorations and practice drawings. The same is true of the cheaper grades of manila paper. The white drawing paper of middle weight sold by the sheet and used for drawing pads and sketch books is of better quality. It is also suitable for a larger variety of media and more general use.

Often when an instructor suggests a paper for a specific problem he mentions the paper's characteristics in relation to the medium specified; nevertheless, the student should try other media with the paper to know of its possibilities and limitations. For example: In class, the discussion of charcoal

paper may be in regard to the use of charcoal; however, after experimenting with wash, hard graphite and other media it becomes obvious that charcoal paper is not suited to all graphic media. The student will also discover that when the media is confined to charcoal, chalks, and other compatible media the results will vary with the different brands and grades of paper—not only because of the roughness and smoothness of texture, but also because of the various weights and sizing practices. Many fine papers are finished only on one side; look for the watermark—a design in the paper visible when held up to the light.

The student should have in his portfolio a variety of standard papers which have been carefully selected and may be easily replaced. He should be familiar with their characteristics and have confidence in their quality. These papers can be supplemented by some of the more expensive handmade papers; however, the student should not become dependent upon rare and open stock papers which are difficult to replace.

The character of a paper is determined by the fiber used in its production. Linen rags, flax, cotton rags, wood pulp, and oriental fibers such as mulberry, mitsumata, hemp, gampi, and kozo each produce a different paper. Rice papers are made from several of these fibers but not from rice as ordinarily assumed.

Papers available today are of three types, machine made, mould-made and handmade. Mould-made papers are the result of a nineteenth century effort to make a paper partly by machine, retaining most of the characteristics of handmade papers. Handmade papers are produced in Japan and in Western Europe by methods which have scarcely changed since the Chinese invention of paper in the second century and its introduction into Europe in the twelfth century.

Some of the handmade and mould-made papers available today are excellent for drawing. They can be obtained in a variety of textures, sizes and weights. The weight is given in pounds per ream of 500 sheets, or in grams per square meter, according to the system used by the mill. Artist's papers have different finishes: Cold-Pressed (CP), Not-Pressed (NP), and Hot Pressed (HP). The Cold-Pressed and Not-Pressed have an open or coarse surface and are best for water media. Hot-Pressed is less suited to wet media, but excellent for opaque media and a variety of other graphic media.

The same papers (rough and smooth) used for water color and printing are often used for drawing. When using dry drawing media these papers can be lighter in weight as they do not have to hold up under pressures of printing nor withstand wet washes which cause wrinkling; when stretched°, lighter weight papers can also be used for wet media.

° Edges of paper are attached to drawing board by means of paper tape. Paper is moistened with sponge and left to dry. Do not remove paper until drawing is completed and dry.

During the past two decades printmakers have done much to improve the quality and supply of fine papers. I have received helpful information on available mould-made and handmade papers from the Tamarind Workshop, Inc., individual printmakers, and commercial paper companies.

Gesso

A gesso panel is one of the most durable and interesting grounds on which an artist can draw. It is not practical for quick sketches because of the expense and time involved in its preparation; however it is excellent for long and careful studies in ink, charcoal, crayon, wash, pencil, silverpoint, or mixed media. The panel is a challenging ground for the methodical worker and also for those who are more spontaneous in their approach.

Ready-made panels may be purchased in art supply stores, but for quality, economy and experience it is better for students to prepare their own. Aside from the experience in craftsmanship, they get a knowledge of the ingredients used in the preparation and the types of surfaces that are possible.

The first problem is to select a proper panel. Untempered masonite is the most practical and widely accepted material; plywood, if it is of sturdy composition and well glued, furnishes an excellent base. The student can save money and time by making a large number of panels at one time. He should get a four-by-six or four-by-eight-foot sheet of one-eighth-inch thick masonite or of plywood one-quarter-inch thick. It is best to cut these materials with a circular or band saw, for a heavy gauge handsaw can separate the layers of plywood and leave irregular edges on the masonite, eventually causing the gesso to chip. Panels larger than sixteen inches should be cradled for insurance against warping. Some artists prefer the panels without wood strips on the backs because of the space problem in storing and also because they work better for matting. Other artists use cradling, even on smaller panels, both to get the reinforcement and to have an edge suitable for nailing or gluing to the frames or for stripping.

For cradling the masonite or plywood, strips one-inch square are suggested for smaller panels (those not exceeding twenty-four inches in one dimension); for the larger panels strips one inch by two are recommended. These strips can be glued flush with the edges on the backs of the panels with any of the plastic glues or other strong adhesives. Nailing the masonite and plywood to the strips is hazardous because the wet gesso can cause the nail heads to rust and eventually to burn through the gesso surface. Most plywoods have one side which is inferior in quality and the strips should be glued to it, leaving the smoother surface for the gesso. For the larger panels, strips should be glued across the central section in addition to the strips that line the edges.

To prepare and apply the gesso to the panels, the following materials are necessary: a double boiler, rabbit-skin glue or gelatin, gilder's whiting, pow-

dered zinc (or titanium white), a bowl, a flat brush (sash-tool type), and cheese-cloth. If rabbit-skin glue is used, the proportion is two and three-quarter ounces of glue to one quart of cold water. The mixture should stand five hours or more before it is heated in the double boiler. In the case of gelatin, two ounces are combined with one quart of water. The gelatin will soften in fifteen minutes and the mixture can then be heated in a double boiler.

The double boiler is placed on the stove over moderate heat, and the contents are stirred slowly and thoroughly until the glue has completely dissolved. One heaping tablespoon of whiting is added to the hot size, which is then ready to be applied to the panels. This mixture is the priming coat. If the panel is small, the brush strokes can be carried from one side to the other; but if the panel is more than seven or eight inches wide, it is better to apply three-inch or four-inch sections (squares) at a time until the surface is covered. The adjoining squares should be applied as rapidly as possible, permitting the edges to join before drying. This first or priming coat must dry completely (twelve hours or more) before the gesso is applied.

For the gesso mixture the same glue or gelatin solution will serve, and while the mixture is hot (never boiling), the whiting and zinc are added. One part of zinc to two parts of whiting assures whiter surfaces than will those recipes using smaller proportions of zinc. The powders are slowly sprinkled into the solution, allowing time to settle below the surface, and then the mixture is gently stirred. Stirring too rapidly will produce air bubbles. When the mixture is about the consistency of coffee cream, the gesso is ready for application. For a specific proportion of powders to solution, one and one-half ounces of powders to each ounce of priming solution is recommended. Let me repeat that care should be taken that the solution does not become overheated. The gesso is transferred into a bowl, and the upper boiler and brush are cleaned. The upper boiler is prepared for straining the gesso by fastening over its top edge with string or rubber bands two thicknesses of cheesecloth or a fine-meshed woman's stocking. The brush can be used to force the liquid through the cloth. After the brush is washed again, the gesso is stirred gently but thoroughly. It may possibly be jellied at this point and may need to be placed over the hot water to regain its thin liquid state. However, the moment it liquifies, it should be removed from the hot water or air bubbles will result.

The gesso mixture is applied in three- or four-inch sections (squares) just as was the glue sizing. Unlike the size coating, however, the gesso layers should be repeated in fairly quick succession without allowing one to dry completely before the next is added. When the gesso begins to take on a dull appearance, the next coat is applied with the brush strokes at right angles to the ones in the preceding coat (this is important). The painted squares must overlap the edges of those of the underneath coat to prevent ridges from forming. From four to six coats of gesso are recommended.

After the panels are thoroughly dry, the surface should be smoothed with a fine sandpaper or with a whetstone. Sandpaper works best when placed over a small block of wood. A whetstone (approximately three inches long) for smoothing is equally satisfactory and much quicker. The whetstone is dipped in water, held lightly against the gesso, and moved in a rapid circular motion until an area of four or five inches is smoothed. This action is repeated over the entire surface. In this latter process precaution must be taken to shake the excess water from the hand and stone so that it will not drip on the panel and weaken the gesso. The student must also become sensitive to the touch of the drying stone on the gesso; the stone is held level and the pressure lessoned so that the corners and edges of the stone will not cut into the softened surface. After smoothing, a damp sponge is used to wipe the powders off the surface.

Almost any drawing medium works well on gesso, and it is also an excellent ground for mixed media. Vine charcoal and chalk do not adhere well to the smooth gesso ground and require a heavy coat of fixative to insure permanence. When these media are rubbed into the gesso surface, they require less fixative and produce beautiful tones. Interesting textures are obtained by scraping portions of the darker values with a single-edge razor blade, a knife, or a similar tool; and areas can be modulated with a brush and water to work washes, crayons, chalks, and even pencil, into the gesso surface.

Graphite has unlimited possibilities on gesso. Tone areas rubbed onto the surface of the gesso with stumps or erasers and direct linear techniques are the two principal methods. Properly sanded gesso of a medium hardness also affords an excellent ground for silverpoint (Figure 115).

Other Grounds

Students today have access to many new materials that are suitable as drawing surfaces. Usually experimentation with materials is incorporated into the idea being expressed; therefore, it is difficult for the instructor to give the student information on set procedures. Plastics (plexiglass, acetate, celluloid, etc.) and other materials now available offer endless possibilities in the form of light boxes, sculptural forms and varied constructions. Incised lines on plexiglass can be filled with black or colored acrylic and by working on both sides of clear 1/8″ plexiglass a degree of dimension can be expressed; even more dimension is created by drawing on both surfaces of several sheets of plexiglass and leaving some space between the sheets.

Drawing on three dimensional sculptural forms is possible but it can be a risky procedure; the drawing must be right for the structure.

Moholy-Nagy, during the first half of the twentieth century, was most successful in welding color and graphic statement with a variety of new materials; his work was characterized by a unity of materials and processes (Figure 213). He experimented with such materials as bakelite, neolith, galalith, trolit,

115. William Shirley. Silverpoint and egg tempera on prepared gesso panel.
Student drawing, University of Florida.

colou, rhodoit, copper, aluminum, incised plaster, formica, silverith, and plexiglass. He called the three dimensional constructions in which he used transparent foreground materials "space modulators."

Today students inspired by the works of contemporary artists often substitute line and pattern produced electrically for the more painterly use of line and pigment; both processes are used in combination on kinetic as well as stationary sculpture.

In using these new materials as fixed or moving grounds it is unwise and almost impossible to think of drawing as a separate area of the visual arts and force a graphic statement on a material unless the unity of idea, process, and material warrants its use (Figure 116).

116. Ben Nicholson (1894-). *Still Life.*
Photo courtesy of Christie Manson & Woods Ltd., London.

SILVERPOINT

Metal points of gold, silver, and lead served for linear drawing during the Middle Ages, but silverpoint has been used more than the others because of its durability. The techniques mentioned in connection with pen and ink work well with silverpoint; they are direct and do not permit erasing. The result is a beautiful silver tone which can be kept in the original state by applying a fixative or can be left without fixing. If the drawing is left unprotected, the lines will acquire a tarnish which changes them to a brownish color, richer than the natural gray lines and preferred by many artists. As with the other media, preliminary tests and practice sheets will lead the student to more facility in a finished drawing.

The silverpoint tool, easily made, is a piece of silver wire purchased from a jeweler or crafts shop and inserted into a pen holder of the type used for small quill pens or into a stylus cut from a piece of soft wood. The point is then sharpened like a pencil and is used like one. A greater variety of line may be achieved by making a second stylus and sharpening its point to a chisel edge. A small file serves best to shape the points.

Silverpoint will not work directly on regular drawing paper. Thin layers of Chinese white applied to a smooth illustration board or to a good grade of medium weight white drawing paper affords an excellent ground for it. As mentioned before, the gesso panel is also excellent for silverpoint (Figure 117).

117. Wayne Leigh. *Composition*. Silverpoint.
Student drawing, University of Florida.

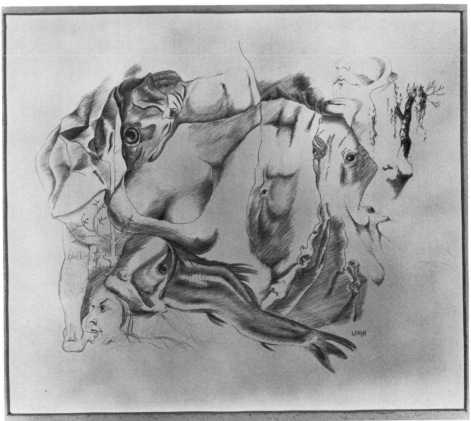

COLLAGE

The combination of collage and drawing is not suggested here for the beginning student. Although one of the early assignments (Schedule IV, Period C) does pertain to collage, it is essentially a problem in value and design rather than in drawing. Students who have done considerable drawing will be capable of using collage to enhance a drawing and give it emphasis or variety; they will not do it just for the novelty. Interest can be heightened by the insertion of various textures, values, colors of paper, and other materials. White papers come in a wide variety of warm and cool tones, and the student may add emphasis to an area by inserting a paper which is either warmer or cooler than the background. By a skillful handling of the graphic medium the edges can be blended and camouflaged so that only the warm and cool changes of tone are evident.

118. *Paper Towels and Newsprint.*
Collage and ink wash.
Student drawing,
University of Florida.

Drawing in Zerox 1968 #00015973

119. Lee Nesler. *Eyes.* Collage and crayon on Xerox.
Student drawing, University of Florida.

In contrast to this subtle use of collage, the technique becomes more obvious when a number of materials are pasted to the ground to give a variety of textures and dimensions to the surface.

This free use of papers, cardboard, cloth, and the like encourages an exciting combination of more colorful and varied drawing media, but the student must always take care that the drawing does not become a hodgepodge, interesting only because of the novelty and variety of materials. One material or medium must dominate a drawing to give it unity, and the student must carefully plan the arrangement of the various elements.

In Figure 118 only newsprint and paper towels have been pasted on a piece of gray chip board. Washes have been used to produce a greater contrast of values. Figures 119 and 120 are additional examples of the effective use of collage and drawing.

120. Abby Drew. *Talking Men Series*. Collage and graphite. Student drawing, University of Florida.

CHAPTER VI
FIGURE DRAWING

In most of the assignments in Chapter VII the human figure is used as the principal subject. A careful study of the problems, however, will disclose that the teaching emphasis falls more on the fundamentals of drawing than on the specific subject. It is not intended that the student become so interested in the technical aspects of drawing the figure that his creative expressions are hampered. For the beginning student the figure should be a common denominator to be frequently drawn with other objects and subjects; for the advanced student the figure can be a point of departure at any time without disturbing his basic approach to drawing. If the student learns to use the elements of drawing effectively while he is drawing the figure, he will be able to draw other subject matter equally well. And when the figure is drawn so extensively in class, it is assumed that still lifes, landscapes, and other subjects will be included in the work done outside of class in the sketchbook.

There are instructors who use only rocks, pieces of wood, and other inanimate objects for subject matter and still do a creditable job of introducing the student to the basic fundamentals of drawing. I prefer to assign the figure for several reasons: (1) Generally speaking, all students are familiar with and interested in the human figure. (2) From association and frequent observation the students possess some general knowledge of the proportions and the basic structures of the figure before their first serious attempt to draw it. (3) It is usually easy for them to relate to the model's poses since they have often taken such positions or can easily imagine themselves in similar attitudes.

The human figure also gives the instructor something tangible to deal with when he presents fundamentals to beginning students. The differing figures and their parts—the head, body, arms, and legs—all offer an appreciable variety of problems but still maintain a general proportion and form. The student while doing descriptive drawing is not likely to say that an arm has only the thickness of cardboard, or that the figure has three legs, or that a figure has no spine.

Finally, the beauty of the human figure permits and encourages the student to recognize and concentrate on the esthetic qualities in drawing. All the subtleties and strengths of lines, values, and textures are expressed in the various types and attitudes of the models, from the simplest to the most complicated combinations. For the advanced student who is primarily concerned with movement, space, and form, the figure presents countless possibilities for transforming a simple picture plane into a vital graphic expression.

There are some basic principles for drawing the figure which will be helpful to the beginning student: He should be ever-mindful of the fact that the figure is symmetrical—symmetry to be accepted and made to serve, but also to be recognized as a pitfall which at first can prevent him from doing a good structural drawing. He must early become sensitive to the slightest change in the figure from the symmetrical to asymmetrical. The identical forms opposite each other in a symmetrical pose move slightly and become asymmetrical. Thus they not only lose the character of their original individual forms, but also become different from each other. The student is then confronted with drawing what he knows to be a symmetrical figure in an asymmetrical position. The difficulty lies in the student's inclination to express the basic symmetry of the figure instead of the asymmetry he observes or that actually exists from his particular point of view.

The student must evaluate his position in relation to the model. He must be aware of the point of eye level which divides those forms above eye level from those below, and he must see to it that every drawn line and form fully describes these relationships.

In figure drawing swifter progress can be made if the student has a clear concept of the problems involved in each assignment. When the student is responsible for initiating his own projects (free period) he should be aware of the time element. If the poses are only fifteen to thirty seconds, or even as long as several minutes, there will be time only for a quick analytical sketch of the movement and attitude of the pose; to emphasize detail, proportion, balance, and form would be unwise. When the pose is longer, these and other things can be given consideration.

The longer poses are initially concerned with placement, balance, and proportion. A good drawing badly placed on a page is unfortunate; a figure dropping out of the bottom of a page, floating up through the top, or looking off the edge with three-fourths of the space behind it can ruin the impact of a well executed drawing.

The same problem holds in regard to balance; a well-drawn figure which is toppling over will inevitably lose its effectiveness. The point or points carrying the figure's weight must be located; then the drawing of the balanced distribution of weight is quite simple. For example, when a standing figure's weight is evenly distributed between the two ankle bones, the student should find the location of the pit of the neck in relation to these two points (Figure

121a). When the model poses with all the weight on one ankle, the student will observe that the pit of the neck is directly over that ankle bone (Figure 121b).

The following statements on proportion will give the student a few guidelines from which he can determine how a particular model differs from the average; they are not intended as a simple formula for all figure drawing:

(1) As shown in Figure 121c the crotch is often considered the midway point between the top of the head and the bottom of the feet. More often the lower portion of the body is actually slightly less than the upper. This is a general rule and can be altered to describe the individual model. At first the student may find it necessary to measure these spaces with a long pencil or brush held at arm's length. This procedure is considered elementary by experienced draftsmen and should not be necessary as the student's eye becomes adept at measuring and recording proportions.

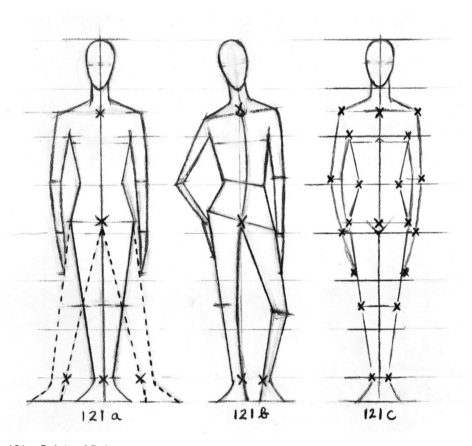

121. *Points of Balance.*

(2) The upper leg (femur) is longer than the lower leg (tibia and fibula), but not longer than the lower leg and foot combined. The same principle is true of the upper and lower arms; the upper arm (humerus) is longer than the lower arm (radius and ulna), but not longer than the lower arm and hand combined. Where the arms are dropped to the sides of the body, the finger tips as a rule fall at a point near the lower one-third of the upper leg.

(3) In comparing the width of the shoulders and hips of the average male and female figures, there are some general rules to follow: The female figure has in almost every case narrower shoulders and broader hips than the male, whereas the opposite is true of the male figure. Differences can be detected in the study of the skeleton, especially in the structure of the rib case and the pelvis. Ordinarily the rib case of the female figure is more pointed and can be likened to the gothic arch, whereas that of the male is usually rounder and takes the form of the Roman arch (especially when the chest is well developed).

It has been previously mentioned that there is the possibility of sacrificing spontaneity and esthetic quality when using any mechanical device or ratio to measure and determine proportions. This danger mainly occurs when the student depends upon a rule which states the average number of heads (usually seven and a half) in the total height of the figure. Here the real danger is that the student will think of the body as a separate unit from the head and so produce a drawing which lacks structural unity. A common procedure among beginning students is to draw the head and body carefully and thoughtfully, and then add two quick necklines to connect the two parts. There is as great a variety of neck spaces in figures, both in length and width, as there is of heads and torsos. Because of this variety and of the important relationship of the neck to the two parts it joins, it is better for the student to draw the neck as part of the body and the head as part of the neck. In drawing the back view, for example, the head, neck, and body become one unit; the trapezius (large flat back muscle) covers part of the back and shoulders, becomes part of the neck, and is inserted into the base of the skull. The sternomastoid muscle and the other parts of the neck have the same inseparable relationship to the body and head.

Often a similar mistake is made in drawing the lower leg. In order to express its structural unity with the foot and upper leg, there can be no direct cutoff for the beginning and ending of a part of the leg. The gastrocnemius muscle extends from the tuberosities of the femur to the tendon of Achilles and can best be drawn by recognizing its origin and insertion and drawing it often. Clumsy and feelingless drawings of the shinbone often are the result of a failure to follow through and express its relationship to the foot; the instep has its beginning in the lower leg and its grace and accuracy can be expressed only by a union of these structures. This fact is as true of the front view as of the side view, and in a front standing view of the leg, the shinbone should be

drawn from the inside of the knee to the inside of the ankle bone and foot; the outside contours can then be formed by adding the gastrocnemius soleus and other muscles. The drawing must express the structural unity which exists because of this interlacing of tendons and muscles.

Until the student has spent some weeks drawing both quick sketches and long studies of the entire figure, he should not try isolated studies of heads, hands, feet and other parts of the body.

While I am calling attention to the most common omissions and errors by beginning students, I must include a discussion of the side view of the figure. Usually through an emphasis on the line of the midsection of the front view and on the line formed by the spinal column of the back view, the student establishes an axis for expressing the rhythm and movement of the figure. In the side view the student usually gives attention to proportions and form, but seldom do beginners give thought to the structural axis that really expresses the rhythm of the side pose. Whether the figure is stooped, rigid, or leaning backwards it can be expressed only by understanding and showing the relation of these directional axes to each other and to the entire body. Both Figure 122a and Figure 122b represent the same rigid standing side view with the head erect, but the contours formed by an emphasis on the structural axes of the parts in Figure 122b best express the spirit of the pose. The correct use of these structural axes is seen in Figure 143. Naturally the relationship of the lines will change with a drop of the head, a bend of the torso, or any other movement of the body, but the relationship should be given primary consideration when the poses are long enough to permit the student to take his time.

The daily assignments are so arranged as to prevent an overemphasis and isolation of figure drawing. The problems in relational, environmental, and interpretive drawing are intended to emphasize space and form relationships more than the representation of the figure. Part III of this book (for the advanced student) emphasizes the creative aspects.

122. *Directional Axis—Side Views.*

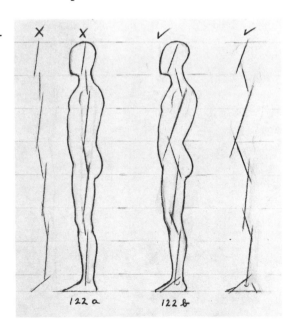

122 a 122 b

PART TWO

A PLAN FOR STUDY

CHAPTER VII

SCHEDULE AND ASSIGNMENTS

The following statements will help the student understand more clearly the general plan of study:

(1) Each weekly schedule consists of six hours of drawing—preferably with two-hour sessions. The critiques and discussions should occur at the end of each week; thus the student will have the weekend to make corrections and try out suggestions.

(2) Assignments must be flexible in order to accommodate the needs of individual students. It is not uncommon to find a student in beginning drawing who has had several previous courses in which much emphasis was placed, for example, on gesture and contour drawing; these students should be encouraged to try other approaches. When they draw from the poses intended for gesture drawing, they should study the *structure* of the figure as well as attempt to express their reaction to what the figure is doing. We do not suggest that a student or artist will arrive at a point where he no longer needs gesture drawing, but he must guard against developing a drawing system that is routine and repetitious.

(3) We recommend the use of a model for most of the daily assignments. The reasons for emphasis on drawing the figure are explained under *Figure Drawing*. However, a majority of the problems involving the figure can be applied to other subjects if the student understands the purpose of the problem (Figures 126 and 134).

(4) The student should remember that these assignments (Part II) are mainly planned for the beginner. Part III deals with the needs of the advanced student. The assignments serve two purposes: (a) to introduce the student to the basic fundamentals; (b) to keep him constantly involved with drawing. At this stage the beginning student should give little concern to the development of an individual style.

(5) The daily assignments are the student's responsibility. The instructor is available for direction, encouragement and inspiration, but he must not peddle out tricks of the trade in regard to his own individual way of drawing.

An advanced student and a teacher can establish a closer rapport if as a beginner the student has attained both experience and a better understanding of drawing.

(6) The *Schedule* and *Assignments* may prove of considerable value to some instructors; others will have their own syllabus and problems for beginning students and may use the weekly schedule only to compare with or supplement their own procedures. Nevertheless, we hope they will find the more academic information contained in Part I and the more creative approach in Part III both stimulating and informative. Those instructors who find the schedule and assignments compatible with their own thinking and needs, may wish to rely on them until they have an opportunity to test and substitute individual problems of their own.

As for students, those already initiated into a planned course of study are advised to make use of these problems in ways which will relate to and strengthen their present involvement.

WORK SCHEDULES AND INSTRUCTIONS

WEEKLY SCHEDULES (30)

I

SCHEDULE NO. I

TIME	PERIOD A	PERIOD B	PERIOD C
30 MIN.	1. Drawing of figure from imagination 2. Drawing of figure and landscape or interior from imagination 3. Drawing of figure from model	Gesture drawings 20 to 30 seconds each	Gesture drawings 20 seconds each
30 MIN.	Quick sketches from model Approx. 30 seconds each (no instructions)	Structure drawings 1 minute each	Gesture-Structure (GS) Drawings 1 minute each
30 MIN.	2 minute poses Standing and little or no action (no instructions)	2 Standing poses 12 minutes each 1. Front—12 minutes 　Weight distributed equally 　on both feet 2. Back—12 minutes 　Weight on right foot	2 Standing poses 12 minutes each 1. Front 2. Back 　Weight on right foot and 　left assisting
30 MIN.	8 minute poses Seated or standing (no instructions)	Structure drawings 5 minutes each	Critique or long pose Approx. 25 minutes

SCHEDULE I PERIOD A THREE FIGURE DRAWINGS

Regardless of how little the student knows about drawing, on this first day he should draw entirely without criticism and should use only soft conté crayon or 4B pencil on newsprint. Near the end of the period the instructor may want to comment on the drawings or may wait to discuss them at the beginning of the next period. The student should critically study his drawings for placement, proportion, balance, line quality, spontaneity and other aspects (as discussed in the chapter on figure drawing) before the next class meeting.

By having the student work independently the first day the instructor gains an insight into his experience and, to some degree, his ability.

Each student will make three eight-minute figure drawings. He will draw each figure on a separate sheet of 18″ × 24″ newsprint, using soft conté crayon or 4B pencil. The drawings will be: (1) figure from imagination; (2) a figure combined with a landscape or an interior from imagination; (3) a figure drawn from the model.

These drawings should be dated, clipped together, and kept for future comparison.

The first period will be followed by thirty minutes of quick sketching from the model, again without criticism. During this period the model will assume short poses of twenty to thirty seconds each. Rest periods may be scheduled according to customary class procedure. Some instructors include three rest periods of five minutes each during a two-hour class, while others prefer one ten or fifteen minute break between the two hours.

In the first half of the second hour the poses will be lengthened to two minutes. The model will stand with little or no action. Three poses, eight minutes in length with the model seated or standing, will take up the remaining half hour.

PERIOD B GESTURE DRAWING

In gesture drawing the objective is to express what the figure is doing rather than to depict the outward appearance. The student will allow the pencil or crayon to travel across the paper, moving according to the attitude of the pose, across, around, up, down and in any direction or manner which the pose suggests. Although the gesture drawings are applicable to other subjects, we recommend that these first experiences involve the figure only. It is easier for a student to relate to a particular human pose than to feel empathy with a chair or ink bottle. It is best for the model to take action poses; however, even when the figure expresses little action, the student should make his gesture drawings moving and dynamic, never static. Students who have much facility in representational drawing and who have done a lot of drawing may have more trouble than the beginner with gesture drawing. They are sometimes

tempted to say what they know about the figure rather than to express, through feeling, its movement in space.

A newsprint or a manila pad is suitable for the gesture drawing. The newsprint permits the crayon and pencil to ramble more freely and is less expensive. Both are available in sizes 12″ × 18″ and 18″ × 24″, and for gesture drawing either size is recommended. The larger 18″ × 24″ will be more practical for general class work. Since there will be numerous drawings daily, it may be necessary budget-wise to place several on one page and even overlap them. Although these drawings are only exercises, they should be kept in a portfolio for evaluation and comparison by the student and the instructor.

For further information on gesture drawing see *The Natural Way to Draw* by Nicolaides.

Figure 123 is an example of gesture drawing. See variations, Figures 124 and 133.

123. *Gesture*. Crayon.
Student drawing, University of Florida.

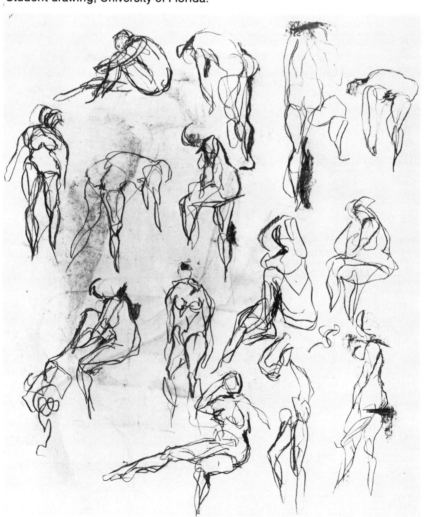

124. *Gesture.* Pen and ink.
Student drawing, University of Iowa.

PERIOD B *STRUCTURE DRAWING*

The verb *to structure* means "to organize, build, and construct." In order to explain *structure drawing* adequately, the word "explore" must be added to this definition. We treat structure drawing as an attempt to explore and express through a drawing media those things relating to the physical makeup of the subject. At times there will be a feeling of actually tearing down the subject or taking it apart in order to understand more about its physical characteristics; at other times structure drawing will be a building-up process and will express some knowledge of the object's structural qualities. These drawings are thus explorations and should be drawn in a way that will enable the student to know and describe adequately the basic structure of the subject. If a shape overlaps another the student should not hesitate to draw through or across the forms in order to locate structure lines and points.

Draw inside out. Beginning students are usually inclined to draw the outline and then fill in the inside areas of an object. To stress the importance of the inner structures, we continually remind the student to draw inside out instead of outside in. Actually, the outside boundaries are structures which can be equally important, and the real aim is to draw first those things that are basic to the physical makeup of the subject. It may be a line, shadow, or texture; it may express direction, position, volume, and other things pertinent to the drawing. To repeat, the secret to good structure drawing is first to draw the important structures; those less basic will readily fall into place. To draw the shadow cast under a chair before drawing the chair itself would be like drawing the outline of a cube before finding its structure points and lines. In the case of the cube, there would be little chance of the exterior outline alone helping the student arrive at correct structure points inside the cube. Conversely, establishing the inside structure points first will assist the student in finding correct outer boundaries. At a glance, the two cubes (a) and (b) shown on the top row in Figure 125 appear equally correct. However, since the inside structure points and lines have been added to those on the bottom row (c) and (d), the student can readily see which of the two was drawn after the inside structure had been established.

For the beginner structure drawing can be extremely rewarding. If he has not understood the structure of the form, he can by this method easily detect it. Embellished surfaces or distorted and exaggerated forms will not successfully camouflage structural deficiencies.

A rigid system for drawing can stifle creativity. However, structure drawing, with its guiding principle "to probe and build," forces the student to explore and present his findings in his own individual way.

125. *Drawings of Cubes— Inside Structures.*

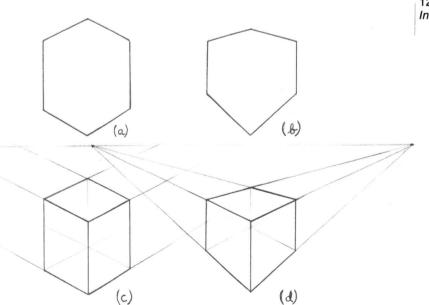

(a) (b)

(c) (d)

The following examples illustrate the more academic approaches to structure drawing by students: Figures 126, 127, 128, 129 and 130. The more familiar approaches by master draftsmen are illustrated by Figures 131 and 133.

126. *Structure Drawing.*
Pen and ink.
Student drawing,
Brooklyn Museum.

127. Dan Shouse.
Structure Drawing.
Conté crayon.
Student drawing,
University of Florida.

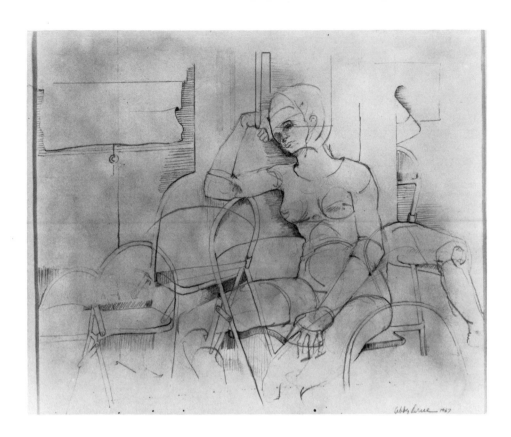

above: 128. Abby Drew.
Structure Drawing.
Pencil.
Student drawing,
University of Florida.

left: 129. Anne Woodward.
Structure Drawing.
Lithograph pencil.
Student drawing,
University of Tennessee
at Chattanooga.

opposite: 130. Anne Woodward
Structure Drawing.
Conté crayon.
Student drawing,
University of Tennessee
at Chattanooga.

131. Jacques Villon (1875-1963). *Two Sketches of a Reclining Female Nude.*
Pen and ink. Courtesy of the Fogg Art Museum, Harvard University, Cambridge, Massachusetts.
Gift of Francis Staegmuller.

PERIODS B AND C STANDING POSES

These will be working drawings involving placement, proportion and balance. The student should make as many corrections as are necessary, giving little thought to neatness. The drawn figure may fill the page, but should not exceed its edges. The model takes first a twelve-minute direct frontal pose with the weight equally distributed on both feet and arms hanging loosely at the sides. If the student is squarely in front of the model, the pit of the neck should fall directly above and in the center of the space between the two ankle bones. This pose presents the figure to the students with as little perspective, foreshortening, and asymmetry as possible; thus, the proportions of the parts can be seen in their correct relationships with each other and with the figure as a whole.

In a large class it is impossible to seat the students in positions that will afford all of them a symmetrical view of the figure. However, this can be more nearly accomplished by posing the model on a stand at the end of the room and placing the drawing benches in two rows directly in front of the model and as closely in line with the central vertical axis of the figure as possible.

The student's chief consideration must be given to proportion, the relationship of the various parts of the body to each other: the length of the radius

and ulna (lower arm) to the humerus (upper arm), the tibia and fibula (lower leg) to the femur (upper leg), the head to the neck, the width of the shoulders to the width of hips, the distance between the crotch and the top of the head to the distance between the crotch and the bottom of the feet, and other relationships (Chapter VI on *Figure Drawing*).

For the next twelve minutes the model takes a back pose with the weight on the right foot and the left hand on the left hip. The central axis which was formerly a straight line now becomes a curved line, and the two equal parts of the figure which were symmetrical become asymmetrical. There is a shifting of structure points at the shoulders, hips, knees, and elbows. The lines connecting these points on either side were formerly parallel, but now a slight degree of distortion and perspective has been introduced. The pit of the neck shifts to a position directly over the ankle carrying the weight of the body.

PERIOD C GS DRAWINGS

Because of the time limit, the one minute GS (gesture and structure) drawings force the student to limit his structure statements to those which are basic and to those which are for the most part felt rather than reasoned. The GS are similar to gesture drawings, but in addition to expressing what the figure is doing the student makes statements pertinent to the figure's physical makeup (Figure 132).

Toulouse-Lautrec, the nineteenth century French painter, was a master at combining gesture and structure as seen in Figure 133.

132. *Gesture-Structure.*
Crayon.
Student drawing,
University of Florida.

133. Henri de Toulouse-Lautrec (1864-1901). *Studies of Horses and Riders*. Pencil. Courtesy of the Fogg Art Museum, Harvard University, Cambridge, Massachusetts. Bequest of Marian H. Phinney.

PERIOD C *CRITIQUES AND DISCUSSIONS*

Critiques and discussions will be scheduled according to the needs of the class. A critique at the end of each week may not be necessary; a two-week period between critiques may be sufficient and more time would then be available for drawing.

The following suggestions are made regarding the first few critiques: each member of the class will pin up one page of short poses and one drawing of a long pose; any special problems recently assigned can be included. At first the comments of the instructor alone will be sufficient, but as the class progresses and the students become more aware of their needs and better understand the general plan of the course, time will also be allowed for the students themselves to discuss their own and other drawings. At the end of a month or of a term, some instructors may invite other art faculty members to attend the critiques. The students will then benefit from the impersonal comments which follow. However, the regular instructor, having followed the student's daily progress, will most likely be in a better position to give specific instructions. The faculty group-critique is particularly suited to the advanced student.

SCHEDULE NO. II

TIME	PERIOD A	PERIOD B	PERIOD C
30 MIN.	Gesture drawings 20 seconds	Gesture drawings 20 seconds	Gesture drawings 20 seconds
30 MIN.	GS drawings 1 minute	GS drawings 1 minute	GS drawings 1 minute
30 MIN.	Structure drawings 3 minutes	Structure drawings 3 minutes	Structure drawings 3 minutes
30 MIN.	2 Structure drawings 12 minutes each	2 Structure drawings 12 minutes each	Critique or long study Approx. 25 minutes Free Period

SCHEDULE II (no instructions necessary).

SCHEDULE NO. III

TIME	PERIOD A	PERIOD B	PERIOD C
30 MIN.	Gesture drawings 20 seconds each	Gesture drawings 20 seconds each	Gesture drawings 20 seconds each
30 MIN.	6 GS drawings 1 minute each 2 Structure drawings 3 minutes each	Structure drawings 3 minutes each	GS drawings 1 minute each Reed or nib pens
30 MIN.	2 Contour drawings 10 to 12 minutes each	2 Contour drawings 10 to 12 minutes each	Contour drawing 25 minutes each
30 MIN.	Contour drawing Approx. 25 minutes	1 Long pose 25 minutes Emphasis on proportion, balance, and structure Conté or pencil	Cross contour 25 minutes

With contour drawing the student will coordinate the sense of touch with the sense of sight. In these exercises the pencil line will record the student's keen observation of, and his feeling for, the edge of the form. The seeing, the feeling, the drawing are all one and they will all begin, move, and end simultaneously.

Materials will consist of a 4B pencil and either a 12″ × 18″ or a 24″ × 30″ sheet of newsprint.

With the pencil well sharpened and held firmly in hand, the drawing will start from any point on the figure. Looking only at the model, the student lets the pencil tip move slowly along the path which in unison the eye sees and the fingers feel. Seeing, feeling, and recording simultaneously, is necessary for contour drawing if one is to derive the most benefit from it.

The student's first concern will probably be with the outer edges of the figure, but he will also draw the edges of the forms within the outer boundaries. Since a line terminates either by coming to an end or by coming in contact with another form, only at that point of termination does the student look down at the paper, and then only long enough to place the pencil at the next point from which he plans to continue the drawing.

The student will have little time during the short periods for careful attention to line quality; however, he will give line quality time and thought during the longer periods. By exerting more or less pressure on the pencil the student will see a variety of lines begin to appear, and in this way he will record his most sensitive responses to the edges of the form. Variations of contour drawing are seen in Figures 134 and 135. The edges become more than boundaries and much is said about the character of the form by the variety of the lines which describe its edges (Figure 38).

PERIOD C *CROSS CONTOUR*

Cross contour drawings are supplementary to contour drawings; while drawing them the student will begin to understand *that contours exist within the form as well as at its edges.* From any point on the outside contour he may draw across the surface of the form to the corresponding point on the opposite edge, keeping the line perpendicular to the form's inside axis. The student will thus draw contours of existing inside shapes, as if the overall form had been cut into segments. One of the simplest ways to illustrate this problem is to have the student first make a contour drawing of a solid loaf of bread, and then have him make a similar one from a loaf that has been sliced but not separated. The sliced loaf will be placed in different positions, on its end, on its side, and with extreme perspective, so that the students may see the cross contours take form. The contours will vary from straight lines to curves which follow the overall form as do the curving hoops on a barrel (Figure 136).

134. *Contour of Clothes on Hangers*. Crayon. Student drawing, University of Washington. Courtesy of Louis Hafermehl.

135. Art Provaca. *Figure with Cross Contour*. Pen and ink. Student drawing, University of Florida.

136. *Cross Contour of Loaf of Bread*.
Pencil. Student drawing.

For more detailed cross contour drawings and longer assignments, the model will assume reclining poses; thus the student may express perspective by placing the lines of the cross segments closer together as they recede in the distance.

In Figure 135, a cross contour line is drawn at only one point, but it gives volume to the entire figure. In many of the early woodcuts and pen-and-ink drawings segments of cross contour lines were employed to show form and value. In Figure 137, Durer has used the cross contour most effectively. In Figures 138 and 139 the students have used cross contour to show movement and form.

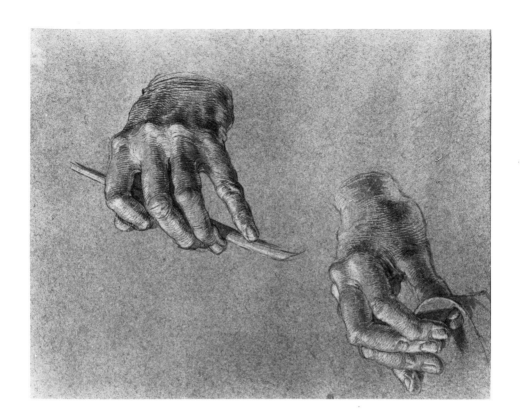

137. Albrecht Dürer (1471-1528).
*The Hands of St. Domenic in the
Feast of the Rose Garlands.*
Pencil. Albertina, Vienna.

138. *Cross Contour of
Standing Figure.*
Conté crayon.
Student drawing,
University of Florida.

139. Don Addis. *Cross Contours*. Pencil.
Student drawing, University of Florida. Courtesy of Gene Grissom.

IV

SCHEDULE NO. IV

TIME	PERIOD A	PERIOD B	PERIOD C
30 MIN.	Gesture Drawings 20 to 30 seconds each 2 Structure drawings 3 minutes each	GS drawings 1 minute each Any medium	No model during period 1 Contour of paper Sacks or crumpled cardboard boxes
30 MIN.	2 Structure drawings 12 minutes each	Structure drawings 3 minutes each Any medium	Value study—Collage, still life from 1 of 3 setups. Use torn paper of 3 values: light, middle, and dark
30 MIN.	Contour drawings 5 minutes each Pen and ink Quill of fine steel White drawing paper	1 Long pose—1 hour Conté pencil or crayon Placement, proportion, balance, and structure	Paste on manila, chip board, or other stiff backing
30 MIN.	1 Long pose Pen and ink Reed or quill type Emphasis on line °	Remind students to bring in several sheets of each of three values of ink washes—Light, middle, and dark (for next class). See instructions under Schedule IV, Period C—Value Study with Collage	

° Outside problem—line expression on various kinds of papers. Use several tools to express a variety of ink lines moving horizontally across the papers. See instructions.

SCHEDULE IV *PERIOD B* *LONG POSE*

The pose will last one hour and will allow the student time for study and corrections. He will use either conté or graphite pencils on 18″ × 24″ white drawing paper.

Whether the model is standing or seated, the drawn figure will fill the page. The drawing emphasis will be on placement, proportions, balance, and structure. These important fundamentals are discussed in Chapter VI, *Figure Drawing*.

The student will at first draw lightly; as the placement and proportions become satisfactory, he will draw gradually darker until the figure begins to develop into a confident statement. The longer the student works on the study, the more careful and deliberate he will make his approach.

The instructor will at this period tell the class to prepare value sheets in readiness for period C. Several 18″ × 24″ sheets of white drawing paper will be covered with a gray wash (or crayon) of middle value. A few more sheets will be covered with black india ink (or black crayon). White paper without any covering will serve as the lightest value. Sheets of chip board or other stiff backing (approximately 18″ × 24″) and rubber cement are the only other materials needed.

PERIOD C *VALUE STUDY WITH COLLAGE*

This problem suggests one of the most effective approaches to value study. It requires the student to reduce intricate and complicated value areas to three simple values: light, middle, and dark. The use of torn paper eliminates the technical process of shading and permits the student to analyze the value pattern in simple and abstract terms.

A description of the materials is found under Period B.

The instructor will set up at opposite ends of the room a number of still-life studies of simple and well defined objects. He will arrange the sources of light to form extreme dark and light areas on the objects. The problem is for the student to represent with collage the three values he sees in one or more of the still lifes.

Without any preliminary sketching, the student will tear out the larger and most basic value shapes and paste them to the cardboard as nearly as possible in the correct positions and relationships as he sees them. It is usually best for him to establish the larger areas first, though this procedure is arbitrary. All the shapes of one value may be pasted on first, or the shapes may be selected in the order of importance or even convenience. If time permits, corrections can be made by tearing and pasting other torn values over the ones originally selected (Figure 140). In the wash drawing in Figure 148, we see the same simplification and abstraction of value areas but in a different media.

140. *Value Study—Still Life.*
Collage.
Student drawing,
University of Washington.
Courtesy of Louis Hafermehl.

SCHEDULE IV OUTSIDE PROBLEM
EXPERIMENTING WITH INK LINE

The object of this first outside problem is for the student to consider and use line non-objectively. The beauty and purpose of line as a free expression is all important in drawing. It is not accidental that this problem is assigned the week after the one in which the student was introduced to contour line: At times the artist has need for a controlled line which may in one sense be termed functional; at other times he may need a line which is so free that it is no more than an expression and is best described as purposeful rather than functional. It is not intended that the student become so conscious of line that he attempts to identify each line he uses, *but he should realize that in the same composition, lines which functionally describe edges, boundaries, textures, and forms can be used with and complement those which are definitely esthetic expressions.* At times the non-objective line approaches calligraphy, and it is sometimes used to relieve an area already bound with descriptive statements.

This problem is highly experimental. The black ink lines, entirely from imagination, should have no restrictions and can approach or even become shapes. The student is encouraged to use tools and instruments in addition to brushes and pens and to use a variety of papers. Some of the most effective drawings will be spontaneous and will only require seconds. After a large number have been made and spread out, some twelve or more of the best ones may be assembled in a long continuous line, cut into approximately 4″ × 6″ rectangles, and mounted on a long strip of paper 4 inches in width. They are then folded accordion-style. In this way the strip may be opened out in order to study the entire relationship; and it can also be refolded into a neat package which will be convenient to store. The sequence of lines should express continuity (Figure 141). In Figure 142 the instructor has required the student to do a carefully controlled rendering of a section of the ink line experiments.

141. Larry Roberts. *Line Experiments*. India ink.
Student drawing, University of Florida.

142. Gail Sobering. *Rendering of Line Experiment*. Pen and ink.
Student drawing, University of Florida. Courtesy of Robert Skelley.

V

SCHEDULE NO. V

TIME	PERIOD A	PERIOD B	PERIOD C
30 MIN.	Modeled drawings 5 minutes each Conté, crayon	GS drawings 1 minute each Any medium	Brush drawings 1 minute each No. 7 brush and india ink Emphasis on line
30 MIN.	Value sketches 1 minute each One strong source of light Soft conté	Structure drawing 3 minutes each	Brush drawings 1 minute each Emphasis on value
30 MIN.	Value drawings 5 minutes each Conté or 4B pencil	2 Value drawings 12 minutes each Pen and ink (Reed or quill type)	Wash experiments No. 7 brush, india ink and water Experiment with Flat and Graduated Values
30 MIN.	Value drawing 25 minutes each Conté or 2B or 4B pencil	Value drawing 25 minutes Any medium	Critique or 3 minute value sketches

SCHEDULE V PERIOD A MODELED DRAWING

The importance to the student of modeled drawing is in the emphasis given to the study of volume and form. The student will use extra soft conté crayon on newsprint.

Light will be focused on the model from both sides, and there should be no one strong source. The student will use as little line as possible, but he will press the darker values into the paper with the sides of the crayon. Short strokes, lighter at first and darker as the form develops, should be worked from the middle of the forms toward the edges. The edges should be the darkest areas, but they may be well defined or sketchy, as the student chooses. Some students will naturally work more loosely than others. The student can use a more linear approach to this problem if he chooses. A similar approach to this problem is seen in Seurat's *Nude*, Figure 143.

PERIOD A VALUE SKETCHES AND VALUE DRAWINGS

The student's first consideration will be given to tonal statements. Line may be used in the short one-minute poses, and tone can be stated in one value

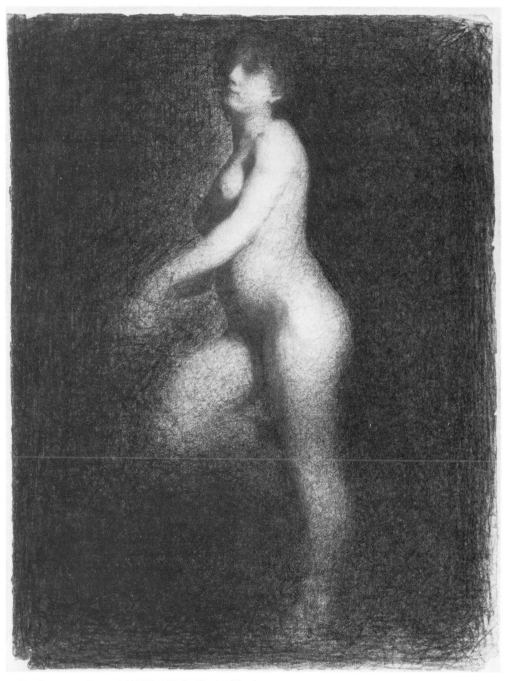

143. Georges Seurat (1859-1891). *Nude*. Black crayon.
Courtauld Institute of Art, London.

with the flat side of the pencil. Because of the time limit, however, the tone may actually be more of a scribble than a carefully designated area. As the poses increase in length the student will give thought and time to relating the shadow to the form. In the longer periods, time will permit the student to carefully designate the shadow areas (Figure 144).

PERIOD C *BRUSH DRAWING*

In the first experience with brush and ink the student will find that his hand becomes somewhat sensitive to the feel of the brush against the paper, and his eye sensitive to line variations. A watercolor brush (size 7), water-

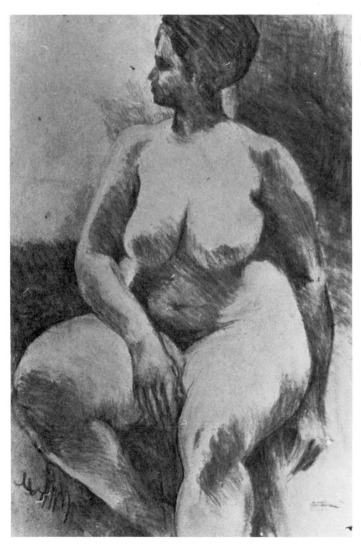

144. *Value drawing.* Charcoal.
Student drawing,
University of Washington.
Courtesy of Louis Hafermehl.

proof india ink, a sufficient number of 18″ × 24″ sheets of manila, and several weights and textures of white drawing paper are the only materials needed.

It is recommended that the student make several pages of brush lines (outside of class) before he attempts to draw from the figure. Even then he should try for brush play rather than representation. He may experiment with brush lines which range from a hairline to a broad blob of ink and create variations by turning and tilting the brush at different angles. With a 2″ or 3″ square of corrugated board held in the free hand, the brush is dipped well into the ink, lightly pulled against the mouth of the bottle, and stroked once or twice against the square board to taper the point and relieve it of any heavy blobs. The ink is then applied to the paper. After the brush comes in contact with several kinds of papers, the student will, after some experimentation, begin to feel the differences in the pull of the brush against various paper surfaces. He will learn that manila paper is somewhat absorbent and registers an intense black statement at first application, but as the brush runs out of ink a grainy stroke will appear and will thus give variety to the line. The tooth of the manila will resist the brush and allow the hand to feel the subtle pressures and movements against the grain. The smoother papers will permit the hand to define more accurate and rapid strokes. Smooth paper is less absorbent than manila, therefore the ink will tend to remain on its surface.

The student will practice line alone the first thirty minutes (drawing from the figure), permitting the brush to ramble freely with little thought for accuracy. The same freedom should be expressed in the one-minute poses of the second half-hour, except that increased stress is placed on value; where the shadows appear the black line will now be resolved into a shape (Figures 22 and 145).

PERIOD C WASH EXPERIMENTS

Through the first exercises in wash the student becomes familiar with it as a medium, with its possibilities and its limitations. Waterproof india ink, paint rags, two large cans of water, a watercolor brush (size 7, of good quality), a mixing tray or watercolor palette, a sponge, and either manila or white drawing paper are the necessary materials. One of the cans of water is for washing brushes, and the other is for clear water. A soft rag will be held in the free hand.

The student will charge the brush with water and apply it quickly to the paper in areas several inches or more in width. While the paper is still very wet, he will paint a full brush stroke of india ink along one edge of the wet area. Making no attempt to blend the ink into the water, he will simply observe the beauty of tone and texture created by the fusion of water and ink. At first this technique will seem accidental and uncontrollable, but it will later prove to be useful and manageable (Figure 101).

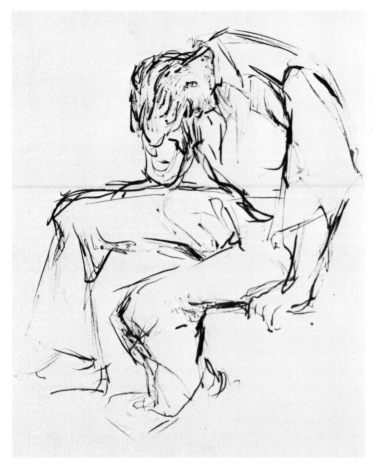

145. Roy Craven, Jr.
Seated Figure.
Brush and ink.
Student drawing,
University of Tennessee
at Chattanooga.

From mixing trays prepared with several values of wash the student will now attempt to model a cylinder from its lightest side (the white of the paper) to its darkest side (the pure black ink). The values next to each other should be painted while wet. On a second cylinder the student will apply the washes from light to dark value and permit each wash to dry thoroughly before the next one is added.

Further experiments can be tried on pieces of scrap paper. The entire brush may be dipped in water, but only the tip in the ink; the brush is then applied lightly and in a perpendicular position to the paper. Turn the brush gradually on its side and push it hard against the paper as the stroke is completed. This should be done with a free and sensitive movement of the fingers and the wrist. The worst mistake a beginner can make is to try to model the wash into perfect tones while it is still wet by working over its surface, or painstakingly to use a dry brush to indicate values. This technique should be unlabored, and the student should make no attempt to rework it, regardless of how uneven it might be. Repeated attempts will eventually result in a more acceptably modeled form.

VI

SCHEDULE NO. VI

TIME	PERIOD A	PERIOD B	PERIOD C
30 MIN.	Structure drawings 2 minutes each	Gesture drawings 1 minute each Brush and ink	GS drawings 2 minutes each Balsa and wash
30 MIN.	Value sketches 3 minutes each Wash areas with brush Lines with crayon, pen or pencil	Wash drawings 5 minutes each Any approach	Structure drawings Balsa and wash 5 minutes each
30 MIN.	Value sketches 3 minutes each Lines with pen, crayon, or pencil. Add wash areas with brush.	Wash drawings 10 to 12 minutes each	Wash drawings 10 to 12 minutes each Brush, pen, balsa, crayon, pencil
30 MIN.	Value drawings 5 minutes each Brush and wash	Wash drawing 25 minutes	Critique or long pose Wash and other media Free period

SCHEDULE VI PERIOD A WASH AND LINE

In the sketches and drawings outlined for period A, *all value statements are to be reduced to abstract, flat areas of wash.* These areas should be spontaneous value patterns, and no attempt should be made to modulate or to show form by gradation of tone. The ink wash and paper are the same as those named in Schedule V, but the student may add several flat red sable or bristle brushes. They may be approximately ½ and 1 inch in width, and should be short (listed as brights) and flat with square tips. Outlines are made with crayon, pencil, or pen. During the first half-hour the student will paint shadow areas with a middle value wash without any preliminary sketches or guidelines. This should be done as one would do calligraphy.

If the student uses the number 7 water color brush, the narrow areas can be made with the point of the brush and the wider areas with its side and by exerting more pressure. When the student uses a flat brush, the edges of the drawing become sharper and more abstract, and the sizes of the value areas can be controlled by turning the brush from its thin edge to its flat and widest edge, with little change of pressure. For small sketches the shadow areas can

be established in a continuous and single stroke, but if the areas are wider than the brush, it will be necessary to fill in the values of the larger ones. When attempting to draw the lines, the student may find that the value areas, put in without guidelines, do not coincide with correct proportions. The lines must therefore be compromised to the values without worrying about the figure being out of proportion or the values extending over a light area. The line is used to enhance the value areas and for making only minor corrections (Figures 146 and 147).

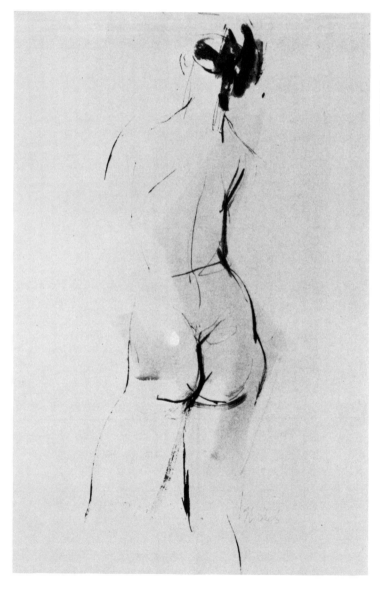

146. Bradley Nickels.
Back View of Figure.
Brush and wash.
Student drawing,
University of Florida.

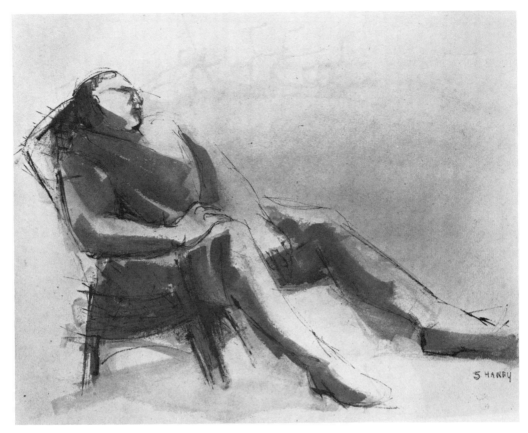

147. Suzanne Haney. *Reclining Figure*. Wash and ink. Student drawing, University of Florida.

During the next half hour the lines of the poses are sketched quickly with pen, pencil, or crayon, and the value areas are painted in accurately if possible, but with the same free and spontaneous approach as in the preceding problem. In Figure 99 Boucher has painted in the value areas after sketching the figures in pen and ink over black chalk.

In the last half hour the length of the poses are increased to five minutes and brush lines are substituted for the pen, pencil, and crayon. The brush is used for line and values without considering whether the *value* or *line* is applied first (Figure 105).

PERIOD B *WASH DRAWINGS AND THE LONGER POSE*

The longer pose in this period allows the student time to improve his control in the handling of wash. Large full-page drawings with preliminary light gray wash or light charcoal lines can be used for placement and basic proportions, and the final wash statements can be put in deliberately and carefully. The earlier emphasis on simplicity and spontaneity should guarantee the student a degree of freshness even with this added control (Figure 148).

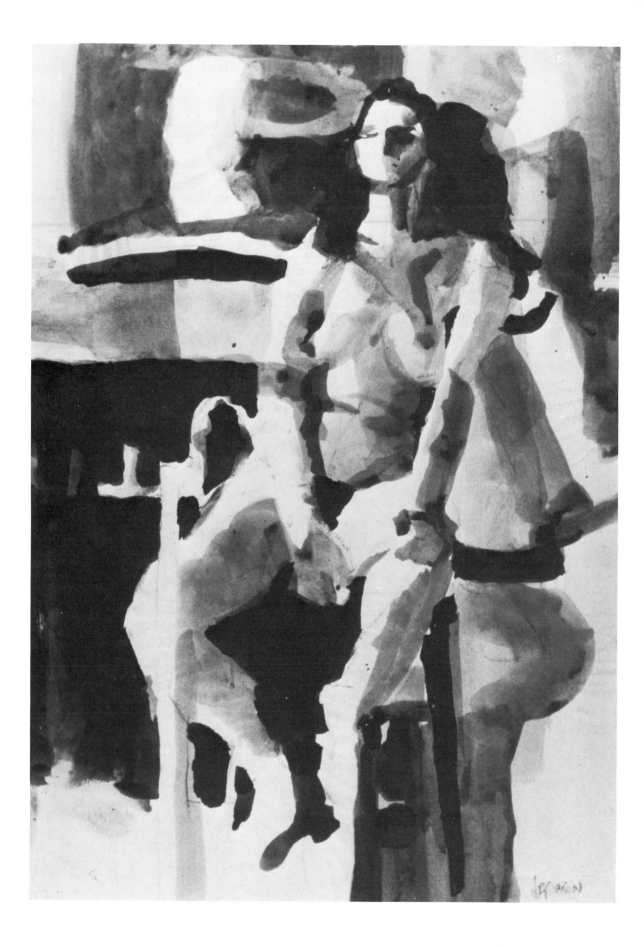

PERIOD C BALSA AND WASH

The use of balsa for drawing with ink or wash solutions is an excellent means of increasing one's sensitivity to line, texture, and value combinations.

A piece of ¼-inch square balsa can be found in any hobby shop and most art supply stores. The stick may be cut into 4- or 5-inch sections with a sharp mat knife or razor blade, making sure that they are cut at right angles.

The student should hold the balsa underneath his hand and wrist, and loosely between the thumb and four fingers. Unlike the method of holding a pencil for writing, this technique permits the student to see on both sides of a drawing and even lets him turn the wrist from a prone to a supine position. One end is dipped into the ink and wiped lightly on scrap paper; a corner or edge of the stick is then used for drawing. The student will first pull the stick lightly across or down the paper to produce a hairline and then increase the pressure or gradually turn it between the fingers so that the line becomes bolder or fuzzier as the balsa runs out of ink. By turning the stick to one of the flat sides and pushing it to a position more nearly parallel to the paper, the student can create a gradated tonal area. At first india ink is tried; later several shades of wash solutions employing the same stick drawing techniques are used (Figures 149, 150 and 151).

Balsa sticks are excellent instruments for applying ink lines over wash areas.

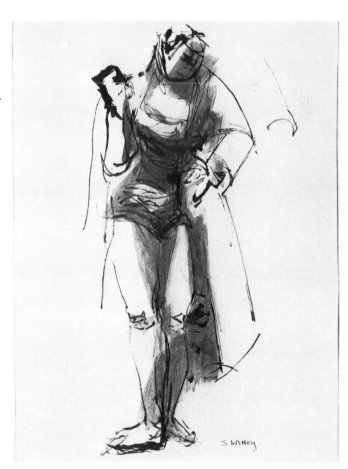

opposite:
148. *Value Study of Seated Figure.*
Brush and wash. Student drawing,
University of Washington.
Courtesy of Louis Hafermehl.

right: 149. Suzanne Haney.
Standing Figure.
Balsa, brush, and ink wash.
Student drawing,
University of Florida.

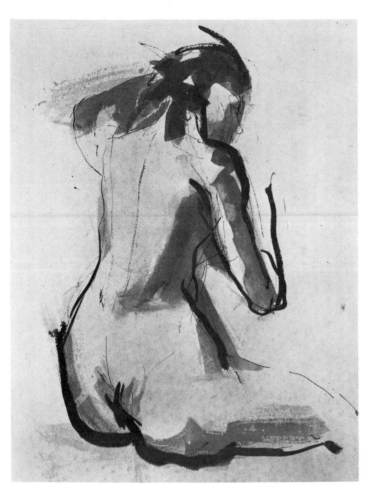

150. *Seated Figure.*
Balsa, brush, and ink wash.
Student drawing,
University of Florida.

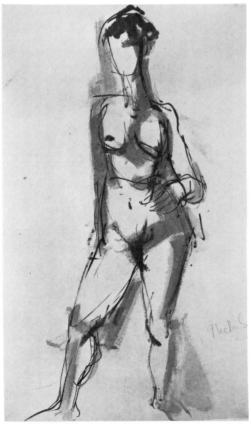

151. Bradley Nickels.
Standing Figure.
Balsa, brush, and ink wash.
Student drawing,
University of Florida.

VII

TIME	PERIOD A	PERIOD B	PERIOD C
30 MIN.	5 GS drawings 1 minute each 3 Contour drawings 5 minutes each	Pencil sketches 2 minutes each	Structure drawings 5 minutes each Any medium
30 MIN.	1 Long study, built contour Pencil 4H to 2B and white drawing paper °	Selected detail drawings Pencil, 4H to 2B 2 Poses of approx. 40 minutes each	Free period drawings 8 minutes each Any medium or approach
30 MIN.			Free period drawings 12 minutes each
30 MIN.	↓	↓	Critique or long pose Approx. 20 minutes Free period

° Outside problem: Built contour (modeled) drawing of plant. On a sheet of best grade drawing paper or board (no larger than 10″ × 12″), using 4H and 2H pencil, make a linear drawing from a plant.

SCHEDULE VII PERIOD A BUILT CONTOUR

The problem of the built contour will reappear in the coming assignments to emphasize the importance in drawing of the reinforced line. This line is often called the modeled line; however, the word *built* best describes the approach to the problem that I present here. The built contour is not the continuous contour which delineates the edge of a form by turning the charcoal or other medium from its sharp edge to its side. It is not a moving and continuous line of a single stroke, but one which grows out of many small strokes knitted together. It is incomparable to any other method of delineation.

For materials the student will use only white paper and pencils of various types; graphite, carbon, conté, compressed charcoal, or any other which can be sharpened to a very fine and strong point. Graphite pencils (numbers 2H to 2B) perform best on a good grade of drawing paper or illustration board. If the pencil is very hard, the necessary repetition of strokes may break through the paper, and if the pencil is extremely soft the heavy black graphite will collect and produce a clumsy line instead of a carefully built statement.

The student will sketch the figure on the paper with an H or 2H pencil, very lightly; he can then build the value areas, beginning with a high key and gradually developing the contour by means of light and dark.

Short, carefully applied strokes will produce a large variety of lines, ranging from the hard, sharp, and black hairline to the lazy soft-valued line. The latter may almost become a shadow area at times, and then again, remain so light that it blends with the value of the paper.

The best way to explain the variety of approaches to the built contour is through references to drawings by artists who have mastered it (Figures 11, 17 and 37). Also see student drawings, Figures 47 and 152.

152. *Leaning Figure*. Conté crayon. Student drawing, University of Florida. Courtesy of Hollis Holbrook.

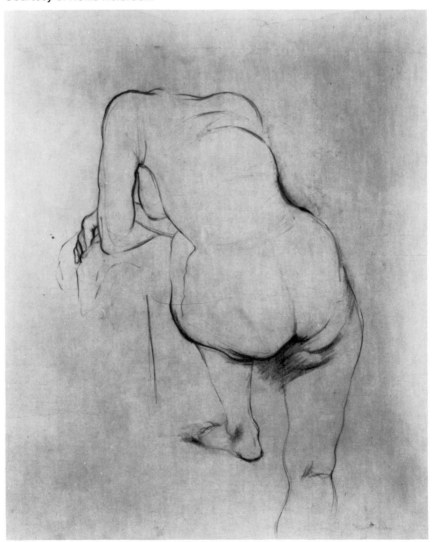

PERIOD B *SELECTED DETAIL*

The selected detail drawing will serve two purposes: It will give the student an opportunity to choose a section of the figure for intensive study and analysis; it will also prevent him from isolating structurally, the carefully studied area from the entire pose.

The student will draw the entire pose lightly and quickly. As he develops the figure, he will give attention especially to one specific part of the pose. This part can be a hand, a foot, an arm, a section of the torso, a leg, the neck, the head, or even a pocket of shadow formed by the crossed hands on the lap. A few art students early become proficient in drawing hands, feet, or other isolated parts of the human body. But these students must take care that when they draw the whole figure, the parts do not appear separated from the figure.

The selected detail should be worked in the same manner of the built contour, except that the shadow areas within the contour should be given the same careful modulation as the contour itself (Figure 15).

SCHEDULE VII *OUTSIDE PROBLEM* *BUILT CONTOUR*

Using the same pencils as in the two preceding problems and a high-quality drawing paper or illustration board, the student will draw a plant, a section of a limb, or a similar object. The object should be sketched lightly, and then the contour carefully built by reinforcing and modeling the line. This drawing requires a deliberate and exacting approach. Success depends on the student's keen observation and on a great deal of discipline, as do all built contour drawings (Figure 153).

153. Marshall New. *Built Contour*. Graphite.
Student drawing, University of Florida.

VIII

TIME	PERIOD A	PERIOD B	PERIOD C
30 MIN.	Figure in movement 5 poses 4 minutes each Moving from one side to other Back view	GS drawings 1 minute each Any medium	Overlapping figures 6 or 7 minute poses On 12″ × 18″ or 18″ × 24″ manila or white drawing paper Space and overlap figures horizontally on page
30 MIN.	Figure in movement 4 minutes each Same as above Front view	Structure drawing 5 minutes each	
30 MIN.	Drawings from memory 1 minute poses Look 1 minute and draw 2 minutes	Selected detail 25 minutes	
30 MIN.	Reverse drawing 2 minute poses Pose model facing side of room Draw reverse	Free period	Either near end of period or over the weekend, convert into design problem by introducing value in negative and overlapping areas

SCHEDULE VIII *PERIOD A* *FIGURE IN MOVEMENT*

In this problem the student will draw several poses showing movement through space. The model will stand with the feet well separated and stationary, the arms away from the body and, reaching up or out, the model will make swinging movements of the torso extending from extreme right to left and back several times. The poses can be back or front views, but the tortion of the waist is more easily seen from the back and the student will be less tempted to draw details of the head. The preliminary movements of the model take only seconds, and the idea here is for the student to look at the movements not draw them. The model will then take in turn five poses of four or five minutes each, showing positions in the successive paths of the movement (Figure 154). By drawing over or through the other drawings, the student should be able to give them all equal importance. Too much detail will weaken the lines of movement, and too much shading will place excessive emphasis on certain areas. Either of these will defeat the purpose of the drawing, which is to show with line the path of the model's movement.

In Figure 23, the student has expressed the movement of the horse's head and also other parts of the body. Figures 48 and 93 are also variations of this problem.

154. Bradley Nickels.
Figures in Movement. Crayon.
Student drawing,
University of Florida.

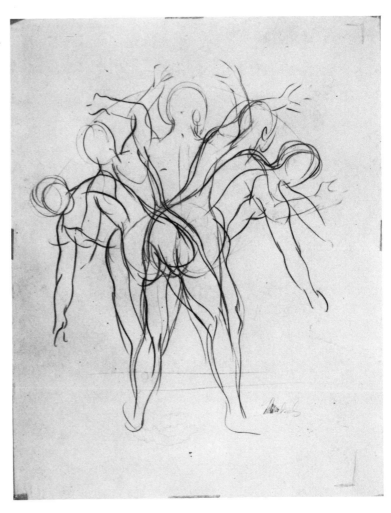

PERIOD A *DRAWINGS FROM MEMORY*

Memory drawings are excellent for improving both observation and retention. The model will pose for one minute while the student carefully studies the pose. Then the model rests and the student makes from memory a two-minute drawing of the pose. The objective is not to determine the *general* attitude of the pose, but to make from memory an accurate recording of the *exact* pose: the space between the legs; the position of an outstretched arm in

relation to the head, both vertically and horizontally; the foreshortening of the body or limbs; the closest point to the student's position; and many other important facts about the pose. After the student observes one minute and draws two minutes, the order is reversed; the student observes two minutes and draws one minute. No matter how simple the pose, concentration on it for a period of time is necessary to observe the figure structurally, and to prevent the eyes from racing aimlessly around the figure's outlines.

PERIOD A REVERSE DRAWING

Reverse drawing, like the previous exercise, is dependent upon keen observation. It requires the student to look at the pose and understand its structural characteristics well enough to be able to draw it in reverse. The model should face a side direction. The poses are for three minutes. The student draws while observing the model—its correct position but reverses the direction it is facing in the actual pose.

PERIOD C OVERLAPPING FIGURES

The problem is similar to the movement problem assigned in Period A, the important difference being that this one involves composition and therefore requires a more creative approach by the student. Other differences include the use of values, and poses showing various positions of the feet instead of the earlier stationary position.

Conté, compressed charcoal, soft pencil, wash, or almost any graphic medium may be used, but since there are a number of new aspects to the problem it is advisable to use a familiar medium. Manila paper or white drawing paper should be used horizontally.

The model should assume an interesting variety of front, back, and side poses. The student will place the first figure arbitrarily on his page. Each succeeding one must be placed in relation to the existing figure or figures, but here there is a choice: He may overlap them or he may space them, whichever way he thinks forms the most interesting patterns. If the figures are separated by space, the student must work carefully with the negative areas. If one position lacks interest, the next pose will furnish new possibilities for changing the shapes and spaces. A figure not related to those already on the page may be drawn in a vacant area of the paper and then later be related to the composition by introducing still other figures. But the student must understand that simply to overlap each existing figure until the page is filled is not the most creative approach.

After the student has drawn a page of figures with overlapping and interlacing lines, he will create value areas of grays within those shapes and within the negative areas. These value areas, too, are arbitrary, and the student's only task is to select and distribute the values in an interesting way, thinking not

only of the beauty of the individual shape but also of the relationships to the other grayed areas in the composition.

Additional time outside of class will probably be needed for the completion of this problem. (Figures 94 and 155).

Some students may express a desire to continue the problem with less regard for the restrictions originally outlined. Figures 156 and 157 are the results of such explorations.

155. Henry Aguet. *Overlapping Figures*. Conté crayon.
Student drawing, University of Florida.

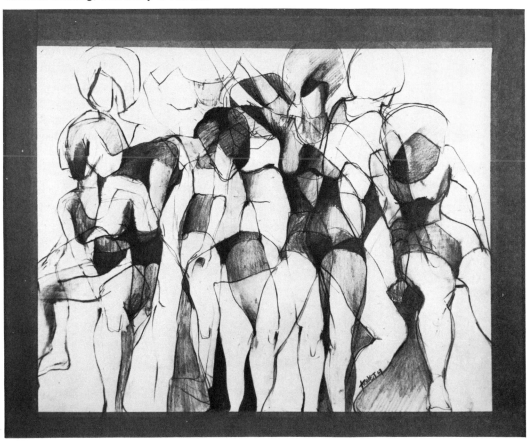

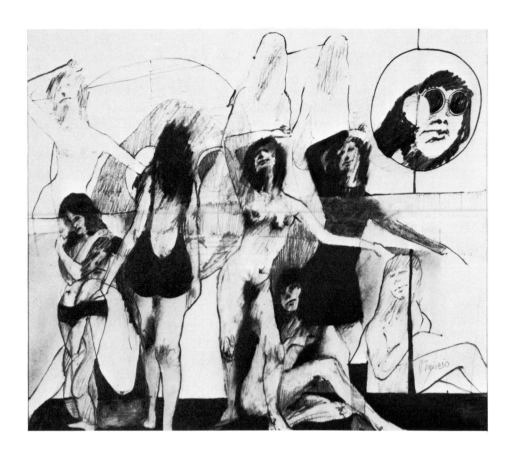

156. *Overlapping Figures—Variation*.
Black pencil.
Student drawing,
University of Florida.

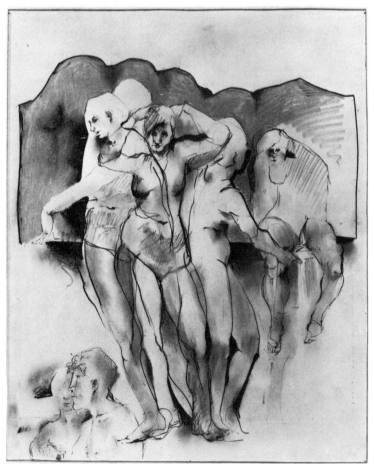

157. Mary Anne Baker.
Overlapping Figures—Variation.
Graphite. Student drawing,
University of Florida.

IX

TIME	PERIOD A	PERIOD B	PERIOD C
30 MIN.	GS drawings 1 min. each Any medium	Moving poses Model to move around and not hold any one pose	Structure drawings 5 minutes each
30 MIN.	Selected detail 25 minutes	12 minute poses Free period	Built contour Large paper, and fill space
30 MIN.	Built contour Select detail if time does not permit drawing entire area Pencils on white drawing paper	1 Reclining pose Free period	
30 MIN.		1 Reclining pose Same pose, change position Free period	Long pose or critique °

° Outside problem: Select one of the poses of Period B, and do same drawing in 10 different media (including mixed media).

SCHEDULE IX PERIOD B MOVING POSES

In this problem the model will move continually into new positions. Watching the model's movements, the student selects and mentally records an image of a particular pose and quickly transfers the image to the paper. It is best for the student after his quick selection, not to refer again to the model until the selected attitude has been drawn. Seeing the model in a different pose will likely confuse and complicate the image the student wants to record. Unlike the drawings made during longer periods of observation, these images should be flash sketches (Figure 158).

PERIOD B RECLINING POSES

The drawing of reclining poses will emphasize the need of perspective and will permit the student to study carefully the principle of foreshortening. The model will pose in as many direct "head-first" and "feet-first" attitudes as possible. Accurate drawings of the overlapping and foreshortened parts of

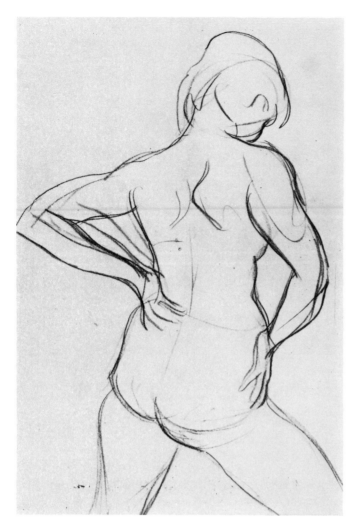

158. *Quick Sketch from Memory.* Crayon. Student drawing, University of Florida.

the body will at first seem awkward and inaccurate, but accuracy is the necessary aim of the student. The careful checking of points and lines in the figure's structure will result in the student's achieving the correct proportions and thus drawing the right perspective.

SCHEDULE IX OUTSIDE PROBLEM: VARIED MEDIA

The student is here encouraged to study the possibilities presented by the use of various media. He will draw the figure several times in the same pose, and will use a different medium in each drawing. The student's thought will thus be directed to experimentation with materials and media rather than with drawing procedures (proportions, spacing, etc.). The following combinations of media are recommended: reed pen and ink with gouache or tempera, wash and chalk, charcoal and crayon, ink and pencil, and others. Appropriate paper will be used to suit each medium. When the several drawings are spread out for comparison, the student will notice the distinct differences created by dif-

ferent materials. If some materials appear to be less skillfully handled than others, the student must determine whether the problem is a lack of skill or the use of an inappropriate medium.

 X

SCHEDULE NO. X

TIME	PERIOD A	PERIOD B	PERIOD C
30 MIN.	Discussion—Critique of drawings done over weekend in varied media	GS drawings 1 minute each Any medium	Sketches 1 minute each Pen or balsa and ink
30 MIN.	Structure drawings 3 minutes each Any medium or approach	Selected detail 25 minutes	Value drawings 5 minutes each Wash and watercolor, using 1 or 2 Colors
30 MIN.	Value studies 12 minutes each Any medium	Built contour Fill large page Lines running off edges if necessary	
30 MIN.			

SCHEDULE X *PERIOD C* *WASH AND WATERCOLOR*

This assignment provides an experience with transparent watercolor. The colors are limited to two: Burnt sienna and Paine's gray. The student will put the emphasis on spontaneity and color effects and not on accuracy. At the beginning of the period he will make several sketches using only one of the two colors in each sketch. The color will be put on the paper as ink wash was applied in Schedule VI.

For the last half hour of the period the two colors are used together, the burnt sienna in the lighter and warmer areas and the Paine's gray in the darker and cooler ones. A rich dark can be obtained by mixing the two colors for extreme shadows and lines. Underneath planes will vary in warmth and coolness; however, the cool shadows should be mostly gray, while the top and lighter planes require a considerable amount of the sienna.

SCHEDULE NO. XI

TIME	PERIOD A	PERIOD B	PERIOD C
30 MIN.	Structure drawings 5 minutes each Any medium	GS drawings 1 minute each Head, different angles	Structure drawings 5 minutes each Head and neck, suggest upper torso
30 MIN.	Cross contour Reclining pose Pen and ink	Value drawings 5 minutes each Head Pencil	Structure drawings 5 minutes each Head looking to one side, drawing in reverse
30 MIN.		Structure drawing 25 minutes Head below eye level Value study Charcoal pencil, pencil or conté	Head study Strong light and shadow placement, conté or compressed charcoal
30 MIN.	Structure drawings 5 minutes each Head only	Structure drawing 25 minutes Head above eye level	°

° Outside problem: Make drawings in sketchbook of parts of skeleton. Draw from skeleton, or anatomy book.

SCHEDULE XI PERIOD B HEAD DRAWING

In this assignment the student will focus his attention on understanding the important structural elements which characterize the study of head drawing. All heads should not be drawn as egg shaped or as though fitted within a cube. Admittedly, some heads do more nearly conform to curvilinear shapes and others to angular ones, but every head has its own important structure points. If these points are understood by the student, every head he draws will have individuality as well as solidity.

The basic structure points of the head are a pair of points on the frontal bone (forehead), points on the malar bones (cheek), points on the inferior maxillary bones (chin). Of equal importance is the occipital bone (base of skull) and the pit of the neck. The less basic structure points such as the eye sockets, nasal bone, nostrils, mouth, and ears, are more easily located in relation to the basic points. They form a kite shape which varies in its proportions as head structures vary. The widest spaces are between the cheek bones, the next

widest are between the points of the forehead, and the narrowest between the points of the chin (Figure 159a). These points as well as the base of the skull and the pit of the neck need not be suggested mechanically by heavy black pencil or charcoal, but may be indicated by a slight smudge of charcoal or light pencil stroke to mark the approximate position. Actually, the student may wish to give more form and emphasis to the top of an eye socket or the hairline, even though these are drawn after the first points are located.

Relating the neck to the head is of utmost importance; the pull of the sterno-mastoid muscle from the pit of the neck to its attachment behind the ear can say as much about the attitude of the head as the features themselves. In the two structure drawings of the head below and above eye level (Figures 159b and 159c), the curved lines of eyes, nose, mouth, chin, and hairline should be noted and lightly indicated. In Figure 160, the student, while drawing several members of the class during rest periods, has indicated his knowledge of the structures without the mechanical analysis shown in Figure 159a. In Figure 161 the student has used a more creative approach to head drawing.

PERIOD C HEAD STUDY (DRAWING IN REVERSE)

The profile views of the head are to be drawn in reverse; that is, if the head is faced left, the student draws it faced right and vice versa, thus placing emphasis on structure instead of likeness.

159. *Structure Points on Head.*
Pencil. Student drawing.

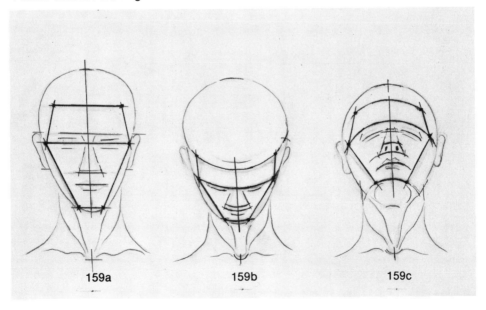

159a 159b 159c

160. *Members of Class—
Structure Points*. Charcoal.
Student drawing,
School of the Art Institute of Chicago.

161. *Heads*. Pen and ink.
Student drawing,
University of Florida.
Courtesy of Hollis Holbrook.

XII

SCHEDULE NO. XII

TIME	PERIOD A	PERIOD B	PERIOD C
30 MIN.	Short poses 1 minute each Any medium	Contour drawing 25 minutes 12″ × 18″ white paper Have drawing fill page	Structure drawings 5 minutes each
30 MIN.	Short poses 5 minutes each Any medium	Contour drawing 25 minutes Exactly same pose as above	Bone compositions During remainder of period make 1 or 2 compositions using bone structure in imaginative way
30 MIN.	2 poses 12 minutes each Any medium	Skeleton drawing 25 minutes Same pose and size as above	
30 MIN.	1 pose 25 minutes Free period Any medium	Skeleton inside contour Draw skeleton inside of one of first hour contour drawings °	Critique if necessary °°

° Complete outside of class. Skeleton should be drawn correct in relation to contour.
°° Study and make sketches of the muscles of front and back views of body.

SCHEDULE XII PERIOD B
CONTOUR DRAWING AND SKELETON

The model will take a single pose for the specified period. It will be a seated pose at the extreme end of the room so that all the students may have a view in profile. During the first hour the student will make a contour drawing with a black pencil.

Then on the same sheet of paper a skeleton will be drawn in an identical seated position. (Anatomical charts will be needed here for reference.) The skeleton will be drawn with red pencil inside of the contour drawing of the live model, showing the bones' exact positions within the fleshly contour of the figure.

This short period will probably not afford enough time for the student to carefully draw and locate the skeleton in its correct relationship to the contour, but the drawing can later be completed out of class, always with the aid of anatomical charts.

After the student has for several days accurately drawn the bone struc-
tures from charts, he will make from memory drawings in which he will relate
the bones and parts of bones to the whole composition. Here he will have
freedom to distort the shapes of the bones or to introduce new shapes and
forms which they might suggest to his imagination. He will introduce contrast-
ing values into his drawings by shading or modeling the shapes and the spaces
between them as he attempts to make the composition more interesting (Fig-
ure 162).

A study of anatomy is required in preparation for Schedule XIII, *Anatom-
ical Drawings*. Sketches from books and charts are suggested.

162. Bill Schaaf. *Bone Structure Composition*.
Pencil. Student drawing, University of Florida.

SCHEDULE NO. XIII

TIME	PERIOD A	PERIOD B	PERIOD C
30 MIN.	Anatomical drawing Entire period Front view of male model Weight on left foot, hand on right hip	Anatomical drawing Entire period Male model Same as period A except draw back view	Value drawings 12 minutes each Emphasis on anatomy Standing poses
30 MIN.	Fill in muscles with red pencil or red or brown conté pencils		Side, front, back, and some torsion
30 MIN.			
30 MIN.			

SCHEDULE XIII PERIODS A, B ANATOMICAL DRAWINGS

This will be a two-day assignment. The student will draw the front and back views of the model and in his drawing he will emphasize the surface muscles and the bone structures. He will work on an 18″ × 24″ sheet of manila or white drawing paper, the figure filling the page but not bleeding off. Drawing the muscles without the help of anatomy charts or books, he will indicate the tendons, origins, and insertions either in heavier lines or in lines of a different color. Some students may prefer to draw the contour of the figure in soft pencil, the muscles in red or brown conté crayon and the tendons, origins and insertions in pen and ink. Any combination of media will be all right. But the student should make a real effort to draw the muscles as they would look if the skin had been removed from the model's body. When the two-day assignment is finished, the student may use anatomy charts to check his drawings for errors (Figure 163).

PERIOD C *VALUE DRAWINGS (Emphasis on Anatomy)*

The student will make twelve-minute drawings of a standing model suggesting, through shading, the superficial muscles and bones which he will observe on the surface of the model's body. For these exercises it is best to have a well developed male model and to pose him under controlled, artificial lighting (Figure 164). In Michelangelo's *Studies for the Libyan Sibyl* (Figure 165) shadow has been used to describe the pattern of the muscle structure on the surface of the body.

opposite: 163. *Anatomical Study of Muscles.*
Red pencil and graphite.
Student drawing.

164. Ray Bradley.
Surface Muscles. Charcoal.
Student drawing,
University of Tennessee
at Chattanooga.

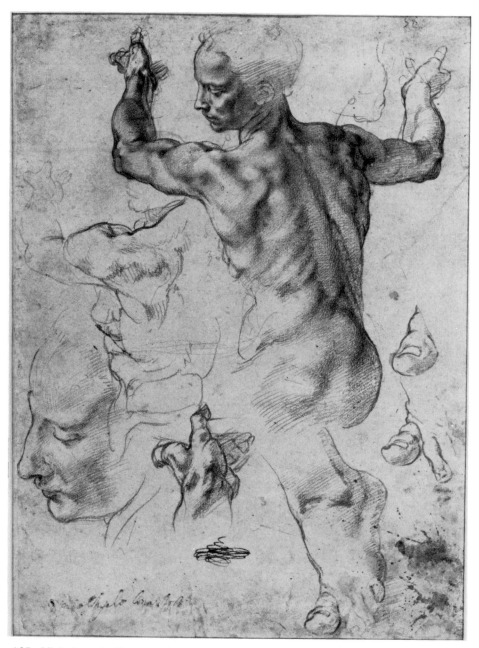

165. Michelangelo Buonarroti (1475-1564). *Studies for the Libyan Sibyl.*
Red chalk. The Metropolitan Museum of Art, New York.
Purchase, 1924, Joseph Pulitzer Bequest.

SCHEDULE NO. XIV

TIME	PERIOD A	PERIOD B	PERIOD C
30 MIN.	Sketches 1 minute each	Environmental drawing 1 hour Use conté, vine, or compressed charcoal	Perspective drawing Entire period 12″ × 18″ white drawing paper 18″ ruler Plastic right angle 2H, H, HB and 2B drawing pencils
30 MIN.	Balsa and wash drawings 5 minutes each		
30 MIN.		Environmental drawing 1 hour Same as above	
30 MIN.	Wash drawings 12 minutes each		

SCHEDULE XIV PERIOD B ENVIRONMENTAL DRAWING

The student is to relate the figure to its actual environment, giving attention to the model's position in the room, to the lighting of the pose, and to any objects or shapes which may fall within the picture plane. The picture plane may fill the entire sheet of paper, and the size of the figure within the plane will determine how much of the surrounding area will be included in the drawing. If the model is posed on a stand in the center of the room in a well illuminated area of diffused light, the drawing will indicate this position and the environment; if the model is posed in a dark corner of the room with only one source of direct light and with deep dark shadows in contrast to the strong light areas, the drawing will present this setting. The student will remember that the values and structural drawing of both the background and the foreground must be as accurate as those of the figure itself. This problem stresses the importance of drawing the figure in the exact space and surroundings in which it exists. The composition is not emphasized, but the tonal key and the mood of the drawing are important (Figures 30 and 110).

An interesting extension of this problem is to put the model in a similar pose but to place him in two contrasting environments. To do this, a temporary partition can be set up at one end of the room, extending from the floor to the ceiling; one side of the partition may be flooded with light and the other left in shadow. The separation will offer both low- and high-key environments in which the model will be drawn. The student will more easily see the value relationships if he does both drawings on the same page, letting the edge of the partition divide the two.

PERIOD C *PERSPECTIVE (LINEAR)*

This problem introduces the student to *one-point* and *two-point* perspective.

The materials include a sheet of 12″ × 18″ white drawing paper; 2H, H, HB, and 2B drawing pencils; an 18″ ruler and a plastic right angle.

166. *Perspective.*

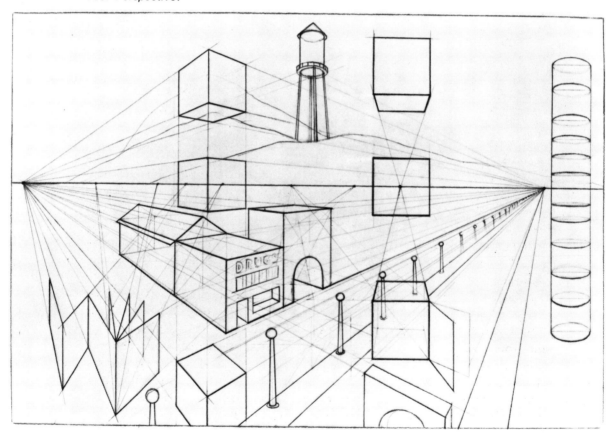

The student will draw numerous cubes and three dimensional rectangles on a single sheet of paper, placed both parallel and oblique to the *horizon line* and both above and below the horizon. The *picture plane* can be the entire sheet, or a narrow margin can be indicated 1/2″ or 1/4″ from its edges.

With a 2B or HB pencil a horizon line should be drawn somewhere near the center and parallel with the upper and lower edges of the picture plane. Two *vanishing points* are established on the horizon, either outside the picture plane or just inside the two vertical edges. These two points will serve those objects which are drawn in an oblique or angular position to the horizon (two-point perspective). Somewhere between these two vanishing points another point is established for those objects drawn parallel with the horizon and the top and bottom edges of the picture plane (one-point perspective). The page is then filled with volumetric square and rectangular shapes drawn above and below the horizon (Figure 166).

XV

SCHEDULE NO. XV

TIME	PERIOD A	PERIOD B	PERIOD C
30 MIN.	GS drawings 1 minute each	Sketches 1 minute each	Free periods 25 minute poses
30 MIN.	Sketches 5 minutes each Pen and ink and wash	Related Drawing 1-1/2 hour pose Use entire page for picture plane and relate figure to art forms within	
30 MIN.	Sketches 3 minutes each Balsa and ink and wash		
30 MIN.	Wash drawings 12 minutes each		Critique if needed

SCHEDULE XV PERIOD B RELATED DRAWING

In related drawing the student will put his major emphasis upon relationships between the parts of the whole composition. The pose of the model will

determine the other shapes and spaces to be included in the picture plane, but the student must remember that all shapes and spaces in the drawing are equally important whether they are a part of the figure or of its surrounding. The figure will initiate the drawing, but it may be taken only as a point of departure. It may lose or retain its own descriptive character, thus becoming subordinate or dominant to the other shapes and spaces in the composition. The student must put his emphasis on creativity, and the product he produces is the all-important objective. He may draw any distortions or inaccuracies of form, shape, line, value, or space he wishes, but these distortions must not conceal poor drawing. They are drawn to create interesting and meaningful relationships between the shapes of the figure and the spaces between them. More creative directions will occur to the student if he is amenable to the abstract or semi-abstract approach as opposed to strict realism.

It is in doing the related drawing—the relation of one part of a composition to another part—that the student will understand the importance of negative as well as positive shapes. As he becomes more inventive, he will be able to experiment freely in the interchange of space and shape relationships (Figures 90 and 167).

167. Katherine Schooley.
Seated Figure and Environment.
Conté crayon.
Student drawing,
University of Florida.

XVI

SCHEDULE NO. XVI

TIME	PERIOD A	PERIOD B	PERIOD C
30 MIN.	Structure sketches 1 minute each Head, neck, and shoulders Brush and ink	Structure drawings 5 minutes each	Contour drawings 12 minutes each Pen and ink
30 MIN.	Wash drawings 5 minutes each Head, neck, and shoulders	Composition Multiple image 1-1/2 hours Many drawings of same pose arranged within picture plane	Environmental drawing 1-1/2 hours Any medium
30 MIN.	Mixed media drawing 1 hour Head Wash and other media	Sizes and values can vary	
30 MIN.			Critique if necessary

SCHEDULE XVI PERIOD B MULTIPLE IMAGE

The approach here is quite different from the preceding one, but this assignment also emphasizes shape and space relationships. A single pose will be drawn repeatedly within the one picture plane. The student will create interest by drawing variations in the placement of the figure, in scale, values, textures, and techniques. His effort will be to produce an interesting space concept by delineating the movement of the figure forward and backward in the picture plane as well as up and down and across the paper's surface. At his disposal will be such methods as overlapping, drawing only isolated portions of the figure, obscuring or losing sections of the figure in shadow or light areas, contradictory perspective, and any other means his imagination may devise. Figure 156 is a variation of this problem; instead of one pose several have been used.

XVII

TIME	PERIOD A	PERIOD B	PERIOD C
30 MIN.	Calligraphic drawings 1 minute each Brush and ink	Gesture drawings 20 to 30 seconds each	Value sketches 5 minutes each Diagonal technique Pencil
30 MIN.	Water color drawings 12 minutes each	Contour drawings 12 minutes each	Value studies 12 minutes each Diagonal technique Pencil and charcoal
30 MIN.		Selected detail 1 hour	Selected detail Value study 1 hour Diagonal technique Charcoal pencil or vine charcoal
30 MIN.	Water color sketches 5 minutes each		°

° Outside problem: Composition using diagonal technique for figures or parts of figures (other forms or structures can be included if needed). Use vine charcoal on charcoal paper.

SCHEDULE XVII OUTSIDE PROBLEM—DIAGONAL TECHNIQUE

The major emphasis in this problem will be put on the control of a single technique. By using only short diagonal strokes, the student will express edge, line, form, value, shape, and space. Contour lines and rubbed tones are not to be used at all.

The materials are an 18″ × 24″ sheet of charcoal paper and a stick of vine charcoal. The subject may be any number of figures placed in appropriate surroundings. The student sharpens the charcoal stick to a wedge-shaped point an inch or more in length. He draws his composition solely with short diagonal strokes, and must take care that the size of the stroke is guarded. It must be long enough to give rhythm to the stroke, but short enough to sharpen the edges of the shapes and spaces when desired. The technique is thus really a building process, and the tonal areas must be gradually worked from light to dark. Sensitive and flickering strokes should be used for the dark areas as well as for the light, but the former will require more applications of the charcoal to give the desired tonality.

The problem has disciplinary value in that it requires a skillful, light-handed application of the medium. It is an academic approach to a technique which rules out linear statements and forbids an unrestricted use of value technique (Figures 75 and 168).

In further explorations of the problem the student need not limit himself to charcoal. Such a drawing can also be effective when made with pen and ink, or with pencil, or with other graphic media (Figure 169), and variations can be created by using horizontal or vertical strokes which can be as effective as the diagonal (Figures 170 and 171).

168. Sally Curtis. *Diagonal Technique.* Charcoal.
Student drawing, University of Florida.

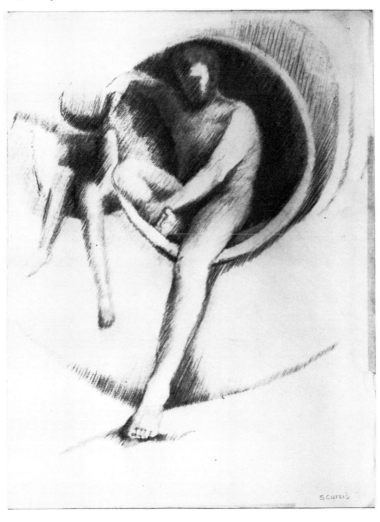

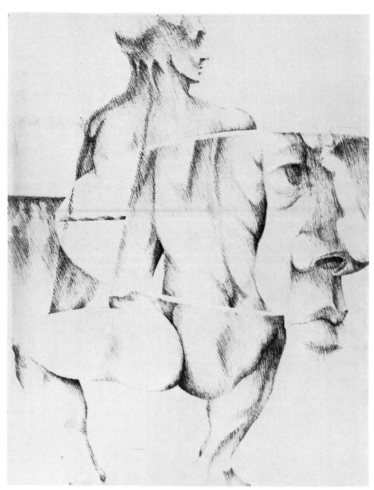

169. William Shirley.
Diagonal Technique.
Pen and ink.
Student drawing,
University of Florida.

170. Paige Pinnell.
Vertical Technique and Collage.
Pencil and collage.
Student drawing,
University of Florida.

171. Pierre Auguste Renoir (1841-1919). *L'Assommoir.*
Pen and ink. Courtesy of the owner.

XVIII

SCHEDULE NO. XVIII

TIME	PERIOD A	PERIOD B	PERIOD C
30 MIN.	Gesture drawings 20 seconds each	GS drawings 1 minute each	Long pose 2 hours Standing pose Modulated tones Vine charcoal, white charcoal paper
30 MIN.	Short poses 5 minutes each	Structure drawings 5 minutes each	
30 MIN.	Chalk drawings 5 minutes each	Related drawings 12 minutes each Figure related to other art forms in picture plane	
30 MIN.	Chalk drawings 12 minutes each		Critique if necessary

SCHEDULE XVIII (no instructions necessary).

SCHEDULE NO. XIX

TIME	PERIOD A	PERIOD B	PERIOD C
30 MIN.	Structure drawings 5 minutes each	Structure drawings 5 minutes each Poster paint: black, white and grays on colored poster paper Stiff brush	Contour drawings 12 minutes each
30 MIN.	Environmental drawings 12 minutes each Chalk and charcoal on gray paper	Value studies 12 minutes each Poster paint	Built contour
30 MIN.	Environmental drawing 25 minutes each Any medium	Environmental drawing 1 hour Black, white and grays One warm and one cool color Brush, poster paint on chip board	
30 MIN.	Free period		°

° Outside problem: Draw figure and interior, building contour of figure with related objects and areas. Assorted pencils and white drawing paper.

SCHEDULE XIX PERIOD B OPAQUE MEDIA

Here the student will work with a brush and opaque water paint. Such work will enable him to give his drawing a plastic quality and will permit him to make corrections in his drawings that were not possible with the transparent water media.

The materials should include several flat stiff bristle brushes (¼″ to 1″ in width), 12″ × 18″ sheets of black, white, gray, and some colored construction paper, a mixing tray, a water pail, paint rags, and poster paint. The poster paint is sometimes called tempera, and for this assignment the student will bring his tempera in black, white, and several warm and cool colors.

It may be necessary to dilute the paint in order to better control it, but the tempera must be sufficiently thick to obscure the value of the ground. The student will blend his tones on the paper while the paint is wet, and he can then modulate his values from light to dark on a dark ground, or from dark to light on a light ground. He can also apply the tempera in flat areas of value.

The edges of these areas will be crisp and abstract if each layer of paint is permitted to dry before the next one is applied.

The model will assume five-minute poses. These short poses will demand directness and freedom rather than meticulous care. When the poses are longer, the student can work more carefully. Color should be introduced on a neutral ground. I suggest a warm color for the light areas and a cool color for the shadow areas. But the student must remember to give more attention to value relationships than to the matching of the color of skin tones.

SCHEDULE XIX OUTSIDE PROBLEM
BUILT CONTOUR COMPOSITION

The class is assigned a figure composition to be drawn over the weekend. In it the student will build the contours of the figure and its surroundings (see *Built Contour,* Schedule XIX). All the objects drawn within the picture plane will receive the same emphasis.

The student will ask someone—a friend or a member of the family—to pose standing or seated in a room. The chairs, tables, curtains, lamps, plants are to be in their usual places in the room, and they will become integral parts of the composition. The student's problem is to use the building technique to express the varying qualities of several different contours. The environmental drawing in assignment XIV required the expression of mood and value relationships, but the student's effort here will be solely to build the exact contours of the figure and the objects he sees in the room.

The *built contour* is a careful and deliberate approach to drawing; the student should use hard pencils (2H-H-HB) on a good grade of drawing board so that he may carefully express the edges of each object in the picture.

XX

SCHEDULE NO. XX

TIME	PERIOD A	PERIOD B	PERIOD C
30 MIN.	GS drawings 1 minute each	Structure drawings 5 minutes each	Long pose 2 hours Charcoal
30 MIN.	2 Cross contour drawings 40 minutes each Reclining poses on same page, one with feet toward class, other with head toward class	Environmental drawing 25 minutes	
30 MIN.		Selected detail 1 hour	
30 MIN.			

SCHEDULE XX (no instructions necessary).

XXI

SCHEDULE NO. XXI

TIME	PERIOD A	PERIOD B	PERIOD C
30 MIN.	Long study Vine charcoal		
30 MIN.			
30 MIN.			
30 MIN.			Critique

In this assignment the model will take a simple pose and will reassume exactly the same pose after each break. The problem is to describe the shapes and surfaces of the model's body as accurately as possible in regard to line, value, texture, and proportion.

The student will need to recheck the structure points and values of the model each day. To do so, it will be necessary for him to mark the position of the model, the model stand, the spotlight, etc., and of course, his own drawing bench and easel.

The entire figure should be lightly spaced to fill the paper, using vine charcoal sharpened as instructed in Schedule XVII (Directional Technique). The kneaded eraser can be used as necessary. The student should put two sheets of smooth paper underneath the drawing to furnish a pad that will protect the subtle value tones from the hard surface of the drawing board.

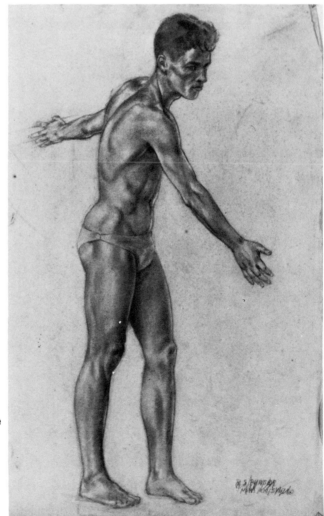

172. *Long Study.* Charcoal.
Student drawing,
The School of the Art Institute
of Chicago.

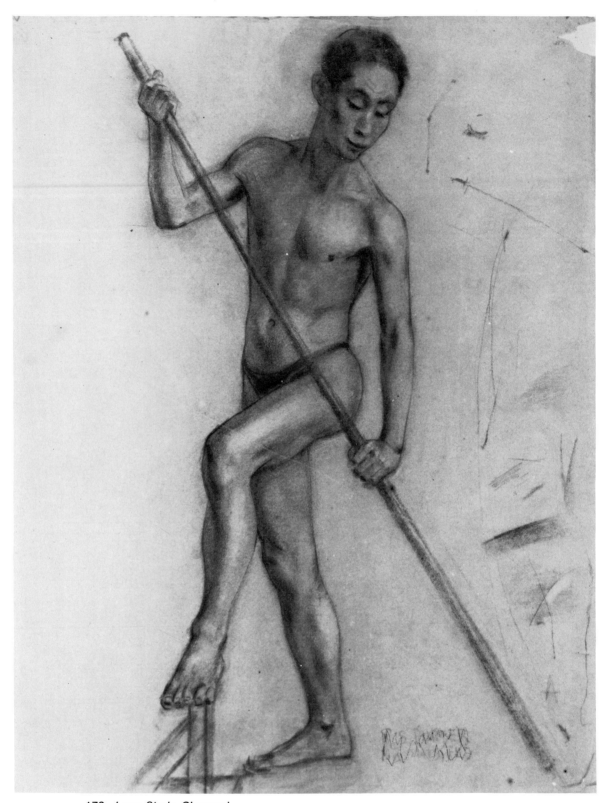

173. *Long Study*. Charcoal.
Student drawing,
The School of the Art Institute of Chicago.

Most of the shading can best be done with the tips of the fingers and these must of course be clean and free from grease. A chamois cloth is handy to remove mistaken areas of value and line in the drawing, and it can also be used to wipe charcoal dust from the hands. The other cleaning agent, the already-mentioned kneaded eraser, should be worked into a soft pliable substance. It can then be sharpened to a point like a pencil or made flat like a chisel. The student will use it for lining as well as cleaning and erasing.

There is no objection to using stumps, but once the student has mastered the fingertip technique, he will achieve a sensitive value control and will be able to describe the exact tone and texture of the figure's surface areas (Figures 172 and 173).

Since accuracy and technical skill are basic to the draftsman, the photographic appearance of these drawings should not disturb the creative student. He will in fact view the problem simply as a means to an end, and after completing it, will find himself better equipped to explore the more imaginative approaches.

XXII

SCHEDULE NO. XXII

TIME	PERIOD A	PERIOD B	PERIOD C
30 MIN.	Sketches 5 minutes each	Built contour (Environmental) Pencils and good grade of drawing paper or board	Free period 25 minute poses
30 MIN.	Multiple image Same as Schedule XVI		
30 MIN.			
30 MIN.			Critique if needed

SCHEDULE XXII (no instructions necessary).

XXIII

TIME	PERIOD A	PERIOD B	PERIOD C
30 MIN.	Sketches 5 minutes each	Long pose Using two models Pose of one to overlap that of the other Concern with negative areas	Free period 5 minutes each sketch
30 MIN.	Multiple image Give concern to negative areas, value, and texture		Long pose
30 MIN.			
30 MIN.		°	Critique if needed

° Outside problem: Make sketches and studies exploring other possibilities when drawing from the two-model pose.

SCHEDULE XXIII PERIOD B TWO MODEL POSE (2 hours)

Through the two-hour period (with breaks) two models will pose together on the same stand. The student will draw the two figures in relation to each other, handling with equal care the positive and the negative shapes. He must give each figure its proper individuality, and he must accurately depict the spatial relationships between the two created by the relative positions of the models.

One model will pose somewhat in front of the other so that portions of the figures overlap. To create a problem in perspective, the model in the rear can extend an arm or a leg, or both, past the other model toward the front edge of the picture plane.

The success of the drawing will depend on the student's close observation of the relationships between the two figures and on his ability to record accurately these observations. He must work with a keen awareness of the slight changes in scale and a sensitivity to the subtle tonal variations of the two figures in line and value.

Since creative limitations accompany the drawing of the models in Period B, the student ought to explore further the creative aspects of this project. Over the weekend he may use the completed class drawing as a working model and make many sketches and studies which show other possibilities of the dual pose (Figures 174, 175, 176, 177, 178 and 179).

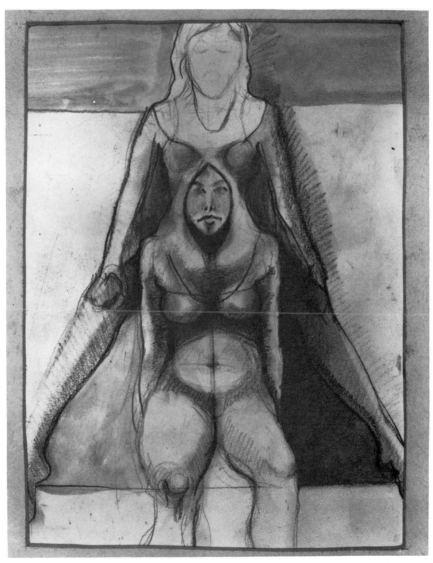

174. Mary Coover. *Two Model Pose*. Charcoal.
Student drawing, University of Florida.

175. Mary Coover. *Two Model Series*.
Charcoal, pencil, white tempera, and wash.
Student drawing, University of Florida.

176. Mary Coover. *Two Model Series*.
Charcoal and ink.
Student drawing, University of Florida.

177. Mary Coover. *Two Model Series*.
Charcoal and pencil.
Student drawing, University of Florida.

178. Mary Coover. *Two Model Series*. Charcoal, pencil, ink and wash.
Student drawing, University of Florida.

179. Mary Coover. *Two Model Series*. Charcoal and ink.
Student drawing, University of Florida.

XXIV

SCHEDULE NO. XXIV

TIME	PERIOD A	PERIOD B	PERIOD C
30 MIN.	Gesture drawings 20 seconds	Long pose Controlled or modulated technique Charcoal on gray charcoal paper, white pencil or white conté	Continue long pose on gray charcoal paper if more time is needed for completion or gesture drawings 20 seconds each
30 MIN.	Structure drawings 5 minutes each		Sketches 5 minutes each Chalks or crayons Gray construction paper
30 MIN.	Selected detail 25 minutes		Mixed media drawing 1 hour On gray paper
30 MIN.	Environmental drawing 25 minutes each		

SCHEDULE XXIV PERIOD B CHARCOAL ON GRAY PAPER

The two hours in Period B should be sufficient time to complete this assignment. However, the drawing must be carefully executed and, if necessary, part of Period C may be used for further work on it. Gray charcoal paper is used so that the value of the paper will serve as the middle tone and the student can spend his time modulating the light and dark values. He will work with a white conté pencil to show the gradations of light to middle values, and with either a charcoal or black conté pencil, to modulate the tones darker than the middle values (Figures 180 and 181). Pierre Paul Prud'hon's *La Source* (Figure 110) is an example of a longer, carefully executed study made with black and white chalk on gray paper.

180. *Value—Gray Ground*.
Charcoal and white chalk on gray paper.
Student drawing,
University of Washington.
Courtesy of Louis Hafermehl.

181. Paul Cadmus (1904-). *Inventor*.
Black and white chalk, black ink,
white gouache on brown paper.
Courtesy of the Fogg Art Museum,
Harvard University,
Cambridge, Massachusetts.

XXV

SCHEDULE NO. XXV

TIME	PERIOD A	PERIOD B	PERIOD C
30 MIN.	Long study Vine charcoal →		
30 MIN.			
30 MIN.			
30 MIN.	↓		°

° Outside problem: The student should prepare grounds for silverpoint problem in Schedule XXVI (Periods B and C): The practice sheet should also be done before class meets (Period B). See instructions.

SCHEDULE XXV (no instructions necessary).

XXVI

SCHEDULE NO. XXVI

TIME	PERIOD A	PERIOD B	PERIOD C
30 MIN.	GS drawings 1 min. each Pen and ink (Fine point)	Selected detail from model 25 minutes Silverpoint on paper or board covered with chinese white poster paint	Figure composition Use gesso panel and Compose figure Drawing from imagination Using one medium or combinations of wash, silverpoint, pencil, charcoal, conté, ink, etc.
30 MIN.	Short study 12 minutes each Value study Pen and ink	Long study from model Silverpoint on prepared paper or gesso panel	
30 MIN.	Selected detail 1 hour Hatching and cross-Hatching technique Pen and ink		
30 MIN.	↓	↓	Work outside ↓

SCHEDULE XXVI *PERIOD B* *SILVERPOINT*

To seek a mastery of the delicate and disciplined technique of silverpoint as a contemporary medium is the objective of this problem. The student will first review the information on *Silverpoint* given in Chapter V on Materials and Techniques.

The grounds are prepared by painting several thin layers of Chinese white on heavy, fairly smooth drawing paper or illustration board. Each paper will have different surface characteristics, requiring the student to try varying proportions of water to Chinese white; thus he will determine the best one for each type of paper. When the paper is thoroughly dry he will then make a page of linear techniques in order to become familiar with the use of the silverpoint tool.

These practice sheets are to be done outside, before the class meets for Period B. The student must give considerable time to the practices of hatching, cross-hatching, and modulating areas (Figure 117). In Figure 182 an informal technique is used whereby the strokes were made longer and less orderly than the ones used in the usual silverpoint techniques.

The model will hold the pose for twenty-five minutes. After a brief observation, the student will select a small area of the figure and carefully draw the area in detail; the length of the pose does not allow time for making a careful study of the entire figure. The delicate lines and close range of values make up the real charm of the silverpoint technique; the student should never apply extreme pressure to the tool, not even when he wants to develop a dark area.

The drawing must be sprayed with fixative if it is to retain its beautiful silver-gray quality. However, some artists prefer the richer and darker tones which appear when the drawing is left without a fixative.

The long study in silverpoint should be as carefully executed as the detail study. For the longer study the model will pose in one position for the remaining ninety minutes. The student may or may not have time to complete the entire drawing; the time needed will depend upon his individual approach to the silverpoint technique.

PERIOD C *FIGURE COMPOSITION* *(GESSO PANELS)*

This problem requires the student to give as careful attention to the gesso ground as to the organization of his subject matter in the composition. (See Gesso, Chapter V).

For some purposes the new polymer gesso has advantages over the conventional and historic type used by Renaissance artists. However, for the application of such graphic materials as pencil, silverpoint, wash, inks, and watercolor, a surface prepared with glue size and whiting will still be more responsive than the harder polymer sizes. We have stated before that the gesso prepared with glue size is an excellent ground for silverpoint. Such wet media

as transparent washes and watercolor retain their transparency and freshness when lightly applied to the surfaces. By working them into the gesso and dissolving the glue, degrees of opaqueness will be produced when the medium fuses with the opaque whiting. This type of gesso also permits the use of abrasives to remove mistakes and to produce textures and techniques.

182. Aaron Law. *Figure and Landscape.*
Silverpoint on illustration board prepared with Chinese white.
Student drawing, University of Florida.

A figure composition is suggested for this problem. It will be best to draw from imagination the figure or figures and other objects in the composition. In this first experience with gesso, drawing from the posed model may inhibit freedom in structuring the composition and in the application of the medium. The student may use a single medium, or he may try combinations of pencil, silverpoint, charcoal, chalk, crayon, inks, washes, and other media.

Most students will probably need to spend more time on this problem than that suggested in the work schedule (Figures 115 and 183). The student developed his idea for these panels from an initial drawing made in his sketchbook (Figure 5). Other such exploratory drawings are seen in Figures 184, 185 and 186.

opposite: 183. William Shirley. *Mouth-scape and Running Man.*
Silverpoint and egg tempera on prepared gesso.
Student drawing, University of Florida.

below: 184. William Shirley. *Mouth-scape Series.*
Pencil, ink and colored paper.
Student drawing, University of Florida.

185. William Shirley. *Mouth-scape Series*. Silkscreen.
Student drawing, University of Florida.

186. William Shirley. *Mouth-scape Series*. Ink, pencil and colored chalks.
Student drawing, University of Florida.

XXVII

TIME	PERIOD A	PERIOD B	PERIOD C
30 MIN.	3 Drawings from museum objects, allow one week (or more) for project Pencil renderings on Best grades drawing papers or boards	⟶	
30 MIN.			
30 MIN.			
30 MIN.			

SCHEDULE XXVII PERIODS A, B, C
DRAWINGS FROM MUSEUM OBJECTS

The student will undertake a problem in pencil rendering, and he will use graphite of varying degrees of hardness to describe accurately the textures and materials of three objects. When possible, he will draw from objects in museum collections and exhibitions. African and Pre-Columbian artifacts make excellent subjects. Such medium-sized objects as weapons, masks, containers, sculpture, and ceremonial pieces present the drawing student with challenging textures in wood, metal, leather, ceramics, ivory, cloth, beads, feathers, and the like. If museum collections are not available, contemporary pieces may be drawn.

The student will use graphite (ranging from 6H to 6B) and a good grade of drawing paper or illustration board. He must keep the purpose of the problem in mind: To describe carefully in pencil the materials and textures of the objects he is drawing. Consequently, the largest dimension of each drawing should not exceed 10 inches, nor should it be less than 5 inches. If the drawing is too large, time will not permit a careful rendering of the entire object;

if the drawing is too small, there will be insufficient space to reproduce the surface textures accurately.

The textures and materials of many of these objects can be best rendered by carefully building the drawing with the harder pencils, ranging from 6H to H (Figures 187 and 188). In Figure 189 the student has used a softer graphite (6H to 2B) to describe the metal surface of a piece of sculpture.

187. Jean Purser. *Drawings from Museum Collection.* Graphite. Student drawing, University of Florida.

In Figures 190 and 191 another student has used the more informal technique of rubbing extremely soft graphite (2B to 6B) into the paper's surface. By using stumps, fingertips, and erasers, he has accurately described the black wood surfaces of the masks.

It is likely that some students will need more time than the three class periods. In this case they should either finish the drawing outside of class or use part of the next weekly schedule to complete the project.

188. Charles LeMasters.
Drawing from Museum Collection.
Graphite. Student drawing,
University of Florida.

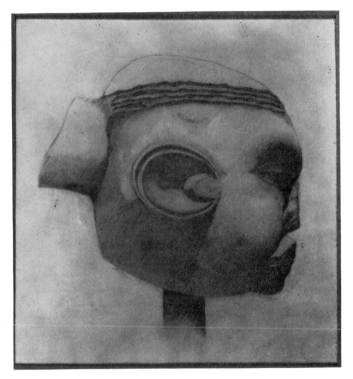

189. *Drawing from Museum Collection.* Graphite.
Student drawing, University of Florida.

190. *Drawing from Museum Collection*. Graphite.
Student drawing, University of Florida.

191. *Drawing from the Museum Collection*. Graph
Student drawing, University of Florida.

XXVIII

SCHEDULE NO. XXVIII

TIME	PERIOD A	PERIOD B	PERIOD C
30 MIN.	Creative problem From imagination Make a number of compositions, using subjects or techniques relating to problem in Schedule XXVII		
30 MIN.			
30 MIN.			
30 MIN.			

The student will work for three periods (A,B,C) on creative compositions which contain subject matter or techniques (or both) that pertain to the problem of the previous week (Schedule XXVII).

This assignment is planned to serve two purposes: (1) It will permit the student to draw more creatively after the necessarily unimaginative work of the previous week; (2) It will afford him the opportunity to apply to a creative situation the technical skills emphasized in Schedule XVII.

In Figures 79, 192, 193 and 194 the student selected the lower portion of the human figure to test some of the pencil techniques used in drawing the museum objects. In Figure 79 he carefully modulated the legs with a very hard graphite pencil and emphasized the subtle gradations of tones by pasting flat areas of red and blue paper in the background. He used a medium graphite to give form to the legs in Figure 192; with extra pressure he pushed the softer graphite into the darkest areas of the form and into the background areas.

192. Ron Chesser. *Running Figure Series*. Graphite.
Student drawing, University of Florida.

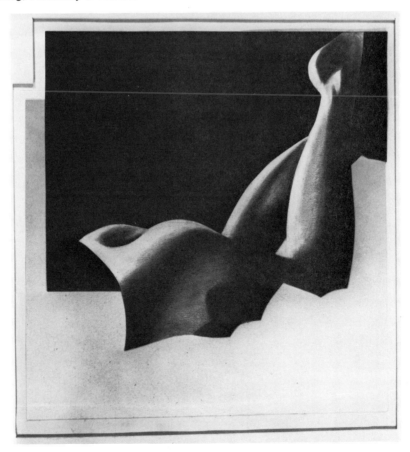

Figures 193 and 194 illustrate both loose and tight techniques. In Figure 194 emphasis was given to the breast by carefully rendering it with hard graphite. Added emphasis was produced by photographing the breast drawing and inserting the photo into the composition.

Another student has in Figure 195 applied the informal technique of rubbing and blending the soft graphite to modulate his cluster of mask forms.

193. Ron Chesser. *Running Figure Series*. Graphite and Collage. Student drawing, University of Florida.

194. Ron Chesser. *Running Figure Series*. Graphite and photograph of graphite. Student drawing, University of Florida.

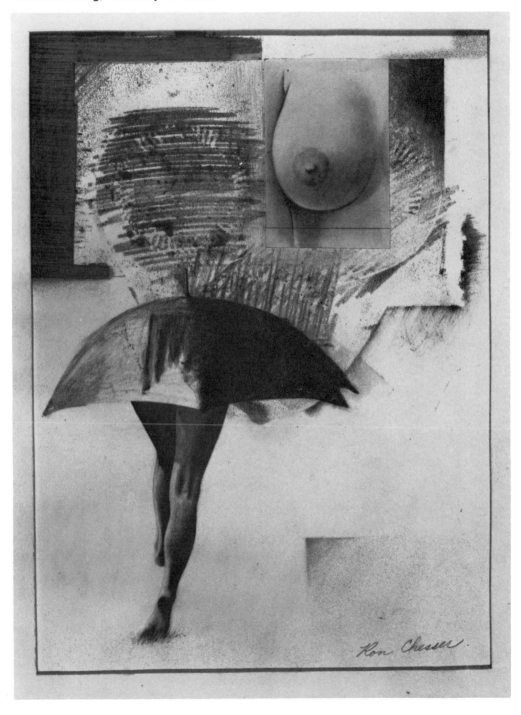

195. Mike Hitchcock.
Creative Problem from Museum Objects
Soft graphite rubbed and modulated.
Student drawing,
University of Florida.

In Figures 196, 197, 198 and 199 the observer is more conscious of the student's use of subject matter than of his use of the rendering techniques emphasized in Schedule XXVII. In the first sketch (Figure 196) he has used the teeth in Figure 191 and the ear shape of Figure 188 as art forms, and has related them to his own ideas. Figures 197, 198, and 199 were developed by further explorations of this subject matter. Here it is obvious that the student's creative urge was stimulated more by the objects he was drawing than by the techniques he was employing. For the purpose of the problem both approaches are valid.

196. Charles LeMasters.
Creative Problem from Museum Objects.
Pencil and watercolor.
Student drawing,
University of Florida.

197. Charles LeMasters.
Creative Problem from Museum Objects.
Pencil and watercolor.
Student drawing,
University of Florida.

198. Charles LeMasters. *Creative Problem from Museum Objects.*
Pencil and watercolor. Student drawing, University of Florida.

199. Charles LeMasters. *Creative Problem from Museum Objects.*
Pencil, watercolor and ink.

XXIX

SCHEDULE NO. XXIX

TIME	PERIOD A	PERIOD B	PERIOD C
30 MIN.	Problem in value Select problem for independent study		→
30 MIN.			
30 MIN.			
30 MIN.	↓		

SCHEDULE XXIX PERIODS A, B, C PROBLEMS IN VALUE

During this entire week the student will be making an independent study of value as an element in drawing. Without assistance from the instructor, he will set up his problem and explore it in terms of his own interests and needs.

In Figure 200 the student has cut out and arranged shapes of balsa wood in a light-box for value study and drawing. The box, left open in front and at the top, made possible the effective use of controlled light; the student was able to draw a variety of patterns of value areas and cast shadows.

In Figure 201 all of the objects were painted white; subtle and close value relations were thus produced. The student was able to determine and attempt to draw the true form of each object and reproduce the accurate value relationships of the various objects to one another. As in Figure 200 the formation of value patterns depended upon controlled lighting as well as the selection and arrangement of the objects.

200. Ken Jewessen. *Value Study—
Light Box and Balsa*.
Student drawing,
University of California
at Northridge.

201. *Value Study—
Objects Painted White*.
Student project,
University of Florida.
Courtesy of Ron Kraver.

Figure 202 illustrates still another approach to the problem. Here the student dealt more with an imaginary space concept within the picture plane than with one created by the arrangement of actual objects. He arbitrarily used planes and values to serve the needs of his composition instead of using value to explain the relative depth of these shapes. He also disregarded the use of scale in determining the correct depth of the shapes within the picture plane. Regardless of the arbitrary use of value and scale, the correct positions of the shapes were easily determined through the use of linear perspective. The vertical lines of each plane were projected to the floor and ceiling where they intersected lines drawn to the vanishing point (also see Figure 203).

202. *Value Study—Space Dividers*. Pencil and tempera. Student drawing, University of Florida. Courtesy of Harrison Covington.

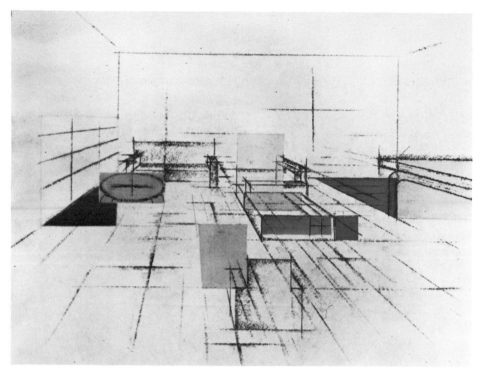

203. *Value Study*—Planes in Space. Crayon and watercolor.
Student drawing, Institute of Design.

Another student made figures of bleached burlap to arrange in interesting compositions for form and value study (Figure 204 and 205). These stuffed figures were also combined with the nude model poses in Figure 206.

All of these compositions suggest a creative and original approach to problems in the study of value as an element in drawing.

204. Rona Kritzer. *Value Study—Stuffed Figures.*
Student project, University of Florida. Courtesy of Robert Mason.

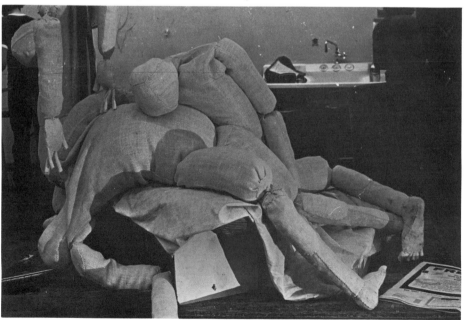

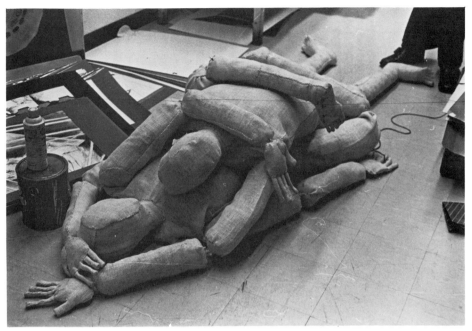

205. Rona Kritzer. *Value Study—Stuffed Figures.*
Student project, University of Florida. Courtesy of Robert Mason.

206. Rona Kritzer. *Value Study—Stuffed Figures and Model.*
Student project, University of Florida. Courtesy of Robert Mason.

XXX

TIME	PERIOD A	PERIOD B	PERIOD C
30 MIN.	Slide projection onto nude model	Develop drawings from Period A (preferably outside of class)	Continue problem of Period A, B
30 MIN.	1 hour pose		
30 MIN.	Slide projection onto nude model Different slide and different pose		
30 MIN.	1 hour pose		

SCHEDULE XXX PERIOD A
SLIDE PROJECTION ONTO NUDE MODEL

The purpose of this problem is to challenge the students with a new situation, to de-emphasize the model as an isolated subject, and to increase the students' awareness of the space around the model.

The model will take two poses of one hour each. A different slide will be projected onto the model for the duration of each pose. Slides which are simple in pattern and which have definite light and dark areas will serve best.

The two drawings can be further developed in class the following two days (Periods B and C). However, to avoid a uniform approach to the situation, the students are asked to develop their drawings outside of class. Above all, an imaginative approach and individual response to the problem are essential.

The student drawings seen in Figure 207, 208 and 209 are the results of the projection of a Francis Picabia slide on the nude model.

207. *Slide Projected on Model*.
Pencil and crayon.
Student drawing,
University of Florida.
Courtesy of Robert Mason.

208. *Slide Projected on Model*.
Charcoal and wash.
Student drawing,
University of Florida.
Courtesy of Robert Mason.

209. Joe Helseth. *Slide Projected on Model*. Pastel and crayon.
Student drawing, University of Florida.
Courtesy of Robert Mason.

PART THREE

THE ADVANCED STUDENT: PROJECTS

CHAPTER VIII
THE ADVANCED STUDENT

Drawing becomes more challenging and rewarding to an experienced student as academic procedures become less stringent and creative avenues more apparent. The student has brought his drawing to an exciting stage: either to the point of realization or to the point of expectancy. With developed facility and knowledge he feels the importance of the existing situation which he can in some measure control, and he is ready and anxious to get on with the work.

A brief discussion of the following three points is appropriate:

(1) *Definition of advanced.* When planning an individual academic program the drawing teacher customarily classifies as advanced the student who has completed the required prerequisites. These prerequisites are the courses which introduce him to the basic fundamentals of drawing; they require of the student a degree of proficiency attained through sufficient studio work.

If finishing these prerequisites would guarantee the student a high level of technical and artistic achievement, the role of the drawing teacher would be less complex. Some teachers establish a superior position of creative achievement as the criterion and claim that only a small percentage of an average senior drawing class is truly advanced. Other teachers are willing to settle for a more liberal definition of advanced, that is, a student beyond the elementary and introductory level who is capable of improving his drawing. Regardless of whether a lofty or minimal requirement is attached to the term "advanced," one must generally agree that there are vast differences between the abilities of students and among their responses to training.

Most teachers will admit that there is no definite line of demarcation between the intermediate and the advanced student. The transition is obvious in some cases, but in others it may be so gradual that the teacher and student are unable accurately to evaluate the actual stage of progress. There are also cases of retrogression. As with even the professional artist, a student will meet setbacks caused by an unfamiliar assignment, a new medium, and many other factors. The serious student will not let such disappointments turn him aside from the fulfillment of his goal.

However, the definition of the word is relatively unimportant because teacher and student alike know that if a student is really advanced he must have done much drawing. Webster's dictionary defines a drawing as "a product resulting from the act of drawing." The student will acquire his advanced position through many "acts of drawing."

Hiram Williams, teacher of advanced painting at the University of Florida, makes the following comment in regard to the senior painter: "Ideally I expect a student coming to me at the senior level to know the traditional information: perspective and foreshortening, modeling, lighting, descriptive drawing, how to paint, the nature of the picture plane, the principle 'styles' of the day, and so on. Of course I do not anticipate that he will be highly accomplished, rather I expect him to be well on the way toward the development of a 'thinking hand' and aware of the difficult route before him toward the development of a personal artistic vision" (Figures 210 and 211). Also see Figures 212, 213, 214 and 215; although the approaches are different it is obvious that all these artists have developed "the thinking hand" to which Hiram Williams refers.

left: 210. Hiram Williams (1917-).
Eye Series.
Drawing on paper and organdy.

opposite: 211. Hiram Williams (1917-).
Eye Series.
Drawing on paper and organdy.

212. Geoffry Naylor (1928-). Sculpture for Hanes Mall, Winston-Salem, N. C. Aluminum, 40' × 36' × 12'.

213. Laszlo Moholy-Nagy (1895-1946). *Mills No. 2*. Oil on plexiglass.
The Solomon R. Guggenheim Museum.

214. Todd Walker (1917-). *Photo Graph*.
Blueprint for figures; Gum-dichromate process for text.

215. Marcia Isaacson (1945-). *Close-Ups*. Pencil and chalk.

(2) *Role of Teacher.* The teacher's position at this advanced stage of the student's development is both indispensable and precarious. The teacher must offer suggestions but advise with caution because there is the possibility that a teacher's own enthusiasm and involvement in drawing will suggest a single procedure for teaching advanced drawing. Admittedly there are as many ways of teaching drawing as there are teachers. A creative teacher will not look for directions that will standardize his teaching; he will continually vary his methods to fit the level of the class and to meet the needs of each individual student. He must inspire and direct those students with proven abilities, and he must help the ones who are at lower levels of accomplishment. Actually there should be less danger of a teacher giving priority to his own pet procedures at the advanced level than at the lower level of instruction where there is definite basic and technical material to be covered. The advanced student should be expected to set his own problems and, mainly, to work independently. In summary, the teacher must be advisor, confidant, coordinator, and inspirator.

Rapport between a teacher and an advanced student can be readily established inasmuch as their terminology and ultimate intentions are nearly parallel. Individual teachers have different ways of establishing rapport. One will prefer a close relation between his own work and the work of those who study

under him. Another will feel that there must be some relation in approach or intent. Still another will dissociate his own creative activity from that of his students and will be able to relate to each student's thinking and to project total empathy with every individual's approach. Often a productive and successful artist-teacher motivates student enthusiasm through his own diligence, productivity, and success. However, to be more than a short-term stimulant he must also relate to, and be interested in, the involvement of each student. So close in some instances is the teacher-student relationship that it often develops into a continuing association in the years following graduation; teacher and student, then both in the role of artist, find pleasure and profit in sharing their ideas and successes.

Finally, one might say that the very nature of drawing as an interpretative and creative art should negate the practice of designating a single path where there is a maze of creative possibilities. If the directions are too explicit, it is likely that the goal will be less enviable when reached. Mindful that each student must set his own goals and find his own path, we here present numerous approaches to drawing in place of any sort of absolute instruction.

(3) *Selection of Drawings in Part III.* The reasons for the choice of the drawings here reproduced and an explanation of the conditions under which they were chosen are pertinent:

First, the drawings by members of advanced drawing classes at the undergraduate level are, with a few exceptions, the results of extensive investigations of individual problems. Here is the general procedure: A class is scheduled to meet and draw six hours each week (student's use of model is arbitrary). In addition to these meetings, all members of the class are required to attend a presentation and critique which meets every two weeks for two or three hours (depending upon the number of students and the amount of work to be presented). At these critiques ideas, sketches, or finished drawings are presented by the students and are then discussed by the instructor and the students.

Previous to the critique, the student chooses a problem involving an idea, technique, medium, or a combination of the three. This choice may be made either independently or after consultation with the instructor. The problem will be explored throughout the term, or until it ceases to challenge or intrigue the student. After a problem is solved or found no longer challenging, the student is advised to select another which might be equally beneficial and stimulating.

The above-mentioned critiques are preferably scheduled in the evenings or at times when other studio classes are not in progress. In this way, instructors from other areas and students not registered for the class are free to attend the critique. These open sessions are held after the students have come to feel comfortable in the class. The visiting instructors (not only from drawing but from other areas) are more needed near the end of the term when the stu-

dents' projects are complete or are nearing completion. The student needs objective criticism directed toward the end product, in addition to the teachers' personal interest in the student's activity and progress.

Second, the students' drawings do not all adhere to the strict conventional concepts of drawing. Some prospectuses for contemporary drawing exhibitions often describe eligible drawings as "delineations by pen, pencil, or crayon (one color) on flat surfaces of paper content." In selecting drawings for Part III we made no attempt to present drawing as a strictly graphic area; on the contrary we maintain that drawing overlaps and identifies with such areas as printmaking, photography, painting, sculpture, and the like. Some students preferred to retain a graphic purity and to keep their sketches and final products within the formal boundaries of the drawing area; but where probings and experimentations led to other forms of visual activity the work was equally acceptable. The teaching intent is to let drawing serve the student as an outlet for his creative energies, whether the end product is a drawing, a print, a painting, a piece of ceramics, sculpture, or any other form of art. *The emphasis is put on sincere involvement with media and an area appropriate to the idea, and not on the fulfillment of a "drawing" requirement.* I repeat, at the senior level drawing should serve and not restrict the student's creative expressions.

Third, the desire to show a variety of approaches to problems made it impossible to require consistent procedures. The students were never encouraged to develop their ideas in teacher-prescribed processes. Consequently, all the explorations do not show the step-by-step stages of the entire development. Some of the explorations are represented by only a few drawings which present a sequential unfolding to a satisfactory solution. In other cases each drawing has been considered a product, and any one of a number of drawings might be called the finished product. In still others it is obvious that the student felt from the first that his idea or problem had been essentially resolved and that there was no need for preliminary sketches; he depended upon one drawing, subject to tests and changes, to produce a complete statement or a final product. Some of the most successful investigations involved stacks of exploratory drawings before an idea was developed; these many probings are often exciting and revealing, but space does not permit a showing here of the complete process.

The use of "master's" drawings for reproduction is a safe and common practice.° However, the author chose to use large numbers of student drawings in Part III for two reasons: *First*, there are many available and excellent books which introduce students to the works of old and contemporary masters. *Second*, we feel that students more readily identify with drawings done by their peers, and thus they will see the importance of experimenting with ideas, techniques, and materials before selecting and following a particular direction.

°See Part I and II.

216. William Schaaf. *Project I. Polish Rider*. Graphite.
Student drawing, University of Florida.

217. William Schaaf. *Project I. Elephant Shapes*. Graphite.
Student drawing, University of Florida.

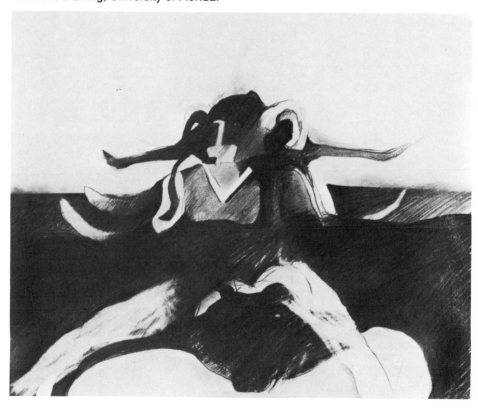

STUDENT PROJECTS

I

Project I—Figures 58, 106, 216, 217, 218, 219, 220,
221, 222, 223, and 224.

Student—Bill Schaaf
Title—*Horse and Rider*

The student made drawings of a variety of subjects (Figures 58, 106, 216, 217, and 218). He selected one of them for further exploration. Figure 216, inspired by Rembrandt's *Polish Rider,* was the one he felt presented the most interest and challenge. Although he set out to restrict his materials to graphite (H to 6B), he also used wash and collage in Figures 223 and 224.

In Figure 216 the student presented a somewhat descriptive horse and rider and a clear definition of space. However, in the other drawings (Figures 219-224) new forms began to challenge the original objects and more interplay became possible between form and space. In the same drawing the space was at times tightened around the forms, and then again the shapes were permitted to intermingle with the negative areas, the shapes almost losing their linear boundaries (Figure 221).

After introducing these new and more complicated forms and relationships within his original rectangular picture plane, the student felt in Figure 224 the need for a change in format. Changing his medium from pencil to wash, he excluded the rider, simplified the horse's shape, and introduced an oval mat to reinforce the movement and form of the rocker in the lower part of the composition.

After making these drawings and many others of the same subject, the student felt that the problem still offered interest and challenge. He chose to continue the exploration in a painting class the following semester.

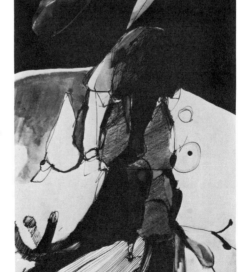

218. William Schaaf. *Project I.
Close-Up—Elephant Shapes.*
Wash, ink and crayon.
Student drawing,
University of Florida.

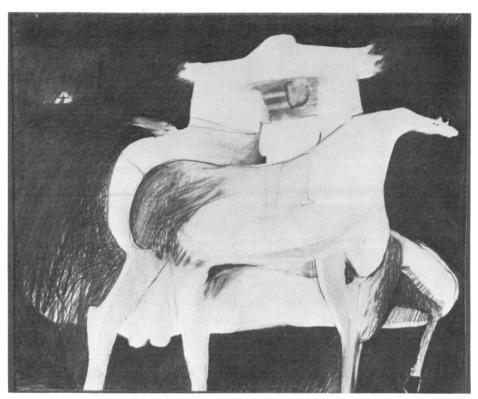

219. William Schaaf. *Project I. Polish Rider Series*.
Graphite. Student drawing, University of Florida.

220. William Schaaf. *Project I. Polish Rider Series*.
Graphite. Student drawing, University of Florida.

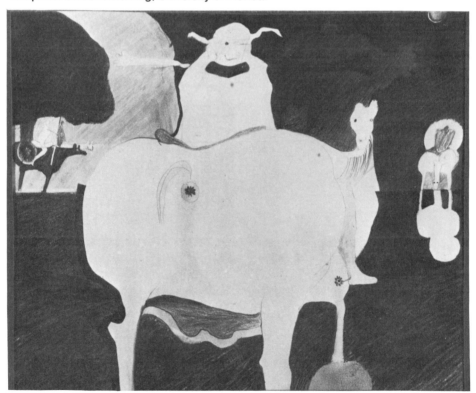

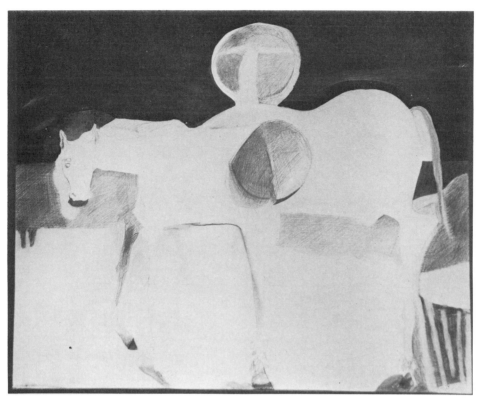

221. William Schaaf. *Project I. Polish Rider Series*.
Graphite. Student drawing, University of Florida.

222. William Schaaf. *Project I. Polish Rider Series*.
Graphite. Student drawing, University of Florida.

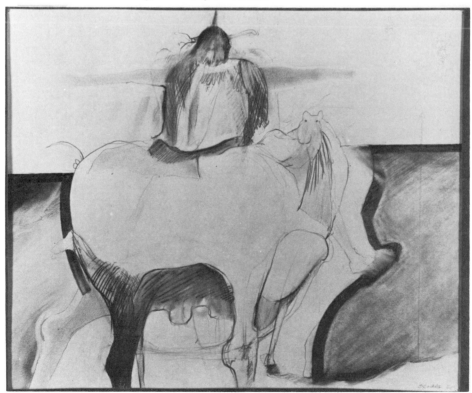

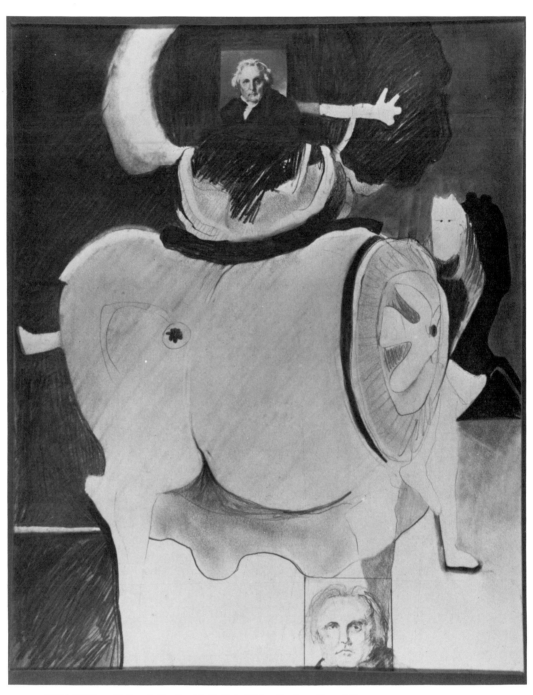

223. William Schaaf. *Project I. Polish Rider Series*. **Graphite.**
Student drawing, University of Florida.

224. William Schaaf. *Project I. Polish Rider Series*. Wash and ink.
Student drawing, University of Florida.

II

Project II—Figures 92, 225, 226, 227, 228, 229, 230,
231, 232, and 233.

Student—Raphael Fiol
Title—*Pen and Ink Techniques*

Here a student majoring in advertising design decided to increase his fa-
cility in pen and ink. Although the principal medium is pen and ink, he did
use graphite when he thought it would give support and variety to the draw-
ing.

In the first drawings (Figures 92, 225, 226) the student tried a variety of
textural techniques while presenting objects in an architectural and formal en-
vironment. In Figures 227 and 228 the balance was less formal, and in Figure
227 the control of space less definite.

At this point he selected a specific subject (Figure 228) for investigation, still using the previously specified medium, pen and ink.

In Figures 229 and 230 the environment became less important; diagrams and charts were introduced to explain as well as represent the subject matter.

The next two drawings (Figures 231 and 232) challenged space in an interesting way. The grid in the upper part of both drawings emphasized and supported the flat tabular quality evident in Figures 229 and 230; the linear perspective used in the lower part of the drawings produced a much deeper space penetration. By extending the grid over the entire surface in Figure 232, the student gave unity to the two contradictory space concepts.

The student carried on further exploration of the same subject; the result can be seen in Figure 233, which is an etching done in a print class later in the semester.

225. Raphael Fiol. *Project II. Pen and Ink Techniques.* Pen, ink, and pencil. Student drawing, University of Florida.

226. Raphael Fiol. *Project II. Pen and Ink Techniques*. Pen, ink and pencil. Student drawing, University of Florida.

227. Raphael Fiol. *Project II. Pen and Ink Techniques*. Pen, ink and pencil. Student drawing, University of Florida.

228. Raphael Fiol. *Project II.*
Pen and Ink Techniques.
Pen and ink. Student drawing,
University of Florida.

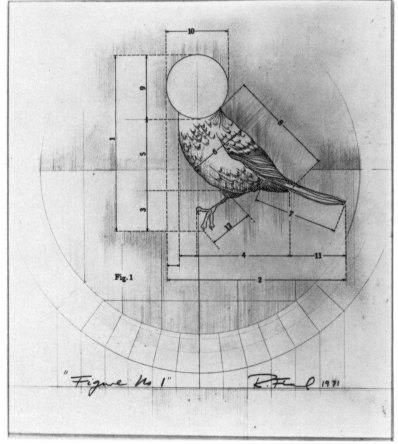

229. Raphael Fiol. *Project II.*
Pen and Ink Techniques.
Pen and ink.
Student drawing,
University of Florida.

230. Raphael Fiol. *Project II.*
Pen and Ink Techniques. Pen and ink.
Student drawing, University of Florida.

231. Raphael Fiol. *Project II.*
Pen and Ink Techniques. Pen and ink.
Student drawing, University of Florida.

232. Raphael Fiol. *Project II.*
Pen and Ink Techniques.
Pen and ink.
Student drawing,
University of Florida.

233. Raphael Fiol. *Project II.*
Pen and Ink Techniques.
Etching.
Student drawing,
University of Florida.
Courtesy of Kenneth Kerslake.

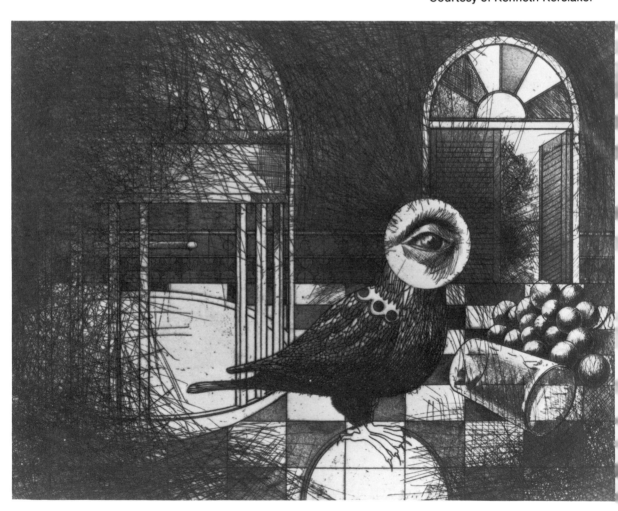

PROJECT III—Figures 65, 234, 235, and 236.

Student—Leonard Weinbaum
Title—*Running Dog*

This student had done considerable drawing and always worked best when permitted to draw and explore ideas without a commitment to subject or medium. Many of his projects were quick investigations completed or cast aside in a period of days; others were probings which extended over longer periods of time and frequently overlapped such related areas as painting and printmaking.

A free style in all the drawings of the *Running Dog* series emphasized feeling and emotion rather than technical facility. There was an attempt to create movement, interesting shape relationships, and a proper environment for the idea. In Figure 234 the student made an effort to create a lively environment by giving movement to the space around the figures. In Figures 65 and 235 he

234. Leonard Weinbaum.
Project III.
Running Dog Series.
Charcoal.
Student drawing,
University of Florida.

reversed the values of the positive and negative shadow shapes in order to strengthen the movement of his images. He also tested in these two drawings the vertical picture plane against the horizontal to determine the one most suited to his idea. In all of the drawings he used fragmented shapes of the dog figures to create movement and environment. His last drawing (Figure 236) was done with obvious authority; the lines, fragments, and repetitive shapes all work together to give vitality and unity to his idea.

235. Leonard Weinbaum. *Project III. Running Dog Series.* Charcoal. Student drawing, University of Florida.

236. Leonard Weinbaum.
Project III.
Running Dog Series.
Charcoal.
Student drawing,
University of Florida.

IV

PROJECT IV—Figures 237, 238, 239, and 240

Student—Paige Pinnell
Title—*The Cloud*

The student chose to explore a simple subject (the cloud) and to restrict his drawings to the graphite medium.

In his first drawing (Figure 237) his shapes are definitely space-filling, and the value areas have clearly defined linear boundaries. The position, size, and modulated forms give emphasis to the central cloud; the small black triangle also directs the eye to the central cloud shape. This main character becomes more important with a change in scale, value, and position in the next drawing (Figure 238); there is more variety in the linear boundaries and space has become a more important factor.

In Figure 239 the use of the dual image has been explored, and there is

unity between the two shapes although there is a definite difference in the environments and shape-space relationships. The cloud shape on the right is locked in space by the tight line which hovers over it and by the simple black areas at the corners. On the left the cloud is loosely contained. With fragmentation, fracturing, and informal value changes, the student created an interplay between shape and space. He then stressed in Figure 240 simplicity and directness of statement; the cloud shape seems to be more comfortably and naturally related to its environment.

For some time the student continued these drawings in the graphite medium before substituting color. During the remainder of the semester he explored the new and interesting problems which developed when he began to work in water color and pastels.

237. Paige Pinnell. *Project IV. Landscape with Cloud Series*. Graphite. Student drawing, University of Florida.

238. Paige Pinnell. *Project IV.*
Landscape with Cloud Series.
Graphite.
Student drawing,
University of Florida.

239. Paige Pinnell. *Project IV.*
Landscape with Cloud Series.
Graphite.
Student drawing,
University of Florida.

240. Paige Pinnell. *Project IV. Landscape with Cloud Series.* Graphite.
Student drawing, University of Florida.

V

PROJECT V—Figures 241, 242, 243, 244, 245, and 246

Student—Aaron Law
Title—*Water Hyacinth*

 The water hyacinth was selected by a student as a subject for investigation. The early pencil sketches emphasized the principal characteristics of the plant, which were the flat surfaces of the leaf shapes and the three-dimensional form of the bulbs (Figures 241 and 243).

241. Aaron Law. *Project V.*
Water Hyacinth Series.
Pencil.
Student drawing,
University of Florida.

242. Aaron Law. *Project V.*
Water Hyacinth Series.
Pencil and watercolor.
Student drawing,
University of Florida.

In Figures 242 and 244 a concern for the flatness of the leaf shapes seems to dominate the space in the picture plane; however, in both drawings the flatness is broken by the small modulated areas which describe the form of the bulbs. The conventional rectangular picture planes have been altered in Figures 243 and 244, and parts of the plant are permitted to hang in space—to some degree they suggest an environment in regard to their natural position on the water's surface.

In a number of drawings the student used the natural colors, green and lavender, to identify shapes, thus canceling the need for structural delineation (Figure 244).

More interest in the bulb forms than in the flat leaf surfaces is expressed in Figures 245 and 246; however, in both drawings the characteristic flat leaf surfaces do appear either as value areas or as white areas with linear boundaries. In these drawings, which are less descriptive, the student also used warm colors (oranges and reds) instead of the natural greens and lavenders. Here the forms seem to be tied to the horizon and suspended into the space below. In Figure 246 one again gets the feeling that the student was attempting to relate the forms to their natural environment on the water's surface.

243. Aaron Law. *Project V. Water Hyacinth Series*. Pencil and watercolor. Student drawing, University of Florida.

right: 244. Aaron Law. *Project V.*
Water Hyacinth Series.
Pencil, ink and watercolor.
Student drawing,
University of Florida.

below left: 245. Aaron Law. *Project V.*
Water Hyacinth Series.
Pencil, ink and watercolor.
Student drawing,
University of Florida.

below right: 246. Aaron Law. *Project V.*
Water Hyacinth Series.
Pencil, ink and watercolor.
Student drawing,
University of Florida.

VI

Student—William Shirley
Title—*Transfers and Air Brush Technique*

The student who completed this project also did Figures 115 and 183 (gesso panels) and Figures 5, 184, 185, and 186 (exploratory drawings). Both series of drawings show considerable technical ability and a high regard for craftsmanship; however, in the latter project the student did not consider necessary the informal investigation seen in the earlier gesso drawings.

247. William Shirley. *Project VI. Transfers and Airbrush.* Student drawing, University of Florida.

In the latter project Figures 247, 248, 249, 250, and 251 were done as formal approaches to a finished product. The problem as the student stated it was to explore the possibilities of combining the grayed and muted colors of air brush and transfer techniques° with the painted bright bands of intense colors used in all the compositions. The carefully painted bands of bright red, orange, yellow, green, blue, and purple are in the lower parts of Figures 248, 249, 250, and 251.

In Figure 250 the student substituted a shape carefully rendered in transparent water color for the transfers which he used in all the other drawings. He made forty or more of these drawings before he abandoned this project and selected another.

248. William Shirley.
Project VI.
Transfers and Airbrush.
Student drawing,
University of Florida.

°The transfer technique is a process by which black-and-white and color prints are transferred from magazines and newspapers onto drawing surfaces. There are several ways of transferring these prints, but the most common is that of wetting the face of the printed area with cigarette-lighter fluid and then rubbing the back of the print with a hard instrument (the back of a spoon) to transfer the softened ink into the drawing ground.

advertisement Bill Stanley 1968

264 THE DRAWING HANDBOOK

Artificially stimulated Plastic Chocolate Syrup. *Bill Shirley 1968*

opposite:
249. William Shirley. *Project VI. Transfers and Airbrush.* Student drawing, University of Florida.

above:
250. William Shirley. *Project VI. Transfers and Airbrush.* Student drawing, University of Florida.

right:
251. William Shirley. *Project VI. Transfers and Airbrush.* Student drawing, University of Florida.

VII

PROJECT VII—Figures 252, 253, 254, 255, 256, and 257

Student—Michael Hitchcock
Title—*The Chair*

Numerous pencil sketches of a table, chair, and bowl of fruit preceded the drawings which have been reproduced. The student desired to investigate a subject of a personal nature, and selected the chair which had been assigned to him at mealtimes during his childhood. After making some descriptive drawings which related the chair to an interior, he finally chose to relate the objects to an exterior (landscape). See Figure 252.

252. Michael Hitchcock. *Project VII. The Chair.* Graphite and airbrush. Student drawing, University of Florida.

In Figures 253, 254, 255, and 256 a chair became symbolic of a disciplinary act related to his childhood experiences, but the student was also interested in the shape and space relationships of the chair. In these four drawings his experimentation involved changes in scale, position, value, texture, and mood. Most important to this experimentation was the informal play of the soft graphite against the more exact air-brush technique. The austerity in these drawings represented the chair as a symbol of discipline. However, the student later chose to return to a more personal and representative style (Figure 257). In this 18″ × 22″ color etching he described the chair structure as he remembered it; by embossing the seat and covering it with a warm red pattern he presented it as a specific cushioned chair. The table and fruit bowl became abstract background shapes, and emphasis was given to his main character through the introduction of color and ornate design.

253. Michael Hitchcock. *Project VII. The Chair*. Graphite and airbrush. Student drawing, University of Florida.

left: 254. Michael Hitchcock.
Project VII. The Chair.
Graphite and airbrush.
Student drawing,
University of Florida.

below left: 255. Michael Hitchcock.
Project VII. The Chair.
Graphite and airbrush.
Student drawing,
University of Florida.

below right: 256. Michael Hitchcock.
Project VII. The Chair.
Graphite and airbrush.
Student drawing,
University of Florida.

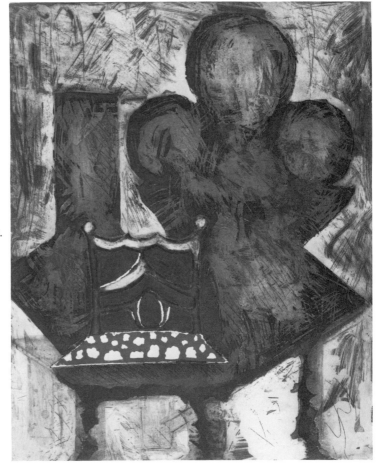

257. Michael Hitchcock.
Project VII. The Chair.
Etching. University of Florida.
Courtesy of Kenneth Kerslake.

VIII

PROJECT VIII—Figures 81, 258, 259, 260, 261, 262, 263,
264, 265, 266, 267, 268, and 269

Student—Henry Aguet
Title—*The Circle (Landscape) (Man of War)*

In this project the student specified two problems for investigation:
(1) the improvement of his technical ability to handle graphite and (2) the pos-
sibilities of drawing within the circular format. In Figures 81, 258, 259, and
260 he explored the use of landscape forms as subject matter, and the circular
picture plane was not altered. Dual images give impact to the format in Fig-
ure 261, as the two circles join and form a figure eight. In all these drawings
the student used a full range of values; the paper served as the lightest value
and the rich black produced by the soft 6B graphite the darkest.

left: 258. Henry Aguet. *Project VIII.*
The Circle-Landscape. Graphite.
Student drawing,
University of Florida.

below left: 259. Henry Aguet. *Project VIII.*
The Circle-Landscape. Graphite.
Student drawing,
University of Florida.

below right: 260. Henry Aguet. *Project VIII.*
The Circle-Landscape. Graphite.
Student drawing,
University of Florida.

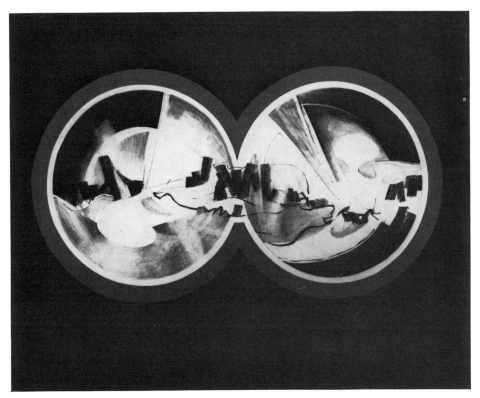

261. Henry Aguet. *Project VIII. The Circle-Landscape.* Graphite.
Student drawing, University of Florida.

The contour of a new subject, the *jellyfish (Man of War)*, did not fit as comfortably into the circular format as did the free forms of the previous subject (the landscape). Consequently, as seen in Figure 262, the student deviated from his original circle in order to make space for the long thread-like tenacles which were characteristic of his subject. Although he continued to limit his medium to graphite, he did give variety to his pencil techniques by sprinkling graphite pencil dust on wet fixative.

In Figure 266 the jellyfish fits comfortably into a large mushroom shape which is seen as the design motif of all the drawings of the subject. These shapes were also used in Figure 267 and 269, suggesting the forms of bones and barbells.

The triptych in Figure 268 is supported by color: silver around the edges of the concave rectangular shapes which house the circular units, and lavender in the background areas of these units.

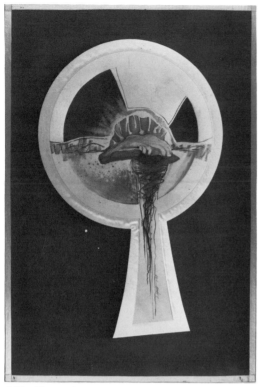

262. Henry Aguet. *Project VIII. Man-of-War.* Graphite. Student drawing, University of Florida.

263. Henry Aguet. *Project VIII. Man-of-War.* Graphite. Student drawing, University of Florida.

264. Henry Aguet. *Project VIII. Man-of-War.* Graphite. Student drawing, University of Florida.

265. Henry Aguet. *Project VIII. Man-of-War.* Graphite. Student drawing, University of Florida.

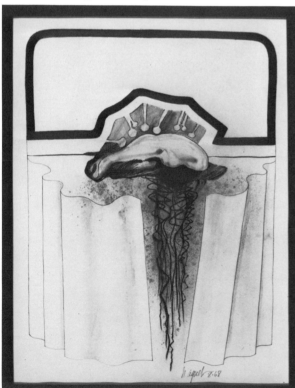

266. Henry Aguet. *Project VIII. Man-of-War*. Graphite.
Student drawing, University of Florida.

267. Henry Aguet. *Project VIII.*
Man-of-War. Graphite.
Student drawing, University of Florida.

269. Henry Aguet. *Project VIII.*
Man-of-War. Graphite.
Student drawing, University of Florida.

268. Henry Aguet. *Project VIII. Man-of-War.* Graphite and acrylic.
Student drawing, University of Florida.

IX

Student Maxine Eisen
Title—*Architecture and Clouds*

At first glance the observer might guess that this student was primarily interested in perfecting the air-brush technique, but the project which she proposed was principally concerned with the space element, trying to discover interesting ways of presenting and challenging the space within the picture plane. Careful study of the drawings will reveal that what appears to be accurate statements of linear and aerial perspective are actually purposefully incorrect; however, the student permitted herself these inaccuracies only when she felt that they would give interest and intrigue to the drawings.

The interchange and inconsistencies of the two subjects, the clouds and the geometrical shapes, also introduce certain ambiguities. At times the puffy clouds are billowy masses floating in space. Appearing lower in the composition, they attach themselves to the horizon and to the geometrical shapes below, and so appear to be the more solid elements of the landscape. A similar interchange also takes place among the geometrical shapes. At times they ap-

270. Maxine Eisen. *Project IX.*
Constructions and Clouds.
Airbrush, pen and ink.
Student drawing, University of Florida.

pear as solid forms, and as they move throughout the composition they are permitted to float in space and to intermingle with the clouds. In Figures 273, 274, and 275 one side of a geometrical shape is treated as a solid form, but on another side it appears to be transparent, permitting the cloud shapes to show through. In Figure 274 the ribbon penetrates the lower portion of the centered trapezoid, and the figure seems to be opaque or closed; in the upper portion of the same trapezoid a cloud shows through a transparent or open shape.

271. Maxine Eisen. *Project IX. Constructions and Clouds.* Airbrush, pen and ink. Student drawing, University of Florida.

272. Maxine Eisen. *Project IX. Constructions and Clouds.* Airbrush, pen and ink. Student drawing, University of Florida.

273. Maxine Eisen. *Project IX. Constructions and Clouds.* Airbrush, pen and ink. Student drawing, University of Florida.

274. Maxine Eisen. *Project IX. Constructions and Clouds.* Airbrush, pen and ink. Student drawing, University of Florida.

Even when the linear and aerial perspective is consistent, as in Figure 272, there are contradictions: the black snake-like band running across the drawing minimizes the importance of perspective and gives a degree of flatness to the overall picture plane.

A form of tiered perspective is presented in Figure 275 (acrylic on canvas). As the geometrical shapes are placed higher in the composition, they seem to recede in the same manner as do the figures in the *Rhodesian Hunting Scene* (Figure 50). The variations and contradictions of the forms in each of the three shapes are different. The repetition of the three shapes gives the composition unity, while the contrast between the forms creates variety.

275. Maxine Eisen. *Project IX. Constructions and Clouds.*
Airbrush and acrylic on canvas.
Student drawing, University of Florida.

X

PROJECT X—Figures 276, 277, 278, 279, 280, 281, and 282

Student—Beckie Hollingsworth
Title—*Chair and Window*

An advertising design student who had in previous courses and projects shown a tendency toward formal and highly technical drawing decided to work for more freedom. She felt that by using medium and soft graphite she would be able to find an informal approach to drawing.

Her initial statement was the chair and the window shown in Figure 276.

276. Beckie Hollingsworth. *Project X. Chair and Window*. Graphite. Student drawing, University of Florida.

After attempting to use the graphite more loosely in the background areas (Figure 277), the student reverted again in Figure 278 to the precision of her early work.

277. Beckie Hollingsworth. *Project X. Chair and Window.* Graphite. Student drawing, University of Florida.

278. Beckie Hollingsworth. *Project X. Chair and Window.* Graphite. Student drawing, University of Florida.

She then substituted softer graphite (4B-6B) for the medium, and in Figures 279, 280, 281, and 282 she was able to create a free and casual relationship between the objects and spaces. The flag was used with the window and chair and an interchange between the tight and loose handling of its elements, the stars and stripes, produced added intrigue. The changes in scale also helped to move the objects and spaces forward and backward in the picture plane, creating an indoor-outdoor effect.

The last two drawings (Figures 281 and 282) were satisfying to the student.

279. Beckie Hollingsworth. *Project X. Chair and Window.* Graphite. Student drawing, University of Florida.

280. Beckie Hollingsworth. *Project X.*
Chair and Window. Graphite.
Student drawing, University of Florida.

281. Beckie Hollingsworth. *Project X.*
Chair and Window. Graphite.
Student drawing,
University of Florida.

282. Beckie Hollingsworth. *Project X. Chair and Window*. Graphite.
Student drawing, University of Florida.

XI

PROJECT XI—Figures 283, 284, 285, 286, 287, 288, 289,
and 57.

Student—Richard Frank
Title—*An Architectural Environment*

 Formerly in architecture, this student chose acrylic and graphite media for his architecturally structured drawings. The problem was to combine either landscape or figures or both with an architectural environment. His first drawing (Figure 283) was entirely architectural, and in Figures 284 and 285 the landscape element was cautiously introduced. In Figure 286 an animated symmetrical form was suggested within in the building construction, and for the first time forms appeared outside as well as inside the enclosure.

283. Richard Frank. *Project XI.
An Architectural Environment.*
Acrylic and graphite.
Student drawing,
University of Florida.

284. Richard Frank. *Project XI.*
An Architectural Environment.
Acrylic and graphite.
Student drawing,
University of Florida.

285. Richard Frank. *Project XI.*
An Architectural Environment.
Acrylic and graphite.
Student drawing,
University of Florida.

In the remaining drawings the non-architectural forms become amorphous rather than animated, and the structures open to become part of the landscape in Figures 288, 289, and 57. No longer are the architectural elements confined to the original arena, but they appear as planes or dividers and work as elements of landscape on the horizon (Figures 289 and 57).

Actually the problem was one of composition—to have the informal landscape and the amorphous shapes work with the formal architectural structures. There was no problem in handling the acrylic, wash, and graphite because the student had achieved technical proficiency in previous architecture courses. Notable in the last three drawings (Figures 288, 289, and 57) was the problem involved in the creation of an interplay between the shapes and spaces drawn at different positions of depth in the picture plane.

left: 286. Richard Frank.
Project XI.
An Architectural Environment.
Acrylic and graphite.
Student drawing,
University of Florida.

opposite: 287. Richard Frank.
Project XI.
An Architectural Environment.
Acrylic and graphite.
Student drawing,
University of Florida.

288. Richard Frank. *Project XI.*
An Architectural Environment.
Acrylic and graphite.
Student drawing,
University of Florida.

289. Richard Frank.
Project XI.
An Architectural Environment.
Acrylic and graphite.
Student drawing,
University of Florida.

XII

PROJECT XII—Figures 290, 291, 292, 293, 294, and 295

Student—Marshall New
Title—*My Car*

This student stated neither a specific problem nor a specific technique. He selected his car as a subject for exploration. In Figures 290, 291, and 292 he was more concerned with drawing the silhouette, or principal contours, of the car than with descriptive renderings, but in Figures 293, 294, and 295 he selected areas within the ghost-like forms and carefully rendered them.

No effort was made to limit the media. His experiments included embossing on paper and metal, drawing with air brush, graphite, ink, and colored pencils, and stenciling.

290. Marshall New. *Project XII. My Car*. Stencil on embossed metal. Student drawing, University of Florida.

291. Marshall New. *Project XII.*
My Car. Embossed metal.
Student drawing, University of Florida.

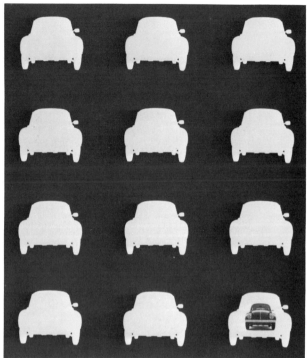

292. Marshall New. *Project XII.*
My Car. Stencil and Photo.
Student drawing, University of Florida.

293. Marshall New. *Project XII.*
My Car. Stencil and airbrush.
Student drawing, University of Florida.

294. Marshall New. *Project XII.*
My Car. Airbrush, stencil and graphite.
Student drawing, University of Florida.

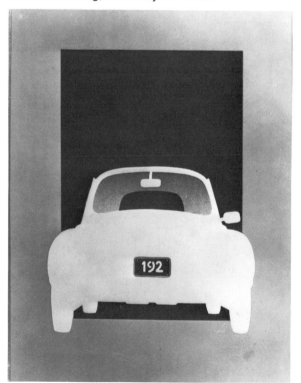

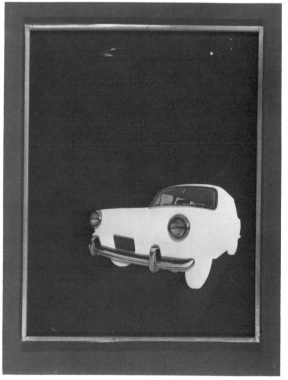

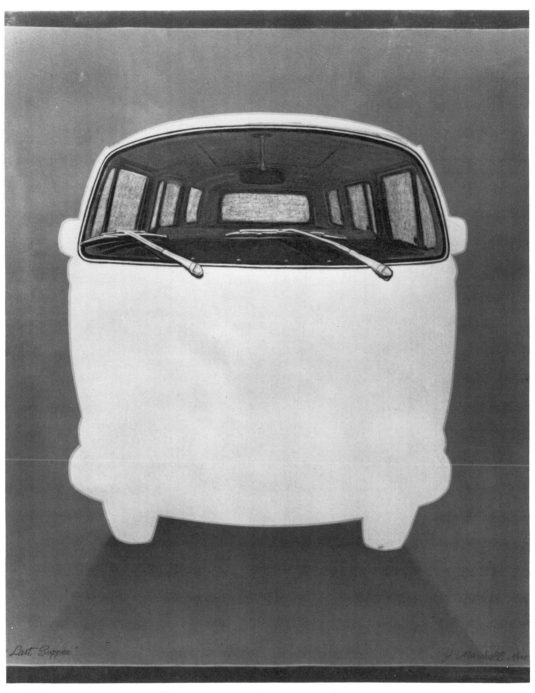

295. Marshall New. *Project XII. My Car.* Airbrush and colored crayons.
Student drawing, University of Florida.

XIII

PROJECT XIII—Figures 296, 297, 298, 299, and 300

Student—Marsha Reifman
Title—"Boy-Girl Sequence—Drawing and Photography"

The primary medium in this project was photography; the drawing was secondary. This student was a photography major, and she chose to use her drawings as background material for her serial or film story. By using photographic processes she created an interplay between the texture of the drawing and the pattern of the dress (Figures 296 and 297).

The five photographs (Figures 296-300) were part of a larger sequence in which she attempted to create interesting shapes and textures, presenting at the same time a personal and intimate subject (story).

296. Marcia Reifman. *Project XIII.*
Boy-Girl Sequence.
Photography and transfer.
Student drawing, University of Florida.

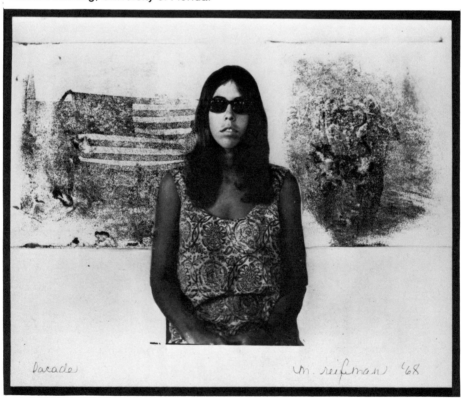

297. Marcia Reifman. *Project XIII.*
Boy-Girl Sequence.
Photography, embossing and transfer.
Student drawing, University of Florida.

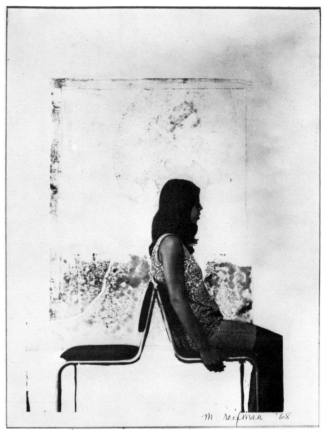

298. Marcia Reifman. *Project XIII.*
Boy-Girl Sequence.
Photography and transfer.
Student drawing, University of Florida.

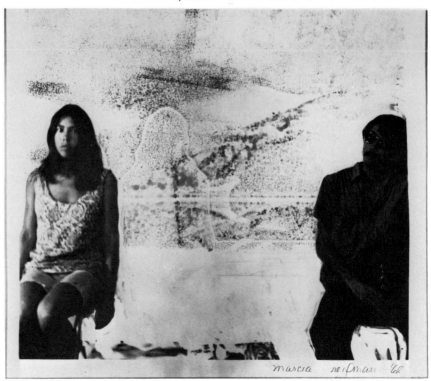

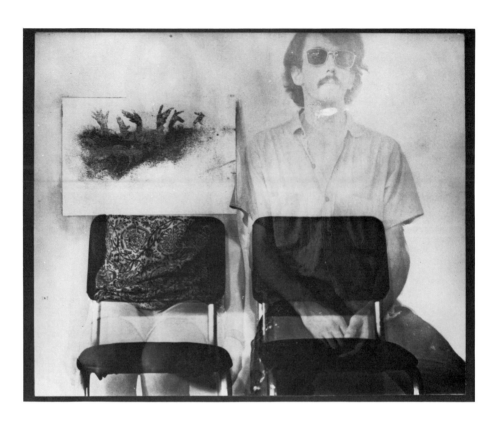

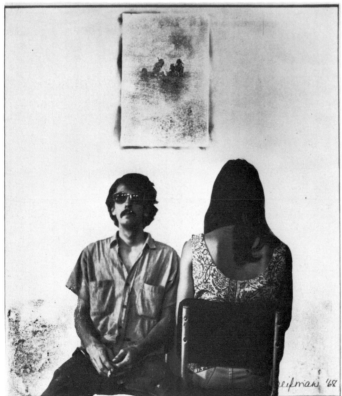

299. Marcia Reifman.
Project XIII.
Boy-Girl Sequence.
Photography, drawing
and transfer.
Student drawing,
University of Florida.

300. Marcia Reifman.
Project XIII.
Boy-Girl Sequence.
Photography and drawing.
Student drawing,
University of Florida.

XIV

PROJECT XIV—Figures 82, 120, 301, 302, and 303

Student—Abby Drew
Title—*Talking Men*

The proposal which this student submitted for her project included a definite statement of subject, *Talking Men,* and specific media, *graphite* and *collage.* Approximately twenty drawings were made in which the student used the same subject and media, as seen in Figures 82, 120, 301, and 302. She then chose to paint a front view of one set of teeth in acrylics, with graphite used sparingly for delineation (Figure 303). Here she was more interested in the impact of the picture upon the viewer than she was in showing the movement of the mouth seen in the other profile drawings.

301. Abby Drew. *Project XIV. Talking Men Series.* Collage and graphite. Student drawing, University of Florida.

302. Abby Drew. *Project XIV.*
Talking Men Series.
Collage and graphite.
Student drawing,
University of Florida.

303. Abby Drew. *Project XIV.*
Talking Men Series.
Acrylic and graphite.
Student drawing,
University of Florida.

PROJECT XV—Figures 56, 304, 305, 306, 307, 308, 309,
and 310

Student—Guilio Porta

Title—*Space Explorations—Figures, Landscape, and Architecture*

Unlike a majority of the drawings presented in these projects, the ones in this series were not done in an orderly sequence. One can readily see that this student did not stay with a problem until he had exhausted its possibilities; instead he selected others and later returned to the original one. Although the subject matter was varied, he was primarily interested in exploring ways of dealing with space within the picture plane.

In Figure 56 and Figure 308 the student was concerned with presenting an interesting and personal pattern of subject matter in conjunction with architectural structures which adhered to strict linear perspective.

In Figure 307 the linear perspective was not emphasized, but still the student achieved the same feeling of depth within the picture plane. The low horizon, the change of scale, and the placement of the figures gave depth to the space concept.

A relatively shallow space concept was drawn in Figures 304, 305, 306, and 309. The extreme dark oval of the eye socket in Figure 304 and the arbitrary dark circle in the man's chest in Figure 305 become accents; they seem to penetrate the surface of the drawing more than do the other shapes and spaces.

304. Guilio Porta. *Project XV. Series of Drawings.* Wash, watercolor and colored pencils. Student drawing, University of Florida.

305. Guilio Porta. *Project XV. Series of Drawings.* Wash, watercolor and pencil. Student drawing, University of Florida.

306. Guilio Porta. *Project XV. Series of Drawings.* Graphite and watercolor. Student drawing, University of Florida.

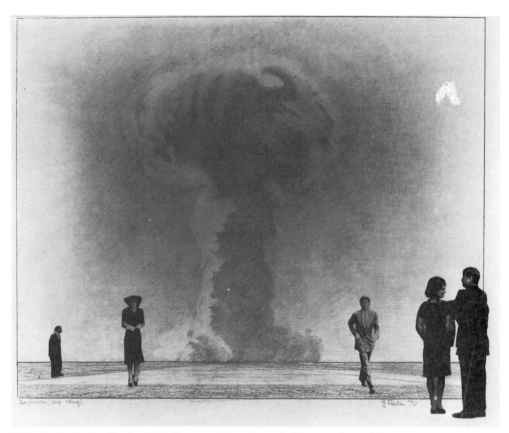

307. Guilio Porta. *Project XV. Series of Drawings*. Collage and graphite.
Student drawing, University of Florida.

308. Guilio Porta. *Project XV. Series of Drawings*. Drawing and print.
Student drawing, University of Florida.

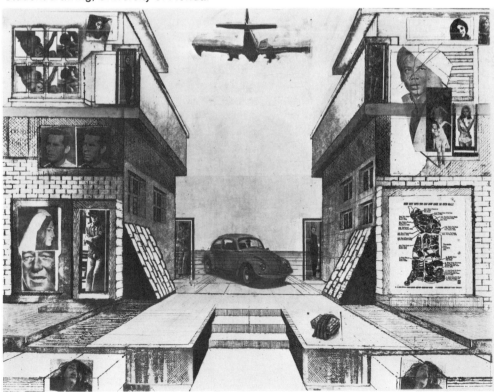

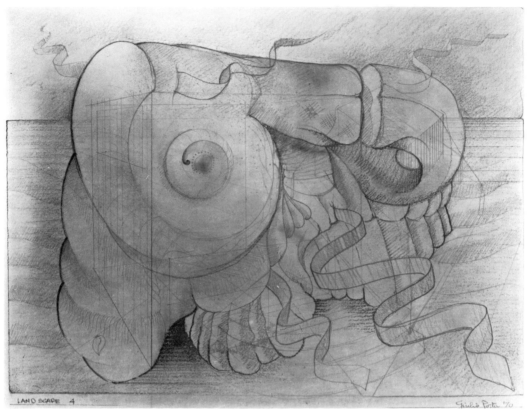

309. Guilio Porta. *Project XV. Series of Drawings.* Watercolor and graphite.
Student drawing, University of Florida.

In Figure 310 the student used ink, graphite, colored pencils, and water-color, successfully combining and controlling both a deep and a shallow play of shape and space across the surface. In contrast to the solid architectural forms on the left side of the composition, the head on the right side, although structurally represented, is two dimensional; the transparent treatment permits some background areas to appear through the face.

This student (a sculpture major) was also involved in making a set of twenty drawings for a sculpture project. The nature of these drawings for proposed pieces of sculpture was necessarily technical and exacting; for a change of pace he chose to have the compositions for the drawing class take a free and unrestricted direction. Most of these drawings were done on 22″ × 28″ paper and larger.

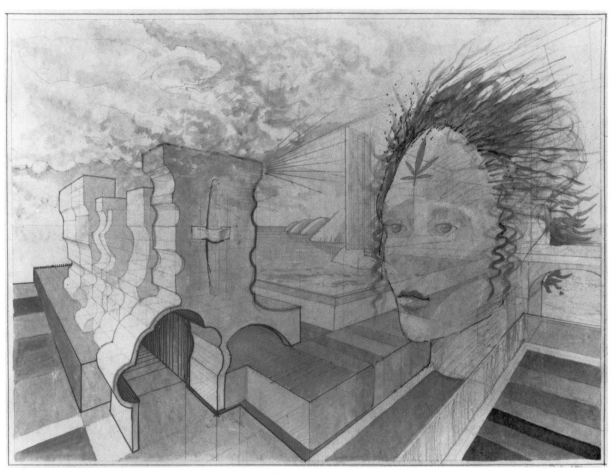

310. Guilio Porta. *Project XV. Series of Drawings.*
Watercolor, colored pencils, ink and graphite.
Student drawing, University of Florida.

XVI

PROJECT XVI—Figures 311, 312, 313, and 314

Student—David York

Title—*Car Series*

A discriminating selection of media and a meticulous execution of technique were important to the success of this project. The student used a full range of graphite from 6H to 6B, and he selected appropriate papers for the techniques to be employed. In Figures 311 and 313 linear and aerial perspective is effectively executed by the careful manipulation of graphite ranging from hard to soft on a single sheet of medium-weight drawing paper. However, in Figures 312 and 314 varying qualities and values of paper are pasted over the base sheet. In Figure 314 the (raised) hood has been cut out of a smoother and whiter paper; this gives actual dimension to the particular area of the car and permits careful modulation with the hard pencils.

The student was also concerned with creating, through texture, value variations, and subject matter, appropriate environments for the cars.

311. David York. *Project XVI. Car Series.* Graphite.
Student drawing, University of Florida.

312. David York. *Project XVI.*
Car Series.
Graphite and collage (embossed).
Student drawing,
University of Florida.

313. David York. *Project XVI. Car Series.* Graphite.
Student drawing, University of Florida.

314. David York. *Project XVI.*
Car Series. Graphite and collage.
Student drawing, University of Florida.

DRAWING RELATED TO SPECIFIC AREAS—Figures 315-334

Student—Linda Frobas (Figures 315, 316 and 317)
Area—*Sculpture*

This student made many exploratory drawings on a two-dimensional surface (Figure 315) using inscribed plexiglass, acrylic paint, and signature paper before executing two pieces of sculpture in plexiglass, neon and aluminum (Figures 316 and 317).

315. Linda Frobas. *Two-Dimensional Drawing for Sculpture.*
Inscribed plexiglass, acrylic paint and signature paper.
Student drawing, University of Florida.

316. Linda Frobas. *Sculpture.*
Plexiglass, Neon and aluminum.
Student work, University of Florida.
Courtesy of Geoffry Naylor.

317. Linda Frobas. *Sculpture.*
Plexiglass and Neon.
Student work, University of Florida.
Courtesy of Geoffry Naylor.

II

Student—Ed Hart (Figures 318 and 319)

Area—*Sculpture*

A graphite working drawing (Figure 318) was made before constructing the final piece of sculpture in wood and mirrored metal (Figure 319).

318. Ed Hart. *Drawing for Sculpture*.
Graphite. Student drawing,
University of Florida.

319. Ed Hart. *Sculpture Project*.
Wood and mirrored metal.
Student work, University of Florida.
Courtesy of Geoffry Naylor.

III

Student—Raphael Fiol (Figure 320)

Area—*Advertising Design*

This student, who chose to explore pen and ink in Project II, used the same medium for a problem in a design class.

320. Raphael Fiol. *Design Project*. Graphite.
Student work, University of Florida.
Courtesy of Jack Nichelson.

IV

Student—Robert Margulies (Figure 321)

Area—*Illustration*

 Figure 321 was one of many graphite drawings by a student interested in medical illustration.

321. Robert Margulies. *Drawing from Cadaver.*
(University of Florida Medical Center). Graphite.
Student work, University of Florida.

V

Student—Helen Phillips (Figure 322)

Area—*Ceramics*

This student was interested in the use of the human figure as a design motif for her ceramics. One project involved drawing directly from the model on a series of ceramic plates. Another project involved using her sketches in adapting the human figure to a series of ceramic boxes (Figure 322).

322. Helen Phillips. *Ceramic Box*. Salt glaze, stoneware.
Student work, University of Florida.

VI

Student—Jere Lykins

Area—*Ceramics*

In Figure 323 the ceramist has combined modeling and drawing on the wet clay to give meaning to his raku wall relief.

323. Jere Lykins. *Underland Cliff Temple Location with Staircase.* Raku wall relief. Ceramist, Berry College.

VII

Students—James Ashley (Figure 324) and Alan Brewster (Figure 325)
Area—*Printmaking*

Both of these students made drawings to be used in a printmaking class.

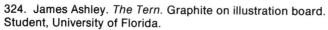

324. James Ashley. *The Tern.* Graphite on illustration board. Student, University of Florida.

325. Alan Brewster. *Seated Couple.* Graphite. Student work, University of Florida.

VIII

Student—Gary Branam (Figures 326, 327, 328, 329 and 330)
Area—*Painting*
These drawings were made from the posed model for a painting project.

326. Gary Branam. *Figure Study for Painting*. Pencil, acrylic and spray paint. Student drawing, University of Florida.

left: 327. Gary Branam.
Figure Study for Painting.
Pencil, acrylic and spray paint.
Student drawing, University of Florida.

below left: 328. Gary Branam.
Figure Study for Painting.
Pencil, acrylic and
spray paint.
Student drawing,
University of Florida.

below right: 329. Gary Branam.
Figure Study for Painting.
Pencil, acrylic and
spray paint.
Student drawing,
University of Florida.

330. Gary Branam. *Figure Study for Painting*. Pencil, acrylic and spray paint. Student drawing, University of Florida.

IX

Student—Beverly Miskin (Figures 331 and 332)
Area—*Photography*

Graphite and torn paper were used with silverprint for a series of photo-drawings (Figure 332).

331. Beverly Miskin. *Photo-Drawing.* Silverprint and graphite.
Student, University of Florida.

332. Beverly Miskin. *Photo-Drawing*. Silverprint, graphite and torn paper. Student, University of Florida.

X

Student—Diane Farris (Figure 333)

Area—*Photography*

 Drawing was used sparingly as an accent by this photography major.

333. Diane Farris. *Introduce Figure*. Photo-drawing. Student, University of Florida. Courtesy of Jerry Uelsmann.

CONTEMPORARY APPROACHES TO DRAWING: Today the approaches to drawing are too numerous and varied to group into a few major categories. Each of the art movements of the first half of the twentieth century, among them fauvism, cubism, expressionism, dadism, futurism, abstractionism, surrealism, and abstract expressionism, presents clear-cut and definite characteristics. The movements supplanting abstract expressionism in the late 1950's and early 1960's produced many revolutionary trends; they are characterized by *experimentation* and *rapid transition*. These changes have occurred so fast that they have allowed little time for critical analysis or labeling. We offer "experimental transitionism" as a term to describe the character and direction of the recent movements in art.

The present diversity of techniques, media, ideas, purposes, and philosophies has opened many creative possibilities in the drawing area, especially to those whose individual expressions are of an intimate and personal nature.

In an effort to determine the limits of what may be properly called drawing today, John Petruchyk, art instructor in drawing, has divided contemporary works into two definite categories: those which employ strictly traditional drawing media and those which use a format that is significantly linear. Because of his interest and knowledge in these transitory trends in art, I have asked Mr. Petruchyk to discuss recent developments in drawing. He states:

"If current art is seen to be in a state of flux, or transition, then recent developments in drawing necessarily reflect this transitory status. It may already appear that one result of transition has been to obscure, or even eliminate, traditional boundaries separating various orders of undertakings within the visual arts. Clear distinctions between drawing, painting, or sculpture seem to be rapidly vanishing, at least in regard to their usefulness as discursive criteria. Perhaps a re-evaluation will result in time. Perhaps altogether new and as yet unformulated categories will replace them. Or perhaps, but least likely, departmentalization will itself be superseded by other systems for the ordering of experiences in the visual arts.

"Because contemporary art is not so often concerned with the rendering of a likeness to the objects around us, the traditional means of representing these objects in terms of drawing have become disengaged from the corresponding forms in the third dimension. That is, line does not necessarily signify edge nor value light. An important area of contemporary drawing involves a play on the concept of representation and the thing represented. A re-evaluation of the traditional duality of form and content is undergone. A drawing may still be a picture of something, but it would be so much more self-consciously. As an example, a picture is drawn from a photograph, in preference to drawing from life. Rather than using the photograph as a point of departure, or as a means of recollection, the photograph becomes the subject. In effect, the manner in which the photograph records images, rather than the image it has recorded, becomes the

principle subject matter in the drawing. In this way conventional illusionism is deleted from the representation. In his later drawings Jasper Johns has reinvestigated the problems of representation earlier explored in his painting and sculpture. In drawings of juxtaposed numerals he alludes to space in a non-spatial subject and employs line as boundary but not as edge. In some of his flag drawings the illusion of space occurs unexpectedly in the apparently dog-eared corner of the drawing paper, at once countering traditional deep space illusion and presenting the drawing as a reconstruction rather than a representation of its flag subject.

"Frequently contemporary drawing is used to convey concepts that make no reference to physical space. Such drawing may be diagrammatic, meant to aid the viewer in reconstructing the concept intended by the artist. Or the drawing may be used in the sense of a demonstration to carry the concept from artist to viewer.

"A second class of 'drawing' comprising a large portion of current artistic activity falls into the latter definition cited above, that is, works distinguished by a fundamentally linear quality. Works in this category include what is perhaps the most extreme extension of draughtsmanship to date. Examples range from a multiplicity of undertakings in rope, wire, metal rods, elastic cords, yarn, chalk marks, spewed molten lead, and other sundry linear material to a number of 'earthworks' in linear form. Whether the particular work is a trench cut in the desert, a meandering line incised in a wheatfield by selective harvesting, or a spiraling breakwater of piled rock, the generalized effect is one of line against plane; the earth's surface becoming the plane, the line being on a comparable scale. In reference to these works the word 'drawing' is used as a verb describing an activity, rather than as a noun classifying an order of objects. The drawing of the particular activity concerned here is the process of making lines on a plane. It is, of course, still true that, with the possible exception of the more extreme forms of 'conceptual art,' some perceptual configuration, some object, is involved in the result."

Sole emphasis upon strict adherence to a rational approach to drawing has prevented many young artists from reaching their potential. The strength of the visual arts lies in the individual artist's ability to become involved in creative activity rather than to search for truths obtained only through logical reasoning. However, a philosophical attitude is essential to those who undertake any worthwhile endeavor, and such an attitude is also vital to the artist. There must be, first, *honesty of purpose*; there must be, second, *constructive activity*, and there must be, third, *recognition of fulfillment*.

The first is so personal to the student that often he will avoid verbal explanations and show evidence of his intentions only through constructive activity (and eventually through fulfillment). Some students are able to state clearly a definite purpose regarding their creative activity, while others are

able merely to say that they wish to create. Few teachers will question a student's honesty of purpose; they assume that he would not give his time and effort to drawing if he was not of serious intent. But activity alone is not sufficient. Honesty of purpose suggests constructive activity aimed toward individual expression and ultimate fulfillment. Pointless and sluggish activity falls behind the more acceptable individual creative approach and often prevents the student from recognizing fulfillment when it appears.

A student's self-evaluation regarding purpose and intent may be helpful to him. Sometimes, anxious to impress the teacher and classmates, the student tries to make each drawing a top performance. He should instead be willing to experience retrogression and failures in order fully to search out his needs. He should make no attempt to gloss it over; that is, to impress or excel by nurturing the more comfortable practices which are barren of challenge and which usually camouflage weaknesses. Honest appraisal aimed at eliminating deficiencies should develop the student's confidence and give more authority to his drawings.

Knowing when to accept fulfillment is all-important. As a student begins to explore a problem and to proceed with its development, the instructor may easily point out errors and direct attention to new possibilities. But regarding fulfillment, the instructor's role must be less directive; the truly advanced student knows his purpose and intent and is often in a better position than the teacher to recognize success. *To the creative person fulfillment is a continuing process, a progression of achievements without finality.*

BIBLIOGRAPHY

ADHEMAR, J., *French Drawings of the XVI Century.* New York: Vanguard Press, 1955.

ALBERT, C. AND SECKLER, D., *Figure Drawing Comes to Life.* New York: Reinhold Publishing Corp., 1957.

AMES, W., *Italian Drawings.* New York: Shorewood Publishers, Inc., 1963.

BARCSAY, J., *Anatomy for the Artist.* Budapest: Corvina, 1955.

BENESCH, OTTO, *Venetian Drawings of the Eighteenth Century in America.* New York: H. Bittner and Company, 1947.

BENESCH, O., *The Drawings of Rembrandt,* 6 vols. London: The Phaidon Press, Ltd., 1954-57.

BENESCH, O., *Rembrandt, Selected Drawings.* New York: Oxford University Press, 1947.

BERGER, K., *Gericault, Drawings and Watercolors.* New York: H. Bittner & Co., 1946.

BERGER, K., *French Drawings of the Nineteenth Century.* New York: Harper & Row, Publishers, 1950.

BLUNT, A., *The Art of William Blake.* New York: Columbia University Press, 1959.

BLUNT, ANTHONY, *The French Drawings at Windsor Castle.* London: Phaidon Press, 1945.

BLUNT, A. AND CROFT-MURRAY E., *Venetian Drawings at Windsor Castle.* London: Phaidon Press, 1957.

BOWIE, T., *The Drawings of Hokusai.* Bloomington, Ind.: Indiana University Press, 1964.

BRADSHAW, P., *The Magic of Line.* New York: Studio Publications, The Viking Press, Inc., 1949.

BRIDGMAN, GEORGE, *Life Drawing.* New York: Sterling Publishing Co., Inc., 1961.

BRIDGMAN, GEORGE, *Constructive Anatomy.*

CALDERON, W. FRANK, *Animal Painting and Anatomy.* Philadelphia: Lippincott.

CHAET, BERNARD, *The Art of Drawing.* New York: Holt Rinehart Winston.

CLARK, K., *Leonardo Drawings at Windsor Palace,* 2 vols. New York: The Macmillan Company, 1935.

COLE, REX VICAT, *Perspective as Applied to Pictures.* Philadelphia: Lippincott, n.d.

COOMARASWAMY, A. K., *Indian Drawings*. London: Royal Indian Society, 1912.

CORDIER, DANIEL, *The Drawings of Jean Dubuffet*. New York: George Braziller, Inc., 1960.

DUNLOP, JAMES, M., *Anatomical Diagrams for the Use of Art Students*. New York: Macmillan, 1929.

D'ALBANELLA, *Venetian Drawings, XIV-XVII Centuries*. New York: The Hyperion Press, 1949.

DE TOLNAY, C., *History and Technique of Old Master Drawings, a Handbook*. New York: H. Bittner & Co., 1943.

DODGSON, CAMPBELL, *Modern Drawings*. London: Studio 1933.

EITNER, L., *Gericault, an Album of Drawings in the Art Institute of Chicago*. Chicago: University of Chicago Press, 1960.

FRANK, ARTHUR J., *Drawing for Everyone*. New York: A. S. Barnes and Co., Inc., 1962.

FRIEDLAENDER, W., *The Drawings of Nicolas Poussin*, 4 vols. London: The Warburg Institute, 1949.

FRIPP, SIR ALFRED AND RALPH THOMPSON, *Human Anatomy for Art Students*. Philadelphia: Lippincott, n.d.

GROSZ, GEORGE, *Drawings*. New York: H. Bittner and Co., 1944.

GIBBEY JOSEPH C., *Technical Illustration*. Chicago: American Technical Society, 1962.

GOLDSTEIN, NATHAN, *The Art of Responsive Drawing*. Englewood Cliffs, N. J.: Prentice-Hall, 1973.

GROHMANN, W., *The Drawings of Paul Klee*. New York: Curt Valentin, 1944.

GUPTIL, A., *Pencil Drawing Step by Step*. New York: Reinhold Publishing Corp., 1949.

HALE, ROBERT BEVERLY, *Drawing Lessons from the Great Masters*. New York: Watson-Guptil, Pubns, Inc., 1964.

HAVINDEN, A., *Line Drawing for Reproduction*. New York: Studio Publications, The Viking Press, Inc., 1941.

HAVERKAMP-BEGEMANN, E., *Drawings from the Clark Institute*, 2 vols. New Haven, Conn.: Yale University Press, 1964.

HELD, J. S., *Rubens: Selected Drawings*, 2 vols. London: Phaidon Press, 1959.

HERBERTS, K., *The Complete Book of Artists' Techniques*. New York: Frederick A. Praeger, In., 1958.

HOLME, BRYAN, ed., *Master Drawings*. London: Studio, 1943.

HOLMES, CHARLES, *Modern Pen Drawings: European and American*. New York: Studio Publications, The Viking Press, Inc., 1921.

HUBBARD, E. H., *Some Victorian Draughtsmen*. Cambridge: Macmillan (Toronto), 1944.

HUYGHE, RENE, *French Drawings of the Nineteenth Century*. New York: The Vanguard Press, Inc., 1956.

KLEE, P., *Pedagogical Sketchbook*. New York: Neirendorf Gallery, 1944.

KURZ, O., *Bolognese Drawings at Windsor Castle*. London: Phaidon Press, 1955.

LECLERK, A., *Flemish Drawings, XV-XVI Centuries*. New York: The Hyperion Press, 1949.

LOZOWICK, LOUIS, *A Treasury of Drawings*. New York: Lear Publishers, 1948.

MACFALL, H., *Aubrey Beardsley*. New York: Simon and Schuster, Inc., 1927.

MAISON, K., *Daumier Drawings*. New York: Sagamore Press, 1960.

MARSH, REGINALD, *Anatomy for Artists*. New York: American Artists Group, 1945.

MAYER, R., *The Artist's Handbook of Materials and Techniques*, Rev. Ed. New York: The Viking Press, Inc., 1957.

MEDWORTH, FRANK, *Perspective*. New York: Scribner's, 1937.

MELLAART, J. H. J., *Dutch Drawings of the Seventeenth Century*. London: E. Benn, Ltd., 1926.

MENDELOWITZ, DANIEL M., *Drawing*. New York: Holt Rinehart Winston.

METROPOLITAN MUSEUM OF ART, *European Drawings from the Collection of the Metropolitan Museum of Art*. New York: Metropolitan Museum of Art, 1943.

MIDDELDORF, U., *Raphael's Drawings*. New York: H. Bittner and Co., 1945.

MONGAN, AGNES, *100 Master Drawings*. Cambridge, Mass.: Harvard University Press, 1949.

MONGAN, AGNES, AND SACHS, PAUL J., *Drawings in the Fogg Museum of Art*. Cambridge, Mass.: Harvard University Press, 1946.

MOSKOWITZ, I., ed., *Great Drawings of All Time*, 4 vols. New York: Sherwood Publishers, Inc., 1962.

MUCHALL-VIEBROOK, T. W., *Flemish Drawings of the Seventeenth Century*. London: E. Benn, Ltd., 1926.

MUNZ, L., *Bruegel, the Drawings*. London: Phaidon Press, 1961.

MURRELL, W., *A History of American Graphic Humor*, 2 vols. New York: Whitney Museum of American Art, 1933.

MUSEUM OF MODERN ART, JUNIOR COUNCIL, *Recent Drawings*, U. S. A. New York: Museum of Modern Art, 1956.

NICOLAIDES, KIMON, *The Natural Way to Draw*. Boston: Houghton Mifflin Company, 1941.

NORLING, E., *Perspective Made Easy*. New York: The MacMillan Company, 1946.

NORTON, DORA M. *Freehand Perspective and Sketching*. Pelham, New York: Bridgman Publishers, 1929.

OPPE, A. E., *English Drawings at Windsor Castle*. London: Phaidon Press, 1950.

PARKER, K. T., *Drawings of the Early German Schools*. London: Ernest Benn, Ltd., 1926.

PARKER, K. T., *North Italian Drawings of the Quattrocento*. London: E. Benn, Ltd., 1927.

PARKER, K. T., *The Drawings of Holbein at Windsor Castle*. London: Phaidon Press, 1945.

PECK, S. R., *Atlas of Human Anatomy for the Artist*. New York: Oxford University Press, 1951.

PITZ, H., *Pen, Brush and Ink*. New York: Watson-Guptil Pubns., Inc., 1949.

POPE, ARTHUR, *The Language of Drawing and Painting*. Cambridge, Mass.: Harvard University Press, 1921, 1931, 1949.

POPE, ANNE MARIE, *German Drawings*. Washington, D. C.: Smithsonian Institution, 1955-56.

POPHAM, A. E., *Drawings of the Early Flemish School*. London: E. Benn, Ltd., 1926.

POPHAM, A. E., AND WILDE, J., *Italian Drawings of the XV and XVI Centuries at Windsor Castle*. London: Phaidon Press, 1949.

POPHAM, A. E., AND POUNCEY, P., *Italian Drawings in the Department of Prints and Drawings in the British Museum*, 2 vols. London: The British Museum, 1950.

POPHAM, A. E., *Selected Drawings from Windsor Castle, Raphael and Michelangelo*. London: Phaidon Press, 1954.

PUYVELDE, LEO VAN, *Flemish Drawings at Windsor Castle*. New York: Oxford University Press, 1942.

REARICK, J., *The Drawings of Pontormo*, 2 vols. Cambridge, Mass.: Harvard University Press, 1964.

REITLINGER, H. C., *Old Master Drawings*. New York: Moffat, Yard & Co., 1923.

REWALD, J., ed., *Renoir's Drawings*. New York: H. Bittner, 1946.

REYNOLDS, G., *Nineteenth Century Drawings*. London: Pleiades Books, 1949.

RICHARDSON, J., *Manet: Paintings and Drawings*. London: 1958.

ROSENBERG, J., *Great Draughtsmen*. Cambridge, Mass.: Harvard University Press, 1959.

RUBENS, DAVID K. *The Human Figure, Anatomy for Artists*. New York: The Viking Press, 1953.

SACHS, PAUL J., *Modern Prints and Drawings*. New York: Alfred A. Knopf, Inc., 1954.

SCHELLER, R. W., *A Survey of Medieval Model Books.* Haarlem: De Erven F. Bohn N. V., 1963.

SCHNEIWIND, CARL, *Drawings from 12 Countries, 1945-1952.* Chicago: The Art Institute of Chicago, 1952.

SCHULER, J. E., *Great Drawings of the Masters.* New York: G. P. Putnam's Sons, 1963.

SELIGMAN, GERMAIN, *The Drawings of Georges Seurat.* New York: Curt Valentin, 1947?

SHAW, J. B., *The Drawings of Francesco Guardi.* Boston: Boston Book, 1955.

SICRE, J., *Spanish Drawings XV-XIX Centuries.* New York: The Hyperion Press, 1949.

SLATKIN, C. E. AND SHOOLMAN, R., *A Treasury of American Drawings.* New York: Oxford University Press, 1947.

SUTTON, D., *French Drawings of the Eighteenth Century.* London: Pleiades Books, 1949.

THOMAS, H., *The Drawings of Piranesi.* London: Faber & Faber, 1942.

TIETZE, H., *European Master Drawings in the United States.* Toronto: Clarke, Irwin, 1947.

TONEY, ANTHONY, *150 Masterpieces of Drawing.* New York: Dover Publications, Inc., 1963.

UEBERWASSER, WALTER, *Drawings by European Masters from the Albertina.* New York: Iris Books, Oxford University Press, 1948.

UNIVERSITY OF MINNESOTA GALLERY, *The Nineteenth Century: One Hundred Twenty-five Master Drawings.* Minneapolis: University of Minnesota, 1962.

VAN SCHAAK, E., *Master Drawings in Private Collections.* New York: Lambert-Spector, Inc., 1962.

VANDERPOEL, JOHN H., *The Human Figure.* Chicago: Inland Printer, 1930.

VON HADELYN, D. B., *The Drawings of Tiepolo*, 2 vols. New York: Harcourt Brace & World, Inc., 1929.

WALKER, R. A., (collected and edited by), *The Best of Beardsley.* London: The Bodley Head Ltd., 1948.

WATROUS, JAMES, *The Craft of Old Master Drawings.* Madison, Wisc.: The University of Wisconsin Press, 1957.

WATSON, ERNEST W., *How to Use Creative Perspective.* New York: Reinhold Publishing Co., 1955.

WHEELER, MONROE AND REWALD, JOHN, *Modern Drawings.* New York: The Museum of Modern Art and Simon and Schuster, Inc., 1947.

WITTKOWER, R., *Carracci Drawings at Windsor Castle.* London: Phaidon Press, 1952.

YALE UNIVERSITY PRESS, *The Drawings of Edwin Dickinson*, New Haven, Conn.: Yale University Press, 1963.

INDEX

Abularach, Rodolfe, 91
 Stele, 91, Fig. 91
Acrylic, 95, 102, 284
Addis, Don, 148
 Cross Contour, 148, Fig. 139
Aerial perspective, 55
Aguet, Henry, 81, 171, 269, 271
 Circle-Landscape, 81, 269, Figs. 81, 258-261
 Man of War, 271, Fig. 262-269
 Overlapping Figures, 171, Fig. 155
Anatomy, 181, 183, Figs. 163-165
Architectural Environment Series, Frank, 55, 284, 286, Figs. 57, 283-289
Ashley, James, 312, Fig. 324
At the Concert, Seurat, 15, Fig. 10

Back View of Figure, Nickels, 160, Fig. 146
Baker, Mary Anne, 171
 Overlapping Figures—Variation, 171, Fig. 157
Balance, 63, 65, Figs. 63, 64, 65
Balsa, 163, Figs. 149-151
Bathers, The, Picasso, 40, Fig. 38
Bathers, The, Renoir, 109, Fig. 111
Battle of the Fishes, Masson, 31, Fig. 26
Beardsley, Aubrey, 91
 A Reflection of Tristan and Isolde, 91, Fig. 89
Bearing the Cross, Poussin, 106, Fig. 107
Bee Keepers, Bruegel, 40, Fig. 39
Benson, Guy, 11
 Line Statements, 11, Fig. 6
Betrothal, The, Gorky, 44, Fig. 44
Bistre, 89, 98
Black Countess, Study for, Lautrec, 9, Fig. 3
Bone Structure Composition, Schaaf, 180, Fig. 162
Bonnard, Pierre, 21
 La Promenade, 21, Fig. 12
Boucher, Francois, 40, 98, 103, 161
 Reclining Nude, 40, Fig. 40
 Eros and Psyche, 68, 103, 161, Fig. 99
Boy-Girl Sequence, Reifman, 292, Figs. 296-300
Bradley, Ray, 183
 Surface Muscles, 183, Fig. 164
Branam, Gary, 313, Figs. 326-330
Brewster, Allen, 312, Fig. 325
Bristow, William, 36
 Landscape, 36, Fig. 35
Bruegel, Pieter, The Elder, 40
 The Bee Keepers, 40, Fig. 39
Brumley, Stan, 44
 Study in Form, 44, Fig. 46
Built Contour, New, 167, Fig. 153
Burial Scene of a King, Rhodesia, 50, Fig. 51

Cadmus, Paul, 205
 Inventor, 205, Fig. 181
Calder, Alexander, 95
 Hippopotamus, 95, Fig. 96
Calligraphic, 97
Car Series, York, 302, Figs. 311-314
Caravaggio, Attributed to, 98
 Study, 98, Fig. 97
Chair, The, Hitchcock, 266-267, Figs. 252-257
Chair and Window, Hollingsworth, 279-281, Figs. 276-282
Chalks and Crayons, 109, 111-113, Figs. 110-114
Charcoal, 83, 85, 197, 199, Figs. 172, 173
Chesser, Ron, 48, 63, 79, 217-218
 Running Figure Series, 48, 63, 79, 217-218, Figs. 49, 62, 79, 192-194
Christ in Limbo, Osservanza Master Painting, 70, Fig. 70
Circle-Landscape, Aguet, 81, 269, Figs. 258-261
Clara Kern, 47
 Figure Movement, 47, Fig. 48
Close-Ups, Isaacson, 234, Fig. 215
Clouds, The, Pinnell, 255-256, Figs. 237-240
Collage, 82, 85, 122-123, 295, Figs. 82, 120, 301-303
Color, 15, 38-39
Composition, Leigh, 121, Fig. 117
Composition, principles of, 57-70
Construction and Cloud Series, Eisen, 63, 275, 276, 278, Figs. 64, 270-275
Conté, 75, 113, 135
Contemporary approaches to Drawing, 318-320
Contour, 146, Figs. 38, 134, 135
Contour, cross, 146, 148, Figs. 135-139
Contour, built, 167, 195, Figs. 11, 17, 37
Contrast, 68
Control, 4-6
Coover, Mary, 201
 Two Model Series, 201, Figs. 174-179
Craven, Lorna Andrea, 109
 Gray Pastel, 109, Fig. 112
Craven, Roy, 157
 Seated Figure, 157, Fig. 145
Crayons (see chalks)
Creative expression, 4
Cremonini, Leonardo, 91, 188
 Maternity, 91, 188, Fig. 90
Crosshatching, 78, 83, 90, Figs. 77, 80, 88
Curtis, Sally, 191
 Diagonal Technique, 191, Fig. 168
Cylinders, 43, Figs. 42 (a, b, c)

Delacroix, Eugene, 66
 The Giaour on Horseback, 66, Fig. 68

Design Project, Fiol, 308, Fig. 320
Deux Femmes Nues, Maillol, 21, Fig. 14
Diagonal Technique, 77, 190-191, Figs. 75, 168, 169
Divers, The, Study for, Leger, 32, Fig. 28
Drawing, definition, 4-5
Drawing from Museum Collection, 36, 79, 213-215, Figs. 78, 187-191
Drawing from the Nazi Series, Lasansky, 21, Fig. 20
Drawing from Sketchbook, Schaaf, 11, Fig. 8
Drew, Abby, 82, 123, 139, 295
 Talking Men Series, 82, 123, 295, Figs. 82, 120, 301-303
 Structure Drawing, 139, Fig. 128
Dürer, Albrecht, 15, 122
 Rape of Europa, 15, Fig. 9
 The Hands of St. Domenic in the Feast of the Rose Garlands, 148, Fig. 137

Egyptian, Old Kingdom, 39, Fig. 36
Eisen, Maxine, 63, 275, 276, 278
 Construction and Cloud Series, 63, 275, 276, 278, Figs. 64, 270-275
Elements, art, 15-55
Emphasis, 69-70
Eros and Psyche, Boucher, 98, 103, 161, Fig. 99
Etching, Fiol, 248, Fig. 233
Expecting Rain, Nettles, 55, 108, Fig. 109
Experimentation, 3-4
Eye Series, Williams, 234, Figs. 210-211
Eyes, Nesler, 123, Fig. 119

F. C. Scale, 4-6
Farris, Dianne, 29, 317
 Introduce Figure, 29, 317, Fig. 333
Fighting Men, Raphael, 68, Fig. 69
Figure and Landscape, Law, 208, Fig. 182
Figures and Animals in Deep Architectural View, 53, Fig. 55
Figure Drawing, 125-129
Figure Interpretation, Lazzo, 44, Fig. 45
Figures in Movement, Nickels, 168, Fig. 154
Figure Movement, Kern, 48, 169, Fig. 48
Fiol, Raphael, 36, 91, 247-248, 308
 Pen and Ink Techniques, 36, 91, 247-248, Figs. 92, 225-233
 Design Project, 308, Fig. 320
Form, 15, 39-40, 43-44
Frank, Richard, 55, 284, 286
 Architectural Environment Series, 55, 284, 286, Figs. 57, 283-289
Freedom, 4-6
Frobas, Linda, 305, Figs. 315-317
Fullerton, Paul, 77, 191
 Diagonal Technique, 77, 191, Fig. 75

G. S. Drawings (gesture-structure), 43, 143, Figs. 132, 133
Gelvan, Ella, 104, Fig. 103
Gericault, Théodore, 9, 34
 Leaf 50 from Sketchbook, 9, 34, Fig. 2
Gesso, 75, 103, 116-118, 208-209, Figs. 73, 115, 183
Gesture drawings, 135-136, Figs. 123, 124, 133
Giaour on Horseback, The, Delacroix, 66, Fig. 68

Gill, James, 63
 Laughing Woman and Close-up, 63, Fig. 63
Gonda, William, 90
 Sculpture Forms, 90, Fig. 87
Gondolfi, Gaetano, 53
 Figures and Animals in Deep Architectural View, 53, Fig. 55
Gorky, Arshile, 44
 The Betrothal II, 44, Fig. 44
Graphite pencils, 75-79, 81-82
Gray Pastel, Craven, 109, Fig. 112
Grounds, 114-120

Haber, Judy, 75
 Rock Shapes and Landscape, 75, Fig. 73
Hands of St. Domenic in the Feast of the Rose Garlands, The, Durer, 148, Fig. 137
Haney, Suzanne, 160, 163
 Reclining Figure, 160, Fig. 147
 Standing Figure, 163, Fig. 149
Hanging Scroll, Japanese, 52, Fig. 53
Hart, Ed, 307, Figs. 318-319
Hatching, 77, 190
Head Drawing, 176-177
Head of a Satyr, Michelangelo, 78, Fig. 88
Helseth, Joe, 228
 Slide Projected on Model, 228, Fig. 209
Hippopotamus, Calder, 95, Fig. 96
Hitchcock, Mike, 218, 266-267
 Creative Problems from Museum Objects, 218, Fig. 195
 Etching, 267, Fig. 257
 The Chair, 266-267, Figs. 252-257
Holbein, Hans, 19, 166
 A Lady Unknown, 19, 166, Fig. 11
Hollingsworth, Beckie, 279, 281
 Chair and Window, 279, 281, Figs. 276-282
Horse and Rider, Smith, 21, Fig. 18
Horses and Riders, Lautrec, 43, Fig. 133
Horse in Action, Richbourg, 21, 169, Fig. 23
Hunting Scene, Rhodesia, 50, Fig. 50

Indian, Jaipur, 21
 Seated Courtier with Sword, 21, Fig. 17
Ingres, Jean-Auguste, 21, 40, 167
 Study of Female Head and Arms, 21, 167, Fig. 15
 Two Nudes, 40, 166, Fig. 37
Ink, 88-91, 152-153, 247-248
Introduction, 3-6
Introduce Figure, Farris, 29, 317, Fig. 333
Inventor, Cadmus, 205, Fig. 181
Isaacson, Marcia, 234
 Close-Ups, 234, Fig. 215
Isometric perspective, 52

Jewessen, Ken, 223
 Light Box and Balsa, 223, Fig. 200

Kern, Clara, 48, 169
 Figure Movement, 48, 169, Fig. 48
Kerslake, Kenneth, 9
 Sketch for Print, 9, Fig. 4

Klee, Paul, 52
 Santa A in B, 52, Fig. 54
Kolbe, George, 101, 158
 Nude Study, 101, Fig. 101
Kritzer, Rona, 226, Figs. 204-206

L'Assommoir, Renoir, 191, Fig. 171
La Promenade, Bonnard, 21, Fig. 12
La Source, Prud'hon, 109, 185, 205, Fig. 110
Lady Unknown, A, Holbein, 19, 166, Fig. 11
Landscape, Bristow, 36, Fig. 35
Landing, Nettles, 85, Fig. 85
Lasansky, Mauricio, 21
 Drawing from the Nazi Series, 21, Fig. 20
Laughing Woman and Close-Up, Gill, 63, Fig. 63
Law, Aaron, 85, 208, 259-260
 Seated Figure, 85, Fig. 86
 Figure and Landscape, 208, Fig. 182
 Water Hyacinth, 259-260, Figs. 241-246
Lazzo, C., 44
 Figure Interpretation, 44, Fig. 45
LeMasters, Charles, 214, 220
 Drawings from Museum Collection, 214, Fig. 188
 Creative Problem from Museum Objects, 220, Figs. 196-199
Leaf 50 from Sketchbook, Gericault, 9, 34, Fig. 2
Lebrun, Rico, 21, 58
 Veterans, 21, Fig. 13
Leger, Fernand, 32
 The Divers, 32, Fig. 28
Leigh, Wayne, 121
 Composition, 121, Fig. 117
Light Box and Balsa, Jewessen, 223, Fig. 200
Line, 15, 17-19, 21, 152
Line Statements, Benson, 11, Fig. 6
Linear perspective, 53, 186-187, Figs. 55, 166
Linear technique, 77-79, 83, 190-191
Lykins, Jere, 311, Fig. 323

Madonna and Child, Moore, 113, Fig. 114
Maillol, Aristide, 21
 Deux Femmes Nues, 21, Fig. 14
Man Mounting Horse, Marini, 21, Fig. 21
Man of War, Aguet, 271, Figs. 262-269
Marquiles, Robert, 309, Fig. 321
Marino Marini, 21
 Man Mounting Horse, Marini, 21, Fig. 21
Massey, William, 78
 Reflections, 78, Fig. 76
Masson, Andre, 31
 Battle of the Fishes, 31, Fig. 26
Materials, 7-8, 71-123
Materials and techniques, 3, 4, 6, 71-123
Maternity, Cremonini, 91, 188, Fig. 90
Michelangelo, Buonarroti, 78, 79, 91, 183
 Head of a Satyr, 78, 79, 91, Fig. 88
 Studies for the Libyan Sibyl, 183, Fig. 165
Mills No. 2, Moholy-Nagy, 234, Fig. 213
Miskin, Beverly, 29, 316
 Photo-Drawing, 29, 316, Figs. 331, 332
Moholy-Nagy, Lazzlo, 118
 Mills No. 2, 118, 234, Fig. 213

Mondrian Piet, 66
 Tree II, 1912, 66, Fig. 67
Moore, Henry, 78, 113
 Women Winding Wool, 78, Fig. 77
 Madonna and Child, 113, Fig. 114
Morandi, Georgio, 21
 Natura Morta, 21, Fig. 16
Mouth Scape Series, Shirley, 11, 211, Figs. 5, 183-186
Movement, 56, 58
Mu Ch'i, 60
 Persimmons, 60, Fig. 60
My Car, New, 289, Figs. 290-295

Natura Morta, Morandi, 21, Fig. 16
Naylor, Geoffrey, 234
 Sculpture for Hanes Mall, 234, Fig. 212
Negative (See positive-negative)
Nesler, Lee, 123
 Eyes, 123, Fig. 119
Nettles, Beatrice, 29, 34, 85, 108
 Expecting Rain, 55, 108, Fig. 109
 Landing, 85, Fig. 85
 Negative Photograph of Pencil Drawings, 34, Fig. 32
 Stars Over Iona, 29, Fig. 24
New, Marshall, 167, 289
 Built Contour, 167, Fig. 153
 My Car, 289, Figs. 290-295
Nicholson, Ben, 120
 Still Life, 120, Fig. 116
Nickels, Bradley, 40, 132, 163, 168
 Back View of Figure, 160, Fig. 146
 Figures in Movement, 168, Fig. 154
 Seated Figure, 40, Fig. 41
 Standing Figure, 163, Fig. 151
Noses, Rivers, 44, Fig. 43
Nude, Seurat, 154, Fig. 143
Nude Study, Kolbe, 101, 158, Fig. 101

Of Domestic Utility, 31, 48, Fig. 27
One, Pollack, 66, Fig. 66
Osservanza Master Painting, 70
 Christ in Limbo, 70, Fig. 70
Overlapping Figures, Aguet, 171, Fig. 155
Overlapping Figures—Variation, Baker, 171, Fig. 157

Paper, 75-76, 102-103, 114-116
Pattern, 49
Pen and ink, 88-91, 247-248, 308, Figs. 34, 87-93, 225-232
Pen and Ink Techniques, Fiol, 247-248, Figs. 92, 225-232
Pencil, 75-79, 81-82
Persimmons, Mu Ch'i, 60, Fig. 60
Petruchyk, John, 318-319
Phillips, Helen, 310, Fig. 322
Photo-Drawing, Miskin, 29, 316, Figs. 331-332
Photo-Graph, Walker, 234, Fig. 214
Picasso, Pablo, 40, 121
 Bathers, 40, 121, Fig. 38
Pinnell, Paige, 191, 255-256
 The Clouds, 255-256, Figs. 237-240
 Vertical Techniques and Collage, 191, Fig. 170
Plexiglass, 118, 120, 305, Figs. 213, 316, 317

Polish Rider Series, Schaaf, 243, Figs. 216, 219-224
Pollack, Jackson, 66
 One, 66, Fig. 66
Polymer, 102
Porta, Giulio, 53, 297-300
 Series of Drawings, 53, 297, 300, Figs. 56, 304-310
Positive and Negative, 47-48
Poussin, Nicholas, 106
 Bearing the Cross, 106, Fig. 107
Principles (See composition)
Proportion, 62-63
Provaca, Art, 146-148
 Figure with Cross Contour, 146, 148, Fig. 135
Prud'hon, Pierre-Paul, 109, 185, 205
 La Source, 109, 185, 205, Fig. 110
Purple Mouth-Scape, 11, Fig. 5
Purser, Jean, 36, 79, 214
 Drawings from Museum Collection, 36, 79, 214, Figs.
 78, 187

Quill pens, 88-90

Rape of Europa, Durer, 15, Fig. 9
Raphael, 68
 Fighting Men, 68, Fig. 69
Reclining Figure, Haney, 160, Fig. 147
Reclining Nude, Boucher, 40, Fig. 40
Reed pens, 88-91, Fig. 93
Reese, Nancy, 48, 166
 Two Figure Study, 48, 166, Fig. 47
Reflections, Massey, 78, Fig. 76
Reflection of Tristan and Isolde, A, Beardsley, 91, Fig. 89
Reifman, Marsha, 292
 Boy-Girl Sequence, 292, Figs. 296-300
Rembrandt, van Rijn, 5
Renoir, Pierre Auguste, 109-191
 The Bathers, 109, Fig. 111
 L'Assomoir, 191, Fig. 171
Repetition, 58-60, Figs. 58, 60, 61
Rhodesia, 50
 Hunting Scene, 50, Fig. 50
 Burial Scene of a King, 50, Fig. 51
Rhythm, 66
Richburg, Lance, 21, 91, 169
 Horse in Action, 21, 169, Fig. 23
 Reed Pen and Ink, 91, 169, Fig. 93
Rivers, Larry, 44, 50
 Noses, 44, Fig. 43
 Stravinsky Collage, 50, Fig. 52
Roberts, Larry, 153
 Line Experiments, 153, Fig. 141
Rock Shapes and Landscape, Haber, 75, Fig. 73
Rodin, Auguste, 98, 107
 Study for a Bas Relief, 98, Fig. 100
 Standing Nude, 107, Fig. 108
Ross, Dave, 11
 Wiring Diagram for Knetic Relief, 11, Fig. 7
Running Dog Series, Weinbaum, 65, 253-254, Figs. 65,
 234-236
Running Figure Series, Chesser, 48, 63, 79, 217-218, Figs.
 49, 62, 79, 192-194

Sandwich, Weinbaum, 29, Fig. 25
Santa A in B, Klee, 52, Fig. 54
Sargent, John Singer, 83, 103
 Study of a Nude Youth with Arms Raised, 83, Fig.
 84
 Spaniard Dancing Before Nine Seated Figures, 103,
 Fig. 102
Schaaf, William, 11, 59, 63, 104, 243
 Bone Structure Composition, 180, Fig. 162
 Drawing from Sketchbook, 11, Fig. 8
 Polish Rider Series, 243, Figs. 216, 219-224
 Project I, 59, 63, 104, 243, Figs. 58, 106, 217-218
Schedule and Assignments, 133
Schooley, Katherine, 150
 Seated Figure and Environment, 188, Fig. 167
Sculpture Forms, Gonda, 90, Fig. 87
Seated Boy with a Straw Hat, Seurat, 34, Fig. 31
Seated Courtier with Sword, Indian, 21, Fig. 17
Seated Figure, Nickels, 40, Fig. 41
Seated Figure, Law, 85, Fig. 86
Seated Figure, Craven, 157, Fig. 145
Seated Figure and Environment, Schooley, 188, Fig. 167
Sempere, Eusebio, 21
 Untitled, 21, Fig. 19
Sepia, 89, 98
Series of Drawings, Porta, 53, 297, 300, Figs. 56, 304-310
Seurat, Georges, 15, 31, 34, 154
 At the Concert, 15, Fig. 10
 Nude, 154, Fig. 143
 Seated Boy with a Straw Hat, 34, Fig. 31
Sheeler, Charles, 31, 48
 Of Domestic Utility, 31, 48, Fig. 27
Shirley, William, 11, 118, 191, 211, 262-263
 Diagonal Technique, 191, Fig. 169
 Mouth Scape Series, 11, 211, Figs. 5, 183-186
 Silver Point and Egg Tempera, 118, Fig. 115
 Transfers and Airbrush, 262-263, Figs. 247-251
Shouse, Dan, 139
 Structure Drawing, 139, Fig. 127
Silverpoint, 90, 121, 208, Figs. 87, 90, 117, 182, 183
Sketchbook, 8, 9, 11, 13
Sketch for Print, Kerslake, 9, Fig. 4
Smith, David, 21, 51
 Horse and Rider, 21, Fig. 18
 Voltron XVIII, 60, Fig. 61
Smith, Robert, 76, Fig. 74
Sobering, Gail, 153
 Renderings of Line Experiments, 153, Fig. 142
South Rhodesia, 50, Fig. 51
Space, 15, 47-55
Spaniard Dancing Before Nine Seated Figures, Sargent,
 103, Fig. 102
Standing Figure, Stormes, 21, 157, Fig. 22
Standing Figure, Nickels, 163, Fig. 151
Standing Figure, Haney, 163, Fig. 149
Standing Nude, Rodin, 107, Fig. 108
Stars Over Iona, Nettles, 29, Fig. 24
Steffanelli, Ray, 78, Fig. 80
Stele, Abularach, 91, Fig. 91
Still Life, Nicholson, 120, Fig. 116

Stormes, Al, 21, 104, 157, 161
 Brush and Wash, 104, 161, Fig. 105
 Standing Figure, 21, 157, Fig. 22
Stravinsky Collage, 50, Fig. 52
Structure drawing, 43, 137-139, 176-177, Figs. 126-133
Structure Drawing, Drew, 139, Fig. 128
Study, Caravaggio, 98, Fig. 97
Study for a Bas Relief, Rodin, 98, Fig. 100
Studies for the Libyan Sibyl, Michelangelo, 183, Fig. 165
Study of Female Head and Arms, Ingres, 21, 167, Fig. 15
Study in Form, 44, Fig. 46
Study of a Nude Youth with Arms Raised, Sargent, 83, Fig. 84
Studies of Horses and Riders, Toulouse-Lautrec, 43, Fig. 133
Stuffed Figures, Kritzer, 226, Figs. 204-206
Sumi, 89
Surface Muscles, Bradley, 183, Fig. 164

Talking Men Series, Drew, 82, 123, 295, Figs. 120, 301-303
Techniques, 71-123, 190-191, Figs. 75, 168, 169
Tempera, egg, Figs. 115, 183
Tension, 58
Texture, 15, 35, 36, 38
Tiered perspective, 50, Figs. 50-53
Tonal Techniques, 79, 81, 83, 213-215
Totten, Kathe, 62, Fig. 21
Toulouse-Lautrec, Henri de, 9, 38
 Studies of Horses and Riders, 43, 139, 143, Fig. 133
 The Black Countess, 9, Fig. 3
Transfers and Airbrush, Shirley, 262-263, Figs. 247-251
Tree II, 1912, Mondrian, 66, Fig. 67
Triumphant General Crowned by a Flying Figure, 98, Fig. 98

Two Figure Study, Reese, 48, 166, Fig. 47
Two Nudes, Ingres, 40, 166, Fig. 37
Two Model Series, Coover, 201, Figs. 174-179
Two Sketches of a Reclining Female Nude, Villon, 139, Fig. 131

Untitled, Sempere, 21, Fig. 19

Value, 15, 28, 29, 31-34, 151, 154, 156, 160, 223, 225, 226
Van Gogh, Vincent, 5, 36
 View of Arles, 36, Fig. 34
Vertical Techniques and Collage, Pinnell, 191, Fig. 170
Veterans, Lebrun, 21, 58, Fig. 13
View of Arles, Van Gogh, 36, Fig. 34
Villon, Jacques, 139
 Two Sketches of a Reclining Nude, 139, Fig. 129
Voltron XVIII, Smith, 60, Fig. 61

Walker, Todd, 234
 Photo-Graph, 234, Fig. 214
Wash, 95-108, 157-163
Water Hyacinth, Law, 259-260, Figs. 241-246
Weinbaum, Leonard, 29, 65, 253-254
 Running Dog Series, 65, 253-254, Figs. 65, 234-236
 Sandwich, 29, Fig. 25
Williams, Hiram, 234
 Eye Series, 234, Figs. 210-211
Wiring Diagram for Kenetic Relief, Ross, 11, Fig. 7
Women Winding Wool, Moore, 78, Fig. 77
Woodward, Anne, 139
 Structure drawing, 139, Figs. 129, 130

York, David, 302
 Car Series, 302, Figs. 311-314